Draw Amazing
MANGA
CHARACTERS

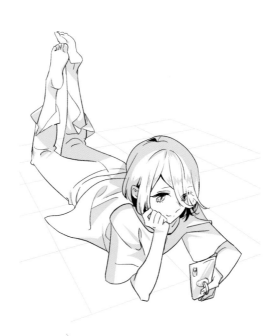

TUTTLE Publishing

Tokyo | Rutland, Vermont | Singapore

CONTENTS

PART 1

11

The Basics from Sketching to Finished Illustration

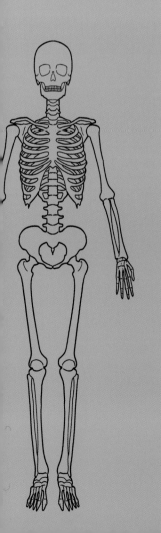

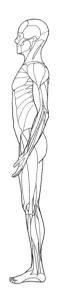

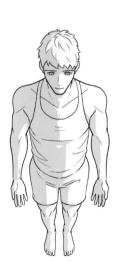

Let's Draw Basic Movements and Poses

Level 1

Expert Tips | 2

How to Draw Different Character Types 56

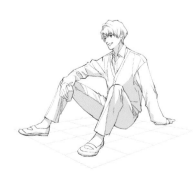

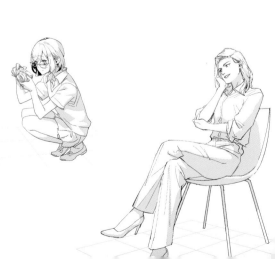

PART 3

79

Let's Draw Basic Movements and Poses

Level 2

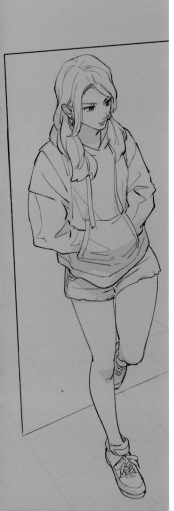

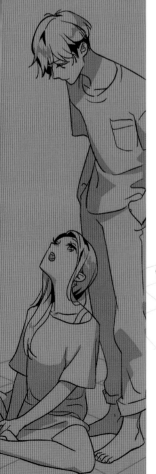

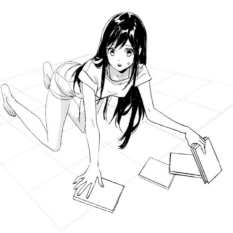

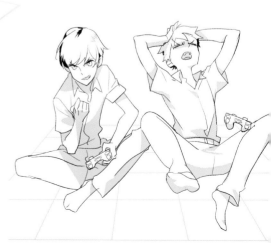

PART 5

169

Let's Try Drawing Special Scenes and Challenging Poses

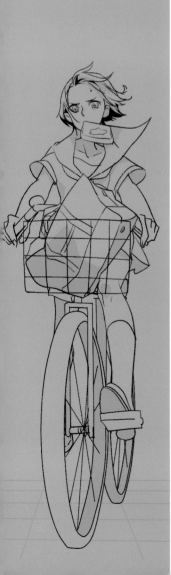

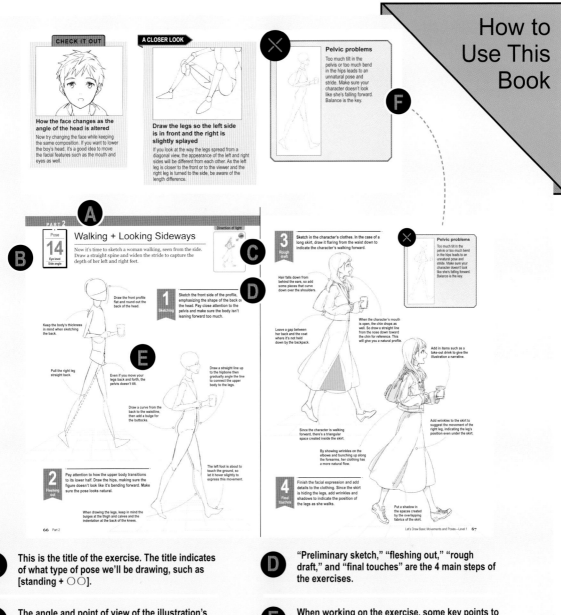

How to Use This Book

The main diagram (page 66-67 spread example):

CHECK IT OUT

How the face changes as the angle of the head is altered

Now try changing the face while keeping the same composition. If you want to lower the boy's head, it's a good idea to move the facial features such as the mouth and eyes as well.

A CLOSER LOOK

Draw the legs so the left side is in front and the right is slightly splayed

If you look at the way the legs spread from a diagonal view, the appearance of the left and right sides will be different from each other. As the left leg is closer to the front or to the viewer and the right leg is turned to the side, be aware of the length difference.

Pelvic problems

Too much tilt in the pelvis or too much bend in the hips leads to an unnatural pose and stride. Make sure your character doesn't look like she's falling forward. Balance is the key.

PART 2
Pose **14**
Eye level / Side angle

Walking + Looking Sideways

Now it's time to sketch a woman walking, seen from the side. Draw a straight spine and widen the stride to capture the depth of her left and right feet.

Direction of light

Draw the front profile flat and round out the back of the head.

Keep the body's thickness in mind when sketching the back.

Pull the right leg straight back.

Even if you move your legs back and forth, the pelvis doesn't tilt.

Draw a curve from the back to the waistline, then add a bulge for the buttocks.

1 Sketching — Sketch the front side of the profile, emphasizing the shape of the back of the head. Pay close attention to the pelvis and make sure the body isn't leaning forward too much.

Draw a straight line up to the hipbone then gradually angle the line to connect the upper body to the legs.

The left foot is about to touch the ground, so let it hover slightly to express this movement.

2 Fleshing out — Pay attention to how the upper body transitions to its lower half. Draw the hips, making sure the figure doesn't look like it's bending forward. Make sure the pose looks natural.

When drawing the legs, keep in mind the bulges at the thigh and calves and the indentation at the back of the knees.

66 Part 2

3 Rough draft — Sketch in the character's clothes. In the case of a long skirt, draw it flaring from the waist down to indicate the character's walking forward.

Hair falls down from behind the ears, so add some pieces that curve down over the shoulders.

Leave a gap between her back and the coat where it's not held down by the backpack.

When the character's mouth is open, the chin drops as well. So draw a straight line from the nose down toward the chin for reference. This will give you a natural profile.

Add in items such as a take-out drink to give the illustration a narrative.

Since the character is walking forward, there's a triangular space created inside the skirt.

Add wrinkles to the skirt to suggest the movement of the right leg, indicating the leg's position even under the skirt.

By showing wrinkles on the elbows and bunching up along the forearms, her clothing has a more natural flow.

4 Final touches — Finish the facial expression and add details to the clothing. Since the skirt is hiding the legs, add wrinkles and shadows to indicate the position of the legs as she walks.

Put a shadow in the spaces created by the overlapping fabrics of the skirt.

Pelvic problems

Too much tilt in the pelvis or too much bend in the hips leads to an unnatural pose and stride. Make sure your character doesn't look like she's falling forward. Balance is the key.

Let's Draw Basic Movements and Poses—Level 1 **67**

A This is the title of the exercise. The title indicates of what type of pose we'll be drawing, such as [standing + ○○].

B The angle and point of view of the illustration's exercise. The 3 key angles are high angle, low angle, and bird view. The 4 key points of view are font, side, diagonal and back.

C The direction of light is indicated by the "light" mark. Let's think about the light source's direction while we shade in our sketch.

D "Preliminary sketch," "fleshing out," "rough draft," and "final touches" are the 4 main steps of the exercises.

E When working on the exercise, some key points to look out for will be explained with these text boxes.

F The illustrations point is explained in the "A CLOSER LOOK" sidebars. Common mistakes will be explained in the ✕ box. And lastly, the "CHECK IT OUT" box will give hints on how to add variations to the character's pose or expressions.

Now you can watch the pros draw on YouTube!

You can watch a special demonstration on YouTube done by Karasuba Ame, one of the illustrators of this book! We are releasing videos of original character sketches for the public. Use this book along with the videos to master your illustration!

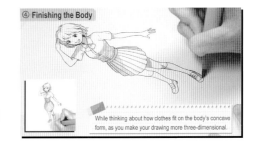

④ Finishing the Body

While thinking about how clothes fit on the body's concave form, as you make your drawing more three-dimensional.

 URL http://www.youtube.com/user/SEITOSHA

You Didn't Start with a Sketch!

I drew while looking at a model but something looks off...

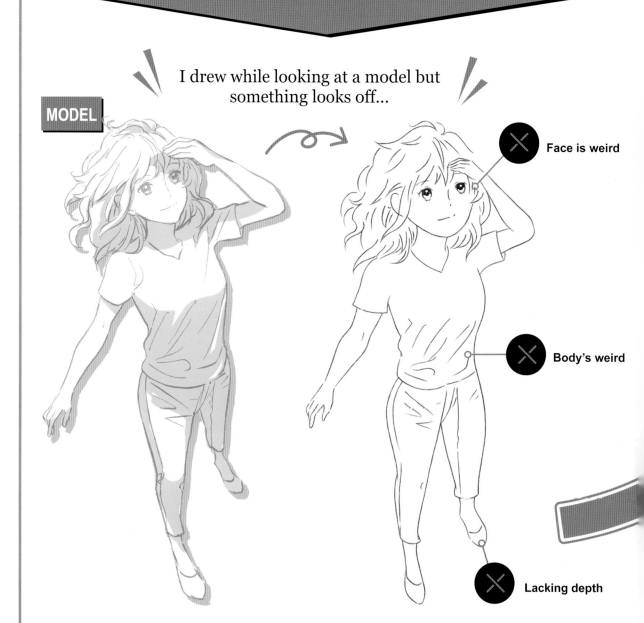

MODEL

Face is weird

Body's weird

Lacking depth

No matter how much I draw while referencing a model, why can't seem to draw well?

What brings out the charm of a character in an illustration is the lively pose, mood of the scene, and the dynamic composition. However, no matter how much you try to copy the model, you can't seem to capture the illustration the same way. Why is that? A good illustrator's brings out their characters charm not from the cuteness or coolness, but by getting the "right reference proportions."

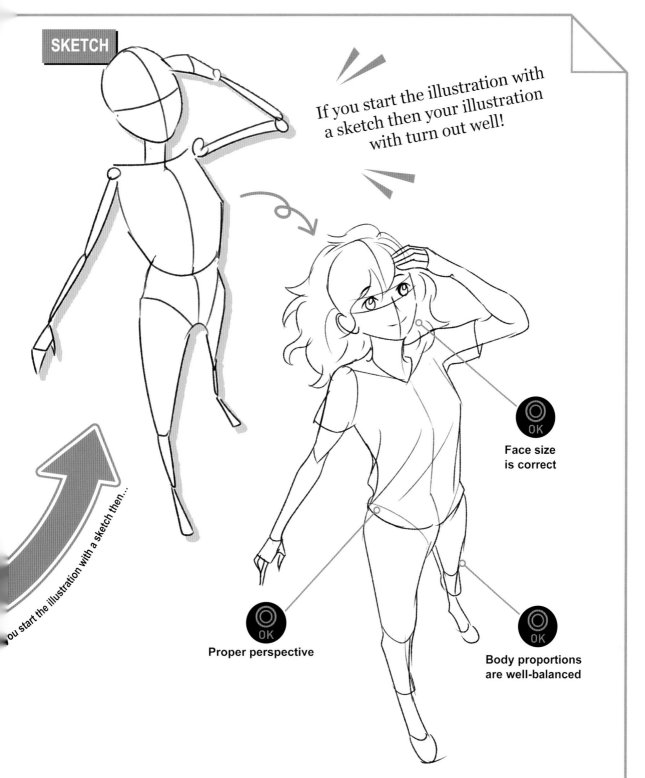

SKETCH

If you start the illustration with a sketch then your illustration with turn out well!

ou start the illustration with a sketch then...

Face size is correct

Proper perspective

Body proportions are well-balanced

Characters drawn by good illustrators are already attractive from the initial stage!

Good illustrators are masters at expressing their characters with their pose, angle, and depth from this preliminary stage. This book will walk you through fundamental yet attractive poses that every beginners should try at least once! Let's learn how to draw a sketch and practice a lot so that you can freely express your own manga character.

The Preliminary Sketch

A blueprint or preliminary sketch determines the characters overall balance. Blocking-in → fleshing out → rough draft → final touches. By learning this 4-step process, you can improve your illustration.

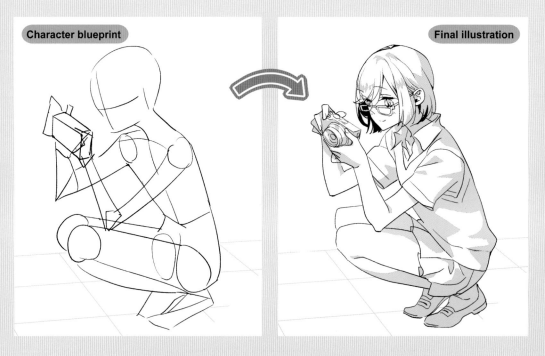

Character blueprint

Final illustration

You can become a unique and accomplished illustrator by mastering the essentials—the key steps!

There are a lot of benefits that come with improving your grasp of the basics. Let's practice drawing various poses and lift the level of your illustrations!

1 Understanding the natural connection between our face, arms, legs, upper and, lower body so you can draw accurate poses.

2 By practicing drawing from various perspective such as high and low angles, you can add depth to your illustrations.

3 You'll learn to draw more realistic proportions by learning the human anatomy such as the human bone structure and muscles.

4 You'll learn to draw more your characters from various angles. Not only from the front, but also from a side and diagonal angle.

5 By perfecting the face shapes and body silhouette, you'll also learn to draw hair and clothes realistically as well.

The Basics from Sketching to Finished Illustration

In this book, you'll be refining your drawing technique by dividing the process into 4 steps, from sketching to the finished product. First let's learn about human anatomy and how to draw from varying angles as the basic techniques for sketching.

Basic Knowledge

1

Let's Learn Skeletal Anatomy

Understanding the structure of the human skeleton is the first step in capturing accurate proportions. Let's understand the difference between male and female bone structure and how the joints in our body connects the bones.

Difference between males and females

There's no major differences between males and females, however, the ribs and pelvis shape are a little different.

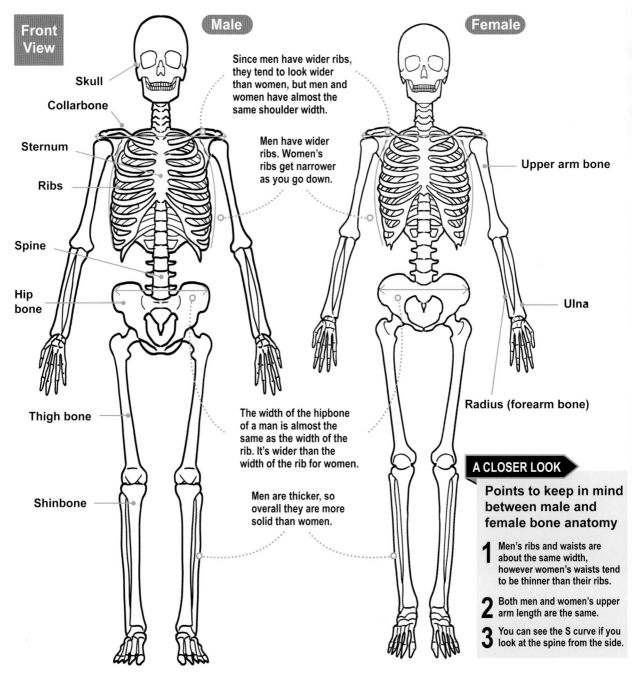

Front View

Male

Female

Skull

Collarbone

Sternum

Ribs

Spine

Hip bone

Thigh bone

Shinbone

Upper arm bone

Ulna

Radius (forearm bone)

Since men have wider ribs, they tend to look wider than women, but men and women have almost the same shoulder width.

Men have wider ribs. Women's ribs get narrower as you go down.

The width of the hipbone of a man is almost the same as the width of the rib. It's wider than the width of the rib for women.

Men are thicker, so overall they are more solid than women.

A CLOSER LOOK

Points to keep in mind between male and female bone anatomy

1 Men's ribs and waists are about the same width, however women's waists tend to be thinner than their ribs.

2 Both men and women's upper arm length are the same.

3 You can see the S curve if you look at the spine from the side.

The bulge of the ribs is the same for male and female. The difference in the body shape depends on placement of the muscle and fat.

Male

Female

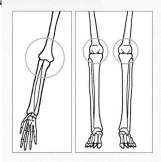

Capturing the bulge of the arm and leg joints

Human arms and legs are connected by joints. Being aware of these joints will help you pose your characters more naturally. Also, even if you have muscles, the joints will stick out! So make sure you're not drawing the legs and arms as just a straight line.

The spine has a slight S shape when viewed from the side.

Back View

Male

Female

The spine supports the back of the head and extends down all the way to the hip bones.

Shoulder blades

Same for the back view, the lines between the ribs and hips are straight for men and narrowed for women.

The heels are shaped like a square to support the body's weight.

Basic Knowledge

2

Let's Learn Muscle Anatomy

IIumans contains muscles and fat along the bone structure throughout the entire body. Understanding where these elements settle on the body is the first step in drawing realistic characters.

Differences between male and female muscles

The lines on the male body are more angled and defined while women are more rounded. Also note the difference in muscle development.

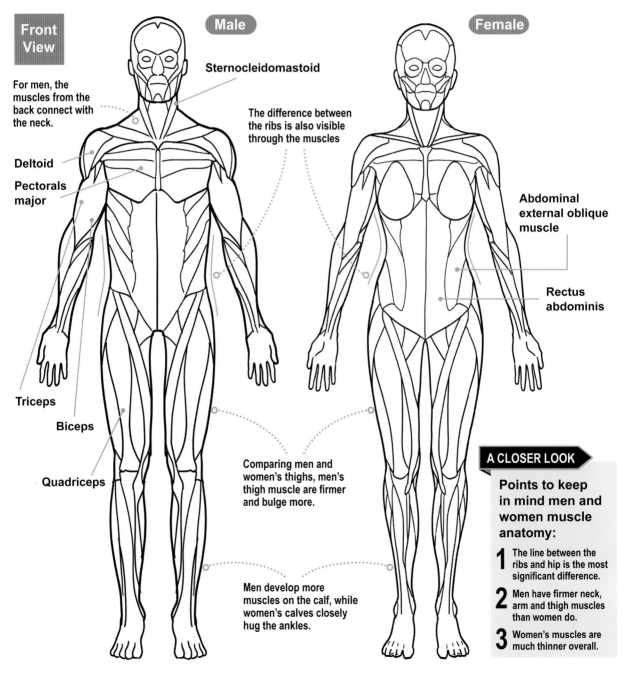

Front View

Male

Female

For men, the muscles from the back connect with the neck.

Sternocleidomastoid

The difference between the ribs is also visible through the muscles

Deltoid

Pectorals major

Abdominal external oblique muscle

Rectus abdominis

Triceps

Biceps

Quadriceps

Comparing men and women's thighs, men's thigh muscle are firmer and bulge more.

Men develop more muscles on the calf, while women's calves closely hug the ankles.

A CLOSER LOOK

Points to keep in mind men and women muscle anatomy:

1 The line between the ribs and hip is the most significant difference.

2 Men have firmer neck, arm and thigh muscles than women do.

3 Women's muscles are much thinner overall.

Side View

Men's forearm muscles are more visible than women's forearms.

Male

Female

Men have flatter buttocks because they're more muscular and solid. While women's buttocks are rounder because they have fat.

A CLOSER LOOK

Men also have a slight bulge at their chest

The front of the body isn't flat, men also has a bulge at their chest from the chest muscle. Draw the chest bulge while paying attention to the roundness of the ribs as well as how the pectoral muscles connect with the abdomen.

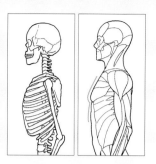

Back View

Male

Female

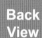

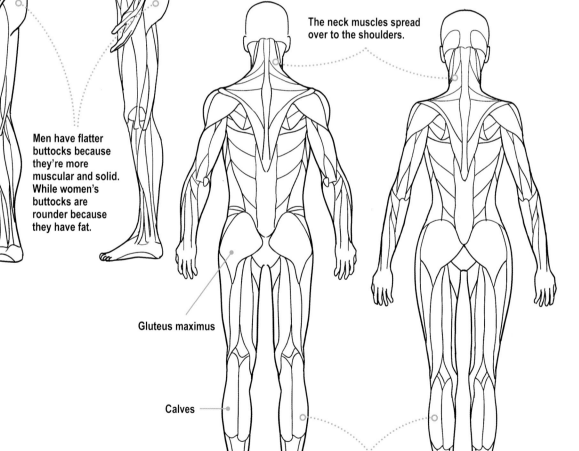

The neck muscles spread over to the shoulders.

Gluteus maximus

Calves

Both men and women have bulges at their calves so be sure to indicate them.

Basic Knowledge

3

Basics of Sketching Women

With the human skeletal structure and musculature in mind, try sketching the female body. In this book you'll be learning a four-step process: 1-preliminary sketching, 2-fleshing out, 3-rough draft, then 4-finishing touches.

Keep in mind that a woman's body has rounder edges than a man's.

Sketching key parts such as the shoulders and elbows helps balance the curves of the chest, neck and hips and more fully suggest the female form. Practice front, side and vertical points of view.

A CLOSER LOOK

Points to consider when drawing women

1 Keep the bone structures in mind when sketching the arms and legs.

2 Keep in mind the curves between chest, waist and hip.

3 Draw wider thighs and tighten the ankles.

Front View

As the shoulders and elbows are key points of movement, capture them when sketching.

Draw lines that curves in between the ribs and hips.

Draw a bulge where the hips connect to the thigh to create a softer silhouette.

Clearly indicate the position of the knees.

1 Sketching

Sketch the position of the head, body and limbs to complete the draft. Draw rounded lines to add curves.

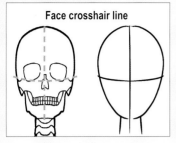

Face crosshair line

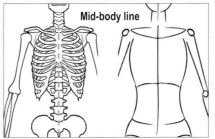

Mid-body line

How to determine where to draw the face crosshair and mid-body line

The crosshair and mid-body lines are the reference lines for symmetrically capturing facial parts such as eyes and noses, and the body. For crosshairs on the face, the horizontal line should pass through the eyes and the vertical line should pass through the nose. As for the mid-body line, it's determined from the spine.

For women, draw a bulge for the breast over here.

Then decide on the eye placement

Draw the hair along the shape from of the head from the top then down towards the tip.

Draw in clothes while keeping in mind the space between the body and the clothing. Depending on whether the outfit is a loose or tight fit.

Bring your character to life by drawing details such as cheeks, eyes and eyebrows.

At parts where the body line changes, you can draw in wrinkles of the clothing to add dimension.

Keep in mind the shape of the joints at places such as the knees.

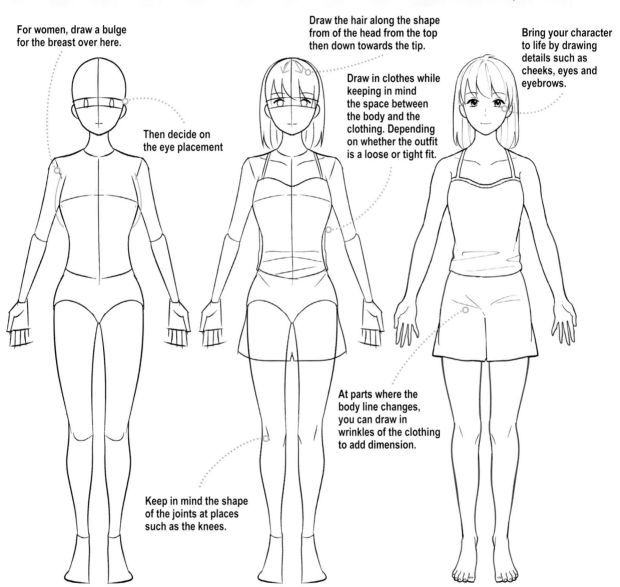

2
Fleshing out

Sketch out the bulges to the muscles. Add roundness at the chest and hips while keeping the arms and legs thin.

3
Rough draft

Add details to the hairstyle, facial features and outfit.

4
Final touches

Erase unnecessary sketch lines, and add facial details and wrinkles to the clothing for the final touch.

Side View

This is the view of the female figure from the side. Note the upper body and bent leg.

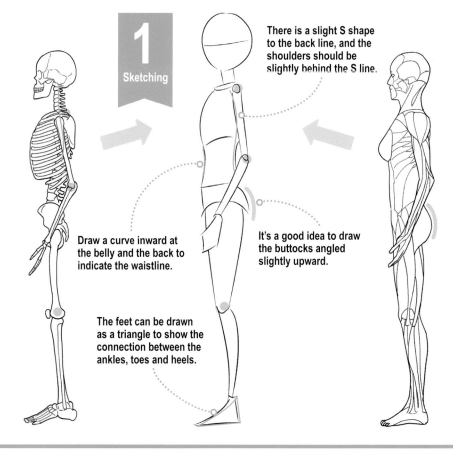

1 Sketching

There is a slight S shape to the back line, and the shoulders should be slightly behind the S line.

Draw a curve inward at the belly and the back to indicate the waistline.

It's a good idea to draw the buttocks angled slightly upward.

The feet can be drawn as a triangle to show the connection between the ankles, toes and heels.

Diagonal View

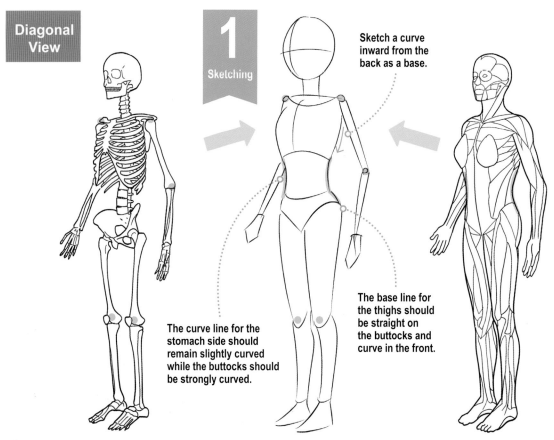

1 Sketching

Sketch a curve inward from the back as a base.

The curve line for the stomach side should remain slightly curved while the buttocks should be strongly curved.

The base line for the thighs should be straight on the buttocks and curve in the front.

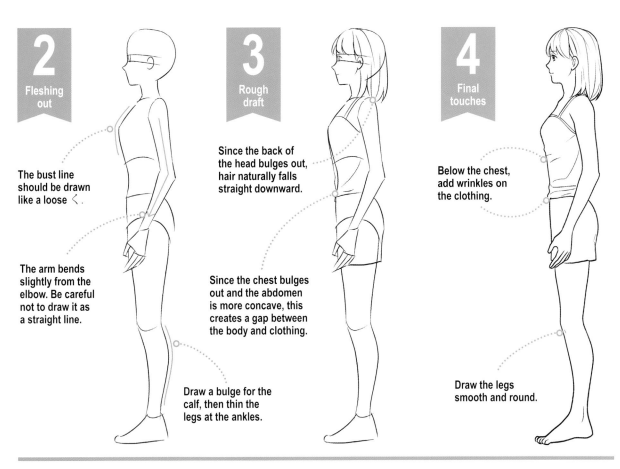

2 Fleshing out

The bust line should be drawn like a loose <.

The arm bends slightly from the elbow. Be careful not to draw it as a straight line.

3 Rough draft

Since the back of the head bulges out, hair naturally falls straight downward.

Since the chest bulges out and the abdomen is more concave, this creates a gap between the body and clothing.

Draw a bulge for the calf, then thin the legs at the ankles.

4 Final touches

Below the chest, add wrinkles on the clothing.

Draw the legs smooth and round.

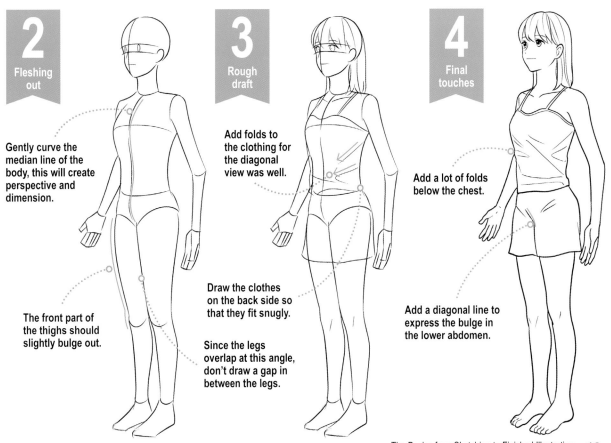

2 Fleshing out

Gently curve the median line of the body, this will create perspective and dimension.

The front part of the thighs should slightly bulge out.

3 Rough draft

Add folds to the clothing for the diagonal view was well.

Draw the clothes on the back side so that they fit snugly.

Since the legs overlap at this angle, don't draw a gap in between the legs.

4 Final touches

Add a lot of folds below the chest.

Add a diagonal line to express the bulge in the lower abdomen.

Basic Knowledge
4

Basics of Sketching Men

Let's sketch while keeping the male skeleton and musculature in mind.

Focusing on the straight and solid.

In contrast of the round and curved lines of the female body, males have a more straight and solid body shape. Keep in mind the stiffness of the muscles when you flesh out the drawing. Let's practice front, side and diagonal view.

Points to keep in mind when drawing men

1 Since there's no waist curve, draw the upper body as a straight line.

2 The neck, arms and legs are thicker and more muscular than women's.

3 Add lines to the muscular parts to express the muscles tension.

The muscles that connect the neck to the shoulders bulge up a little, so it's better to draw a slightly longer neck to create space to draw the muscles.

Because men tend to have bigger shoulder muscles, this creates the illusion that men have wider shoulders. Widen the shoulder points to express this in the sketch.

Front View

The ribs are wide, so draw a straight line down connecting the area to the hips.

There are no curves to the waist, so draw it straight.

1 **Sketching**

Draw a straight line from the waist to the hips. Make the limbs slightly thinner than women's to emphasize the muscularity.

Adapt the way you sketch to fit your style

The first stage is the blueprint for drawing characters, but how it's sketched is unique to each artist. Even the styles presented in this guide vary, for instance, the way the joints and the thickness of the limbs are different from each other. So it's O.K. to develop your own unique way of sketching that works best for you!

Use the chin line as a reference for the thickness of the neck.

Draw a diagonal line to connect the neck and the shoulders to increase the thickness of the back muscles.

Draw a line along the sternocleidomastoid muscle to indicate muscles at the nape of the neck.

For clothing that's a tight fit, the clothing's outline doesn't change too much from the body line.

If you draw a line along the muscles of the upper arm, this creates a 3-dimensional effect.

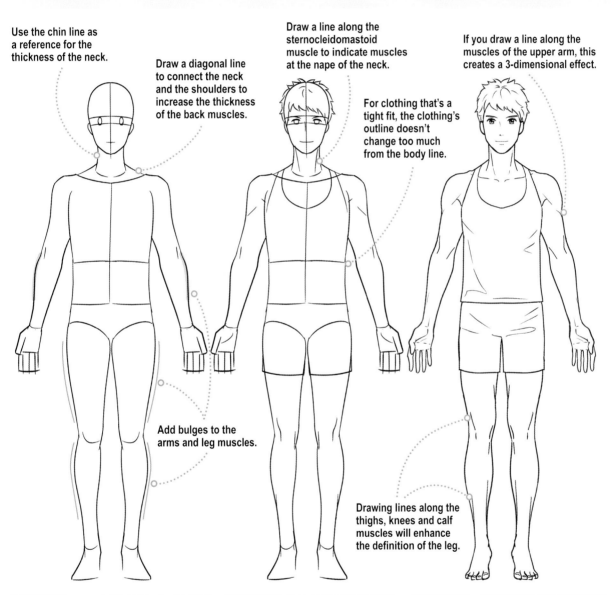

Add bulges to the arms and leg muscles.

Drawing lines along the thighs, knees and calf muscles will enhance the definition of the leg.

2 Fleshing out
Flesh out and add thickness to the neck, arms and legs. Basically, you don't need to draw a curve for the waistline.

3 Rough draft
Roughly draw details such as the face and clothing. Make sure the body line is visible even through the clothing.

4 Final touches
Add detailed lines for the hair and wrinkles on the clothing. Keep in mind where the muscles are and draw lines and bulges accordingly.

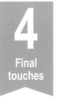

Side View

Side view of the male body. Be sure and capture the main differences between men and women, such as the shape of the buttocks.

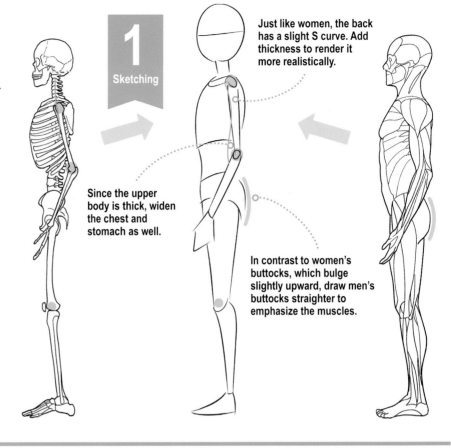

1 Sketching

Just like women, the back has a slight S curve. Add thickness to render it more realistically.

Since the upper body is thick, widen the chest and stomach as well.

In contrast to women's buttocks, which bulge slightly upward, draw men's buttocks straighter to emphasize the muscles.

Diagonal View

View of the male body from a diagonal angle. In contrast to women, men have straighter and more defined body lines.

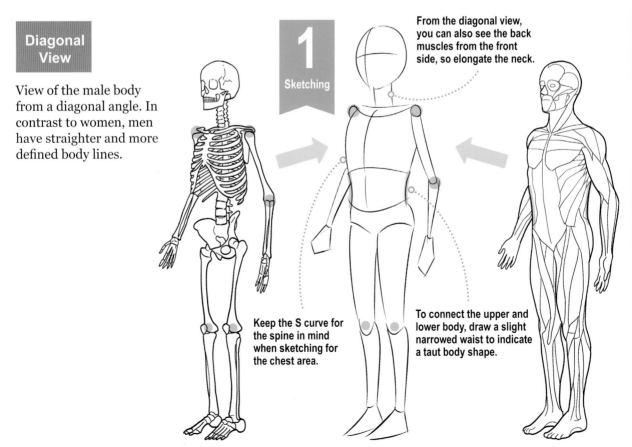

1 Sketching

From the diagonal view, you can also see the back muscles from the front side, so elongate the neck.

Keep the S curve for the spine in mind when sketching for the chest area.

To connect the upper and lower body, draw a slight narrowed waist to indicate a taut body shape.

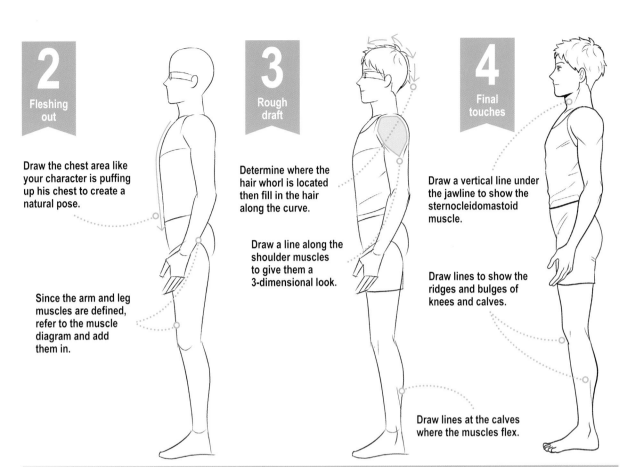

2
Fleshing out

Draw the chest area like your character is puffing up his chest to create a natural pose.

Since the arm and leg muscles are defined, refer to the muscle diagram and add them in.

3
Rough draft

Determine where the hair whorl is located then fill in the hair along the curve.

Draw a line along the shoulder muscles to give them a 3-dimensional look.

4
Final touches

Draw a vertical line under the jawline to show the sternocleidomastoid muscle.

Draw lines to show the ridges and bulges of knees and calves.

Draw lines at the calves where the muscles flex.

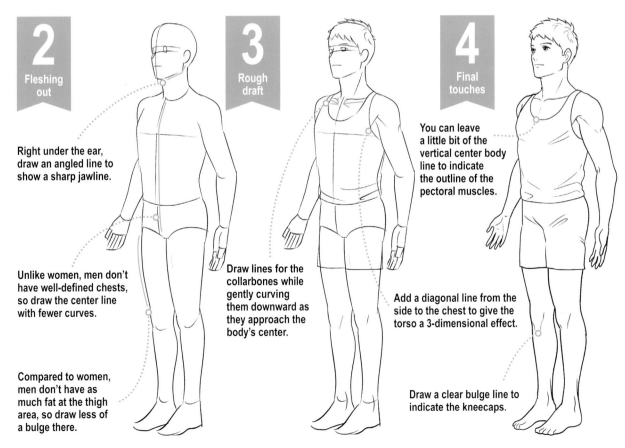

2
Fleshing out

Right under the ear, draw an angled line to show a sharp jawline.

Unlike women, men don't have well-defined chests, so draw the center line with fewer curves.

Compared to women, men don't have as much fat at the thigh area, so draw less of a bulge there.

3
Rough draft

Draw lines for the collarbones while gently curving them downward as they approach the body's center.

4
Final touches

You can leave a little bit of the vertical center body line to indicate the outline of the pectoral muscles.

Add a diagonal line from the side to the chest to give the torso a 3-dimensional effect.

Draw a clear bulge line to indicate the kneecaps.

Basic Knowledge

5

How to Draw Eye Level, High Angle and Low Angle Perspectives

Drawing from a high or low angle adds depth, dimension and variety to your character. Start to familarize yourself with eye-level perspective first so you can then draw different, increasingly complex poses from various angles.

What is eye level?

Perspective can be divided into 3 main categories: direct (eye level), looking up (low angle) and looking down (high angle). For example, if you look at a box from a direct angle, you'll only see the front of the box. But if you shift the perpective, you can see the front and/or bottom. The appearance, viewable range and shape change as your viewpoint alters.

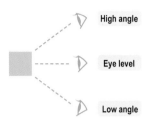

What is perspective?

If you're looking at an object from above, the character will appear narrower as you look from the top to bottom. In contrast, when seen from a low angle, the object or character appears wider from the top to bottom. That's because things that are closer appear larger and as things are farther from us, they look smaller.

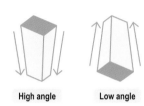

High angle Low angle

Master drawing high and low angles with 2-point-perspective projection!

When applying 2-point-perspective projection, perspective is captured by two vanishing points. The vanishing point is the point where objects get smaller toward the back and are aggregated into one point.

High angle

1 Draw a horizontal line and two points. This will be the vanishing point.

2 Draw a vertical line right below the horizontal line and connect the top and bottom edges to the vanishing points.

3 Using the lines drawn in Step 2 as reference, draw another vertical line on each side.

4 Using the lines drawn in Step 3 as reference, connect the tip above the vertical line with the vanishing points.

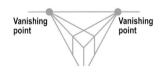

Vanishing point — Vanishing point | Vanishing point — Vanishing point | Vanishing point — Vanishing point | Vanishing point — Vanishing point

Low angle

1 Draw a horizontal line and two points. This will be the vanishing point.

2 Draw a vertical line right above the horizontal line and connect the top and bottom edges to the vanishing points.

3 Using the lines drawn in Step 2 as reference, draw another vertical line on each side.

4 Using the lines drawn in Step 3 as reference, connect the tip above the vertical line with the vanishing points.

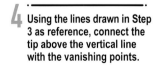
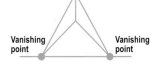
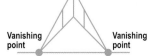
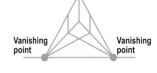

Vanishing point — Vanishing point | Vanishing point — Vanishing point | Vanishing point — Vanishing point | Vanishing point — Vanishing point

Differences between eye level, high angle and low angle

Eye level

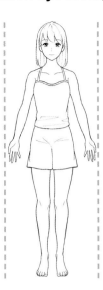

Front view

The upper arm and forearm appear to be about the same length. You can see the body firmly in both the upper and lower body.

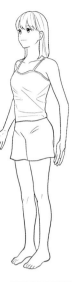

Diagonal view

The upper part of the back arm is hidden. There's no gap between the left and right legs.

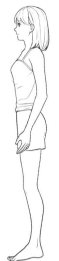

Side view

Arms and legs can only be seen on the side facing the viewer. The line of the calf is not straight, and the part beneath the knee is slightly contoured.

High angle

Front view

The back of the head is wide so you can see the whorls on the crown. The form contours from the upper to the lower bodies.

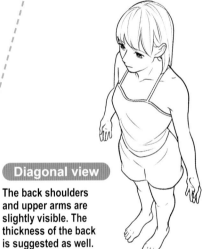

Diagonal view

The back shoulders and upper arms are slightly visible. The thickness of the back is suggested as well.

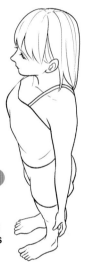

Side view

Draw the left and right chest lines vertically. You can see the back sides of the legs a little.

Low angle

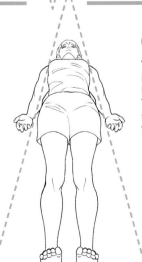

Front view

The upper arms appear short, and the forearms appear longer. You can see the soles of the feet, which you weren't able to from eye level and from above.

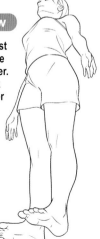

Diagonal view

The bulge of the chest is emphasized, so the body becomes thicker. The legs on the back side are a little longer than the front side.

Side view

You can see the legs on the back side a little. You can also see a small portion of the back.

Drawing from high and low angles

High angle

From head to toe, the head appears closer so draw it bigger. As for the legs, they're farther away, so draw them smaller.

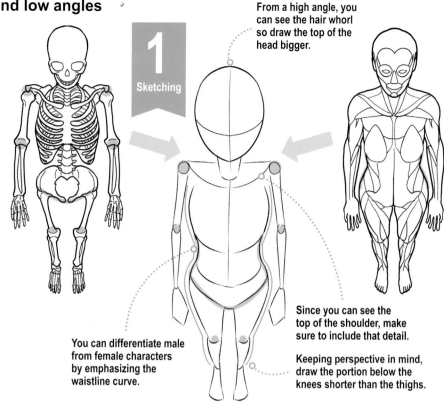

From a high angle, you can see the hair whorl so draw the top of the head bigger.

Since you can see the top of the shoulder, make sure to include that detail.

Keeping perspective in mind, draw the portion below the knees shorter than the thighs.

You can differentiate male from female characters by emphasizing the waistline curve.

Low angle

From toe to head, the legs are elongated and the parts get smaller as you move toward the head.

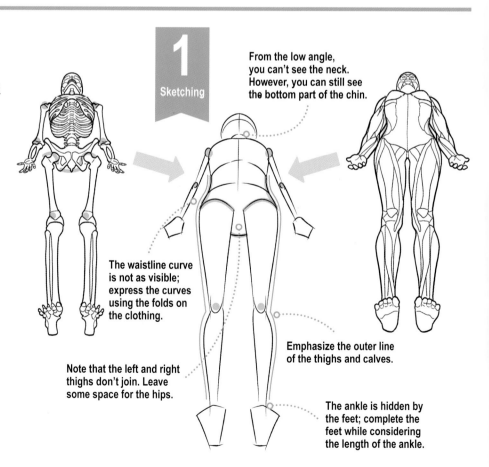

From the low angle, you can't see the neck. However, you can still see the bottom part of the chin.

The waistline curve is not as visible; express the curves using the folds on the clothing.

Note that the left and right thighs don't join. Leave some space for the hips.

Emphasize the outer line of the thighs and calves.

The ankle is hidden by the feet; complete the feet while considering the length of the ankle.

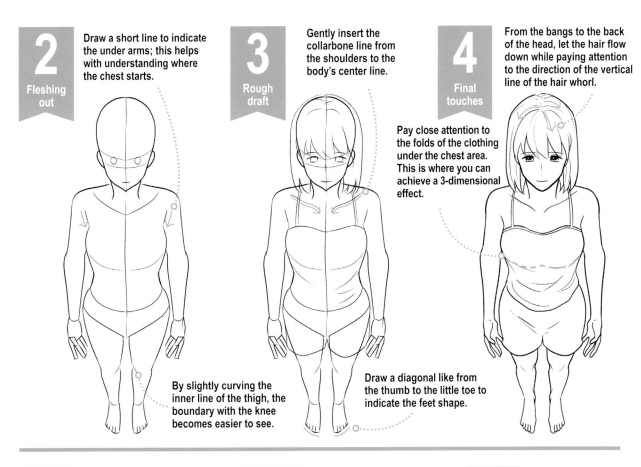

2 Fleshing out

Draw a short line to indicate the under arms; this helps with understanding where the chest starts.

3 Rough draft

Gently insert the collarbone line from the shoulders to the body's center line.

4 Final touches

From the bangs to the back of the head, let the hair flow down while paying attention to the direction of the vertical line of the hair whorl.

Pay close attention to the folds of the clothing under the chest area. This is where you can achieve a 3-dimensional effect.

By slightly curving the inner line of the thigh, the boundary with the knee becomes easier to see.

Draw a diagonal like from the thumb to the little toe to indicate the feet shape.

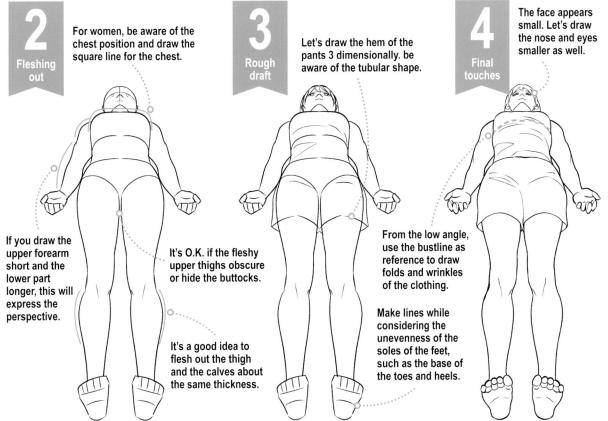

2 Fleshing out

For women, be aware of the chest position and draw the square line for the chest.

3 Rough draft

Let's draw the hem of the pants 3 dimensionally. be aware of the tubular shape.

4 Final touches

The face appears small. Let's draw the nose and eyes smaller as well.

If you draw the upper forearm short and the lower part longer, this will express the perspective.

It's O.K. if the fleshy upper thighs obscure or hide the buttocks.

It's a good idea to flesh out the thigh and the calves about the same thickness.

From the low angle, use the bustline as reference to draw folds and wrinkles of the clothing.

Make lines while considering the unevenness of the soles of the feet, such as the base of the toes and heels.

Drawing men from a high angle

High angle

Make the figure boxier than a woman's. Be conscious of the size of their throat, which should be thicker than women.

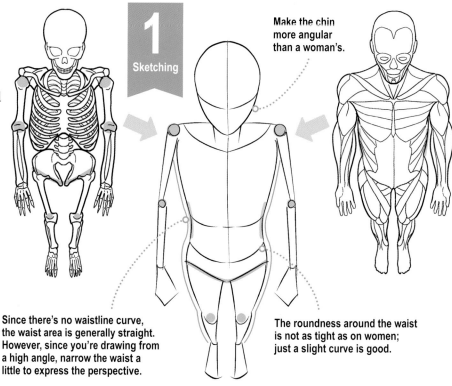

1 Sketching

Make the chin more angular than a woman's.

Since there's no waistline curve, the waist area is generally straight. However, since you're drawing from a high angle, narrow the waist a little to express the perspective.

The roundness around the waist is not as tight as on women; just a slight curve is good.

Low angle

When sketching from this perspective, be sure to keep the musculature and its well-defined lines in mind.

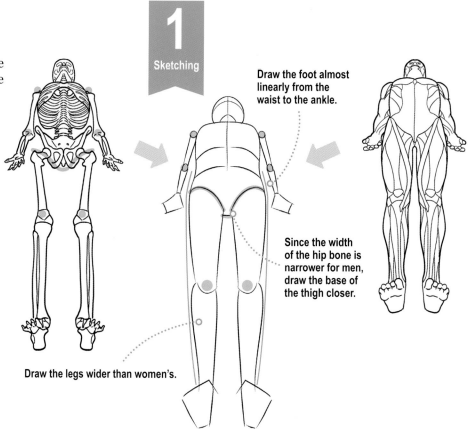

1 Sketching

Draw the foot almost linearly from the waist to the ankle.

Since the width of the hip bone is narrower for men, draw the base of the thigh closer.

Draw the legs wider than women's.

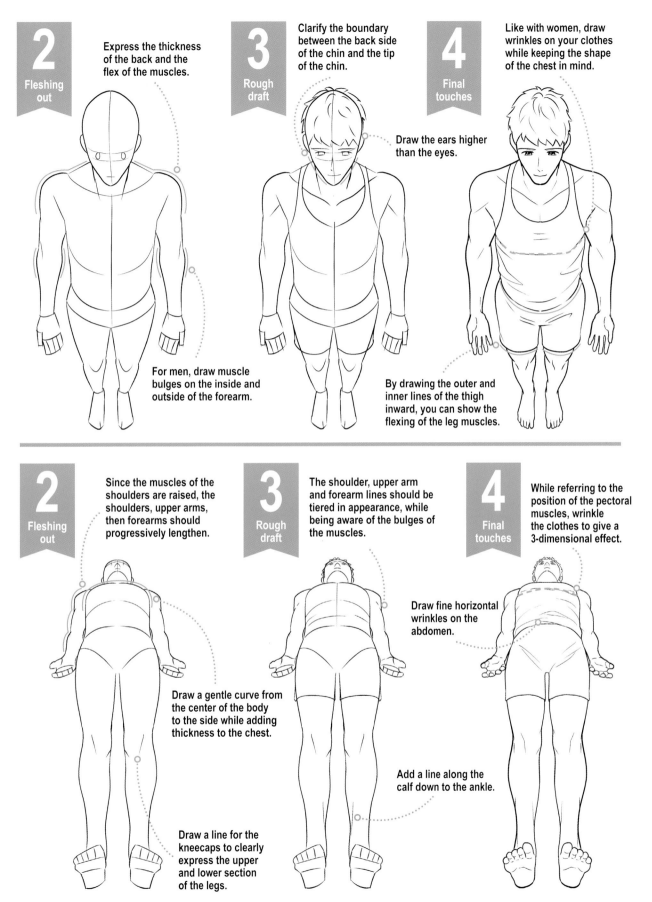

2 Fleshing out
Express the thickness of the back and the flex of the muscles.

For men, draw muscle bulges on the inside and outside of the forearm.

3 Rough draft
Clarify the boundary between the back side of the chin and the tip of the chin.

Draw the ears higher than the eyes.

4 Final touches
Like with women, draw wrinkles on your clothes while keeping the shape of the chest in mind.

By drawing the outer and inner lines of the thigh inward, you can show the flexing of the leg muscles.

2 Fleshing out
Since the muscles of the shoulders are raised, the shoulders, upper arms, then forearms should progressively lengthen.

Draw a gentle curve from the center of the body to the side while adding thickness to the chest.

Draw a line for the kneecaps to clearly express the upper and lower section of the legs.

3 Rough draft
The shoulder, upper arm and forearm lines should be tiered in appearance, while being aware of the bulges of the muscles.

Draw fine horizontal wrinkles on the abdomen.

Add a line along the calf down to the ankle.

4 Final touches
While referring to the position of the pectoral muscles, wrinkle the clothes to give a 3-dimensional effect.

Basic Knowledge

6

How to Shade Your Sketches to Add Dimension

If you add a shadow while paying attention to the contours, depth and movement of the face and body, the dimensions of your character will look more realistic. Add shadow to your sketches while thinking about the direction of the light.

Consider the light source and pose when adding shadow

It's critical to think about the position of the light and to apply a natural shadow. When looking at a person's face and body from the side, there are parts that prominently extend or stick out, such as the nose, chest and the muscles of the arms and thighs. By adding shadows that makes these parts stand out, you can give the character a three-dimensional effect. Applying shading to match the character's movement is also a way to add dimension. Add shadows that match the material and shape of the clothes.

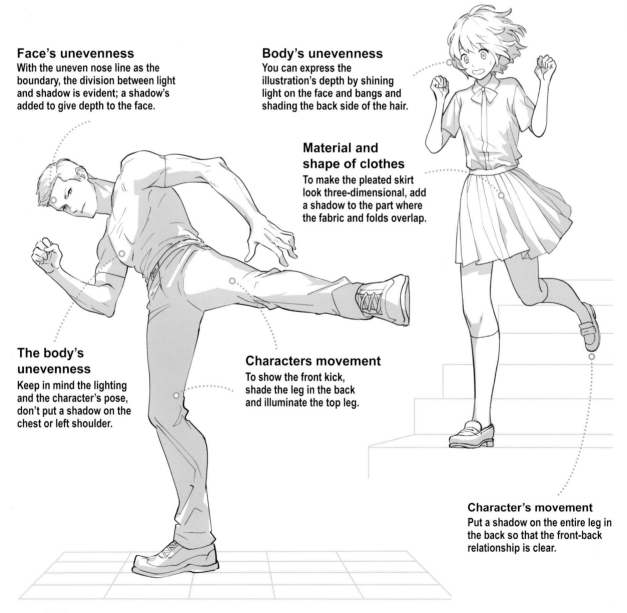

Face's unevenness
With the uneven nose line as the boundary, the division between light and shadow is evident; a shadow's added to give depth to the face.

Body's unevenness
You can express the illustration's depth by shining light on the face and bangs and shading the back side of the hair.

Material and shape of clothes
To make the pleated skirt look three-dimensional, add a shadow to the part where the fabric and folds overlap.

The body's unevenness
Keep in mind the lighting and the character's pose, don't put a shadow on the chest or left shoulder.

Characters movement
To show the front kick, shade the leg in the back and illuminate the top leg.

Character's movement
Put a shadow on the entire leg in the back so that the front-back relationship is clear.

Light Coming from the Top

Light ↓

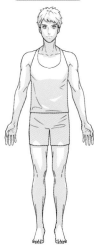
Eye level

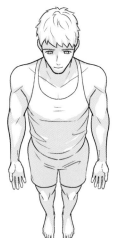
High angle

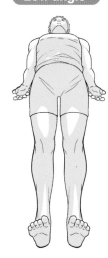
Low angle

Body parts such as the top of the head, face and chest will be lit up; beneath the chest is mostly shaded.

Light Coming from the Bottom

Light ↑

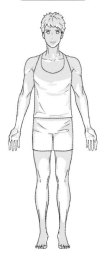
Eye level

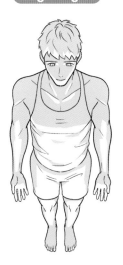
High angle

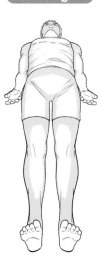
Low angle

This will be the inverse of light coming from the top. A shadow is cast on most parts of the face, perfect for a villain's visage.

Light Coming from the Side

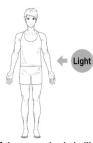

← Light

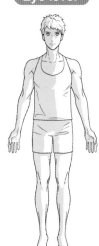
Eye level

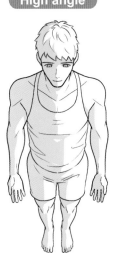
High angle

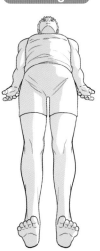
Low angle

Half of the upper body is illuminated, and the shadows fall on the other half. If you add shadow to the opposite side of the limbs, you can achieve a 3-dimensional effect.

How to Draw Facial Expressions & Emotions

When you change the facial features to express emotions, you can bring your character to life. Alter, move and play with the shapes of eyebrows, eyes and mouth to elicit different emotions.

Various types of smiles

A smile expresses the level of enjoyment and intensity through the eyes and mouth. Draw eyebrows to match the eyes.

The mouth is lightly open with a joyous expression.

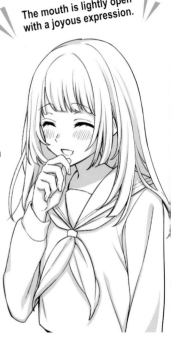

Giggle

Eyes are closed and the corners of the mouth raised. Add some blush to the cheeks to suggest a joyful expression. The hand over the mouth is a nice final touch!

Gentle smile

The point is to lower the outer corners of the eyes to make them look droopy. Raise the corner of the mouth a little to create a gentle vibe.

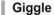

The mouth is lightly open with a joyous expression.

Bright smile

Raise the corners of the mouth and open it wide to the side. Lift the upper eyelids to make the eyes wide open.

Mischievous smile

Raise the eyebrows. If you lift one corner of the mouth diagonally, this gives the smile a mischievous edge.

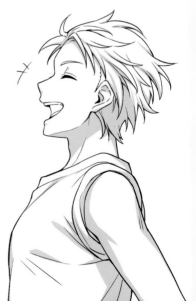

Hearty laugh

For a laugh-out-loud moment, open the mouth wide and big. The face should also raise a little to give the character dimension.

Various kinds of crying

There are various emotions that can provoke or lead to crying, such as joy or regret. Customize the tears to the situation to enliven the expressions.

Though small, teardrops can add dramatic effects!

Big tears flowing

With the eyes wide open, this expresses emotions such has being surprised or confused. Draw a tear line from under the eyes to the chin and express teardrops in circles.

Quiet cry

The emotions are hidden, the eyes are closed, the mouth is tightly sealed, and the eyebrows are slightly lowered. Draw tears on the eyelids and cheeks.

Capture the frustration through shaking shoulders.

Frustration tears

Draw wrinkles between the eyebrows. Lift the ends of the eyebrows and corners of the eyes to make them look glaring. Add clenched teeth to complete the expression.

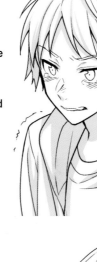

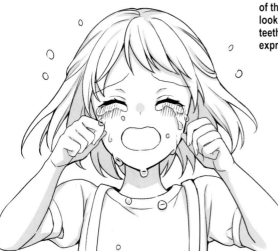

Bursting into tears

Close the eyes tightly, lower the eyebrows and open the mouth wide. The same amount of tears as the width of the eyes collects and streams down the character's face.

Blushed cheeks capture the heightened mood.

Happy tears

Eyes closed and tears flowing, express the joy by opening the mouth wide to the side.

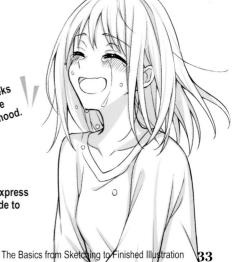

Various kinds of angry faces

Express the feeling of anger while adding manga notation and shadows. Open the mouth or shut it tightly according to the type of ire.

Yelling

Wrinkles appear between the eyebrows as the eyebrows and eyes are narrowed. Draw a square on the mouth and draw lines on the teeth and tongue.

Don't forget to raise the shoulders.

Aggressive anger

Angle the eyebrows and open the eyes for a strong pose. Keep in mind the perspective of the arm. You can even add a pointing finger to for more emphasis!

Silent anger

Lift the corners of the eyes tightly to give a cold impression. Other parts of the face don't move too much and the overall expression is downcast.

Draw a shadow on the face to create a powerful expression.

Built-up anger

You can express a strong feeling of resentment by adding a shadow around the eyes and making them pop out. The mouth can be clenched to show that they're holding their emotion in.

Frustrated anger

While lifting the eyebrows a little, inflate the cheeks. Express the intensity of the irritation by flushing the cheeks.

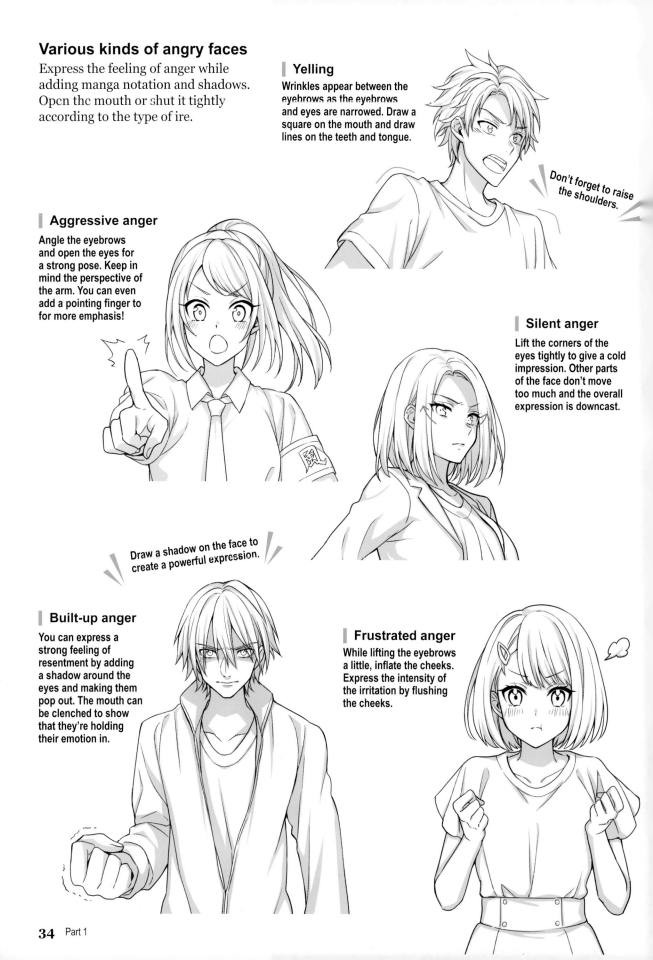

Let's Draw Basic Movements and Poses

Level 1

Let's start practicing sketches for some basic movements and postures, such as standing and walking. You'll steadily improve your drawing if you keep the human body in mind while drawing each pose. Or try them out yourself first!

Pose

1

Eye level
Diagonal view

Standing + Reaching a Hand Out ①

Here you'll be drawing a young woman standing with one arm extended to the front. Think about how to add depth to her extended arm from a diagonal point of view.

Draw a short upper arm and a long forearm to add depth to the right arm.

If you draw the neck removed from the chin, you get the diagonal view of the neck.

1
Sketching

Pull the chin back a little and slightly arch the back. Draw with a sense of perspective so that the arm won't look unnatural.

Don't draw a line from the back of the neck to the shoulder, but add a slight bulge to make the back thicker.

Since the left arm is fully visible, the upper body and left arm could be drawn separately.

Raise the right arm to shoulder height and the muscles will be lifted.

Draw the leg in front a little longer and the one in the back a little shorter to express the angle.

The fingers of the right hand are bent slightly to capture the sense of feeling the breeze with the hand.

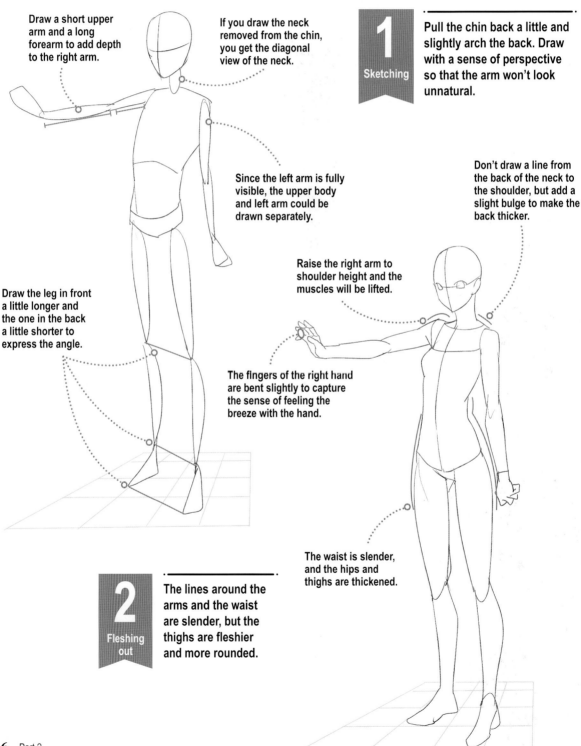

The waist is slender, and the hips and thighs are thickened.

2
Fleshing out

The lines around the arms and the waist are slender, but the thighs are fleshier and more rounded.

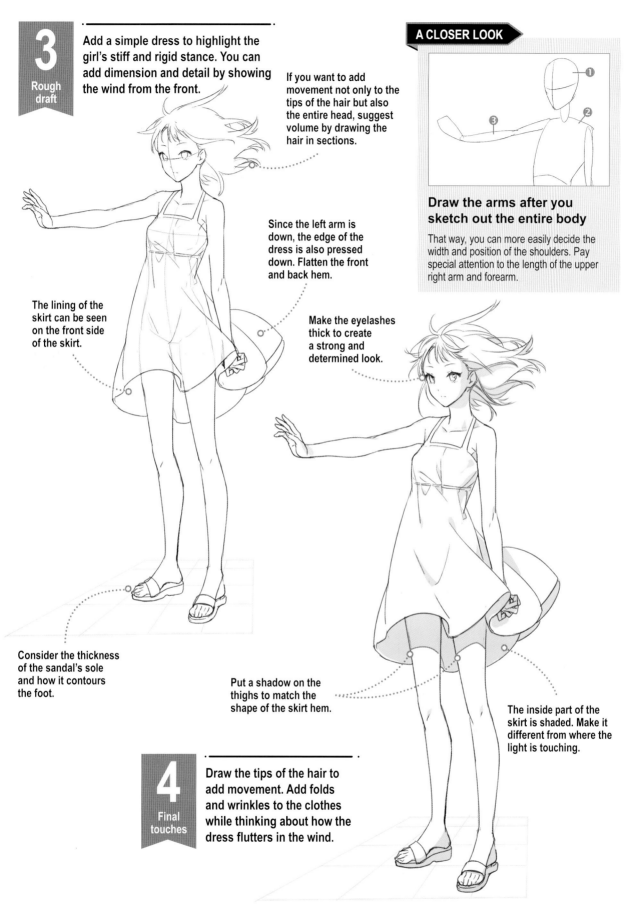

3 Rough draft

Add a simple dress to highlight the girl's stiff and rigid stance. You can add dimension and detail by showing the wind from the front.

If you want to add movement not only to the tips of the hair but also the entire head, suggest volume by drawing the hair in sections.

Since the left arm is down, the edge of the dress is also pressed down. Flatten the front and back hem.

The lining of the skirt can be seen on the front side of the skirt.

Make the eyelashes thick to create a strong and determined look.

A CLOSER LOOK

Draw the arms after you sketch out the entire body

That way, you can more easily decide the width and position of the shoulders. Pay special attention to the length of the upper right arm and forearm.

Consider the thickness of the sandal's sole and how it contours the foot.

Put a shadow on the thighs to match the shape of the skirt hem.

The inside part of the skirt is shaded. Make it different from where the light is touching.

4 Final touches

Draw the tips of the hair to add movement. Add folds and wrinkles to the clothes while thinking about how the dress flutters in the wind.

PART 2

Pose

2

Eye level
Diagonal view

Standing + Diagonal Angle

Here the character's looking down while standing with his weight on one leg, held at a slight angle. When drawing, pay attention to the perspective of the left and right legs and how to indicate the center of balance.

Direction of light

1 Sketching

The weight is place on the leg in the back and the pelvis is pushed forward. Draw a gentle curve from the upper body to the legs.

2 Fleshing out

A man's pelvis is generally narrower than a woman's. Make sure you don't draw it too wide. Create a sense of stability by drawing the thigh muscles firmly.

Since the abdomen is relaxed and the weight is in the hips, push them forward.

The weight is placed on the leg in the back, so sketch straight down to the ground.

The leg in front appears longer than the one in back. Draw the knees and ankles in a vertical angle from each leg.

Since the arms are relaxed, slope the shoulders slightly. Place the arms on the waist comfortably.

When drawing the calves, include the bulge of the muscle on the outer side.

Keep in mind a loose S shape and flesh out the chest and thigh.

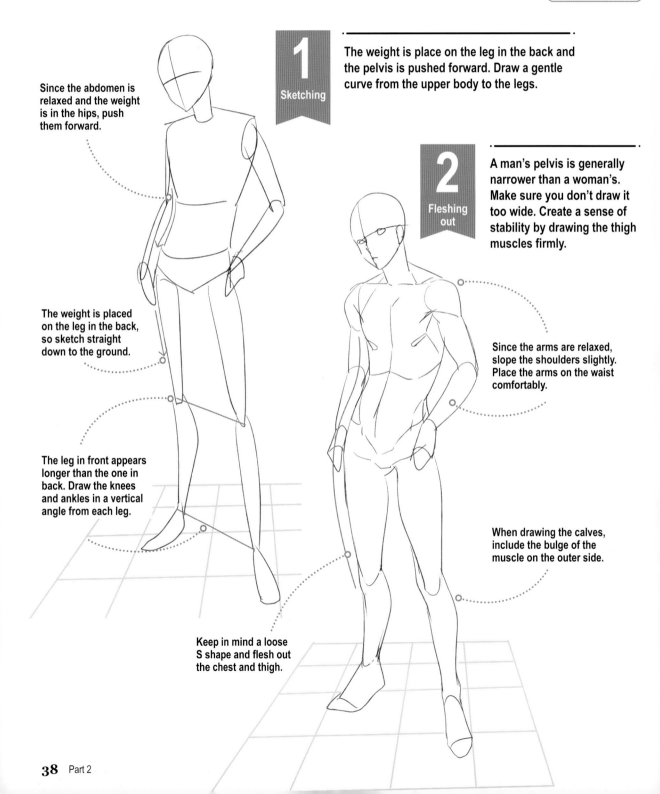

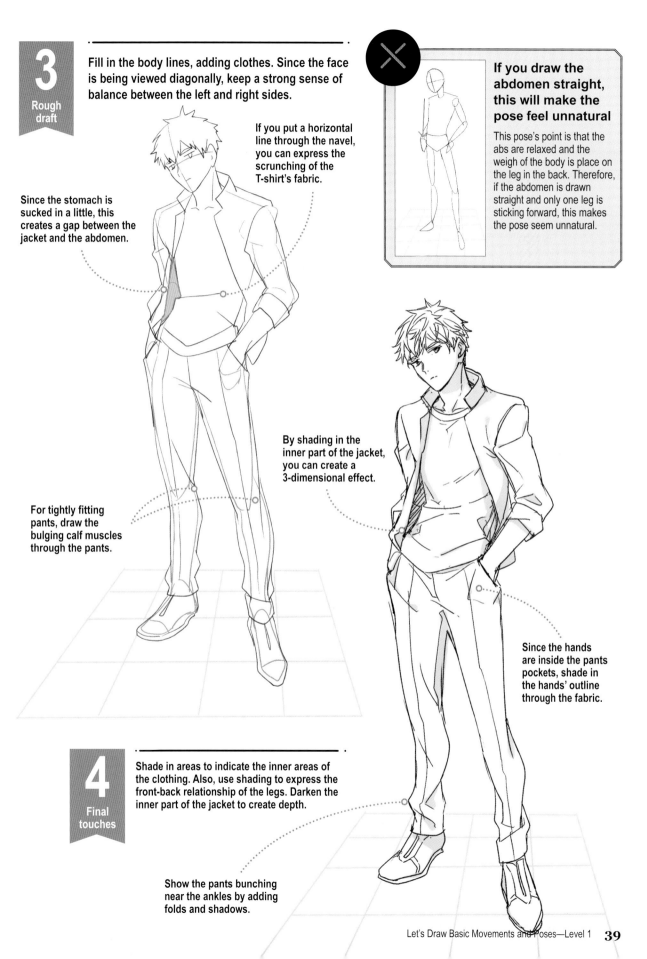

3

Rough draft

Fill in the body lines, adding clothes. Since the face is being viewed diagonally, keep a strong sense of balance between the left and right sides.

If you put a horizontal line through the navel, you can express the scrunching of the T-shirt's fabric.

Since the stomach is sucked in a little, this creates a gap between the jacket and the abdomen.

If you draw the abdomen straight, this will make the pose feel unnatural

This pose's point is that the abs are relaxed and the weigh of the body is place on the leg in the back. Therefore, if the abdomen is drawn straight and only one leg is sticking forward, this makes the pose seem unnatural.

By shading in the inner part of the jacket, you can create a 3-dimensional effect.

For tightly fitting pants, draw the bulging calf muscles through the pants.

Since the hands are inside the pants pockets, shade in the hands' outline through the fabric.

4

Final touches

Shade in areas to indicate the inner areas of the clothing. Also, use shading to express the front-back relationship of the legs. Darken the inner part of the jacket to create depth.

Show the pants bunching near the ankles by adding folds and shadows.

Pose
3
Slightly low angle

Standing + Looking Back

In this pose, a woman is looking back while reaching her hand out. Pay attention to the pivot and twist of the body, the torque and angles created by this simple backward-looking glance.

Direction of light

Light

1 Sketching

Draw the shoulder angled diagonally to show depth. The turning movement is mostly in the shoulders, so be sure to keep the torso mostly facing forward.

One shoulder is drawn back and the other is pulled forward. To capture this, draw the shoulders at a diagonal angle.

When looking back over your shoulders, the face isn't positioned directly in front.

Be sure to properly render the curves of the shoulders.

2 Fleshing out

Exaggerate the curves at the waistline to emphasize the twisting of the body. Keep in mind that the hand is reaching back.

Combine the fingers, except for the thumb, into a solid form.

Draw the back part of the knees as well. Although this area will be covered by clothing, drawing it will help determine the skirt's length.

Flesh out an S curve that connects the back shoulder, back, waistline and hips to create a sleek silhouette.

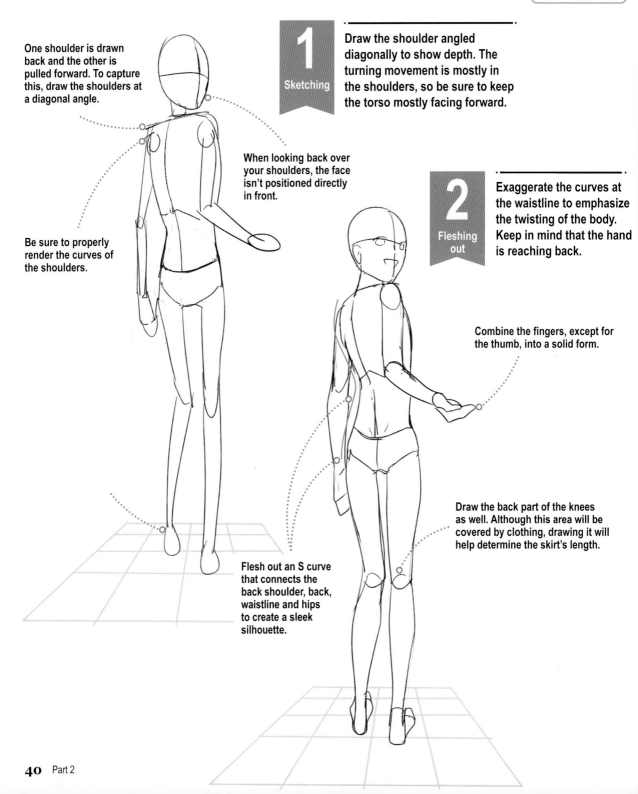

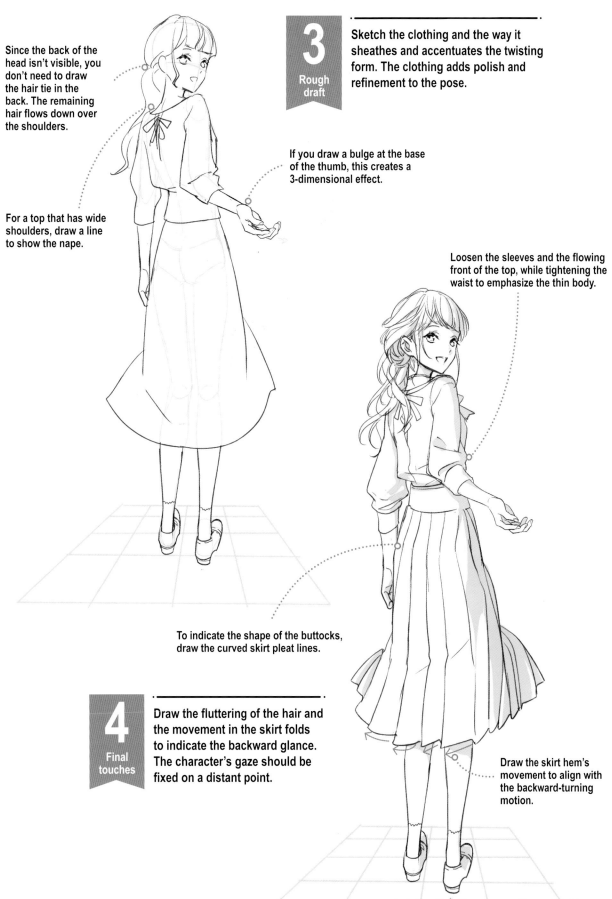

Since the back of the head isn't visible, you don't need to draw the hair tie in the back. The remaining hair flows down over the shoulders.

For a top that has wide shoulders, draw a line to show the nape.

3

Rough draft

Sketch the clothing and the way it sheathes and accentuates the twisting form. The clothing adds polish and refinement to the pose.

If you draw a bulge at the base of the thumb, this creates a 3-dimensional effect.

Loosen the sleeves and the flowing front of the top, while tightening the waist to emphasize the thin body.

To indicate the shape of the buttocks, draw the curved skirt pleat lines.

4

Final touches

Draw the fluttering of the hair and the movement in the skirt folds to indicate the backward glance. The character's gaze should be fixed on a distant point.

Draw the skirt hem's movement to align with the backward-turning motion.

Light

<table>
<tr><td>Pose</td></tr>
<tr><td>4</td></tr>
<tr><td>High Angle</td></tr>
<tr><td>Front</td></tr>
</table>

Standing + Looking Up ①

In this pose, the character is about to reach their hand out towards someone they're looking up to. By drawing with perspective, you can create an effect of you looking from above.

1 Sketching

For a high-angle effect, draw the face, neck, upper body and lower body parts radiating from the center line. Add moment not only to the arms but to the legs as well.

2 Fleshing out

From this perspective, the shoulder line is wide. While the legs are thinner as they move farther from the viewing point, be aware of the bulge of the muscles in the thighs and legs.

Leave the hand at this level as long as you know the direction of the palm.

Draw the thighs narrower as you move toward the ankles.

If you make the section below the knees shorter, this area becomes more visible.

Draw each finger while keeping in mind the hand movement.

Draw the ears below the horizontal face line.

Draw a slight bulge for the thighs and calves.

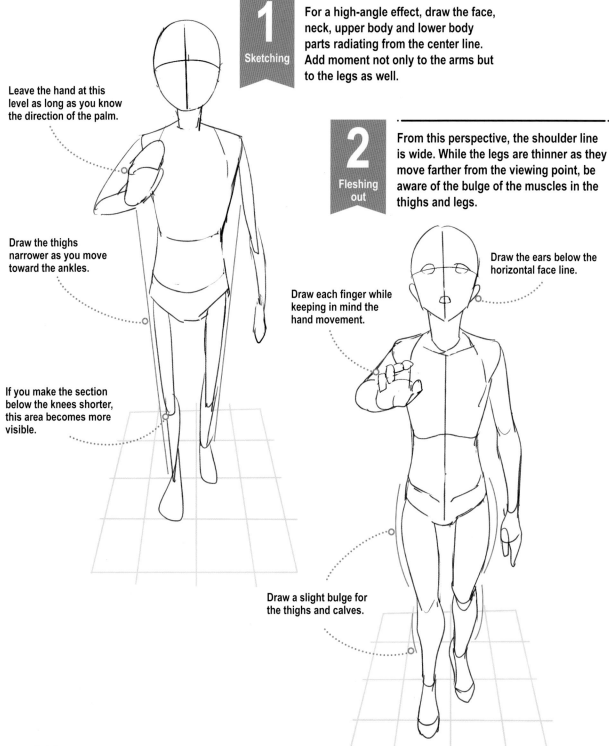

You can express natural movement by drawing a curve from the index finger to the little finger.

3 Rough draft

To create the face features, draw the ears below the face's horizontal line and the eyes higher than usual along the horizontal line. Decide the boy's hairstyle and facial expression as well.

Make the hood of the hoodie wide. There's a space around the neck when viewed from above.

4 Final touches

By shining to light in front (without any shadows), this emphasizes the angle and perspective. Details such as the bangs, inside of the clothing and edges of the feet can be shaded to add depth.

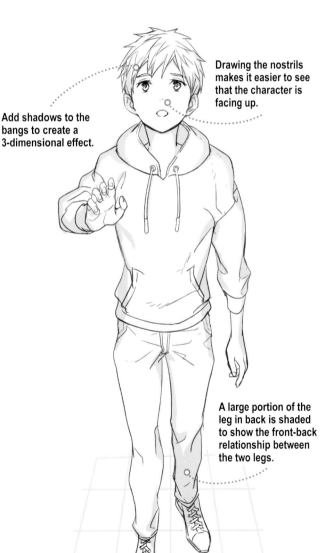

Drawing the nostrils makes it easier to see that the character is facing up.

Add shadows to the bangs to create a 3-dimensional effect.

A large portion of the leg in back is shaded to show the front-back relationship between the two legs.

CHECK IT OUT

How the face changes as the angle of the head is altered

Now try changing the face while keeping the same composition. If you want to lower the boy's head, it's a good idea to move the facial features such as the mouth and eyes as well.

Pose

5

Eye Level
Back View

Walking + Looking Back

Here a young woman is looking back over her shoulder while walking. For this pose, thinking about how the neck moves while the upper body is twisting.

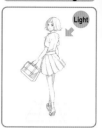

1 *Sketching*

Be sure not to turn the head back too much. Draw a narrow stride to create context for the pose.

Since the neck isn't able to turn 90 degrees, the face also isn't turned at a right angle.

The upper body is twisted and the chest is only slightly visible.

Since the upper body is twisted, sketch the back carefully.

Draw a loose S line that connects the back to the waist and buttocks.

Since the upper body is twisted, the shoulder blades and spine are more defined.

Since the leg in the back is close, draw it longer than the front leg.

Since the character's holding a bag, the back of the hand is visible and the thumb is hidden.

Draw the front part of the foot separately from the heel to show the direction the character's walking.

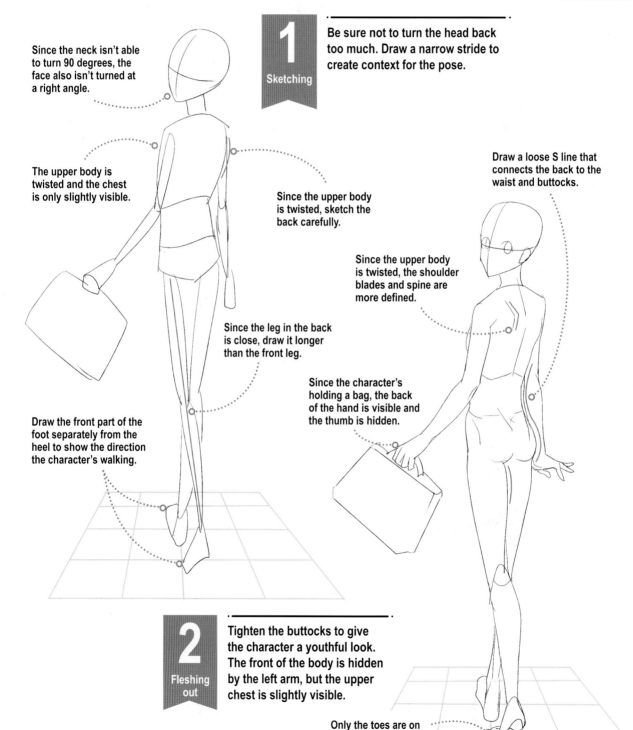

2 *Fleshing out*

Tighten the buttocks to give the character a youthful look. The front of the body is hidden by the left arm, but the upper chest is slightly visible.

Only the toes are on the ground and the foot is arched.

3 **Rough draft**

You can express backward-turning motion by indicating movement in the hair and skirt's hem. Keep the clothing's shape and fit in mind while sketching the character.

Sketch the hair according to the turning direction.

Only the back side of the shirt's collar is visible. Draw in a trapezoid while being aware of the connection with the tip of the collar.

If you draw a vertical fold line on the shirt along the spine, the upper body's silhouette becomes clearer.

Be aware of the correlation between the face and body

When a character is looking or turning backward or twisting around from behind, pay attention to the orientation of the face and body. If the character turns around too much, the pose will look unnatural. Think about how the body rotates and where.

The skirt flutters in the same direction in which the character's turning.

Twisting the upper body also means that the shirt twists too. Draw a horizontal fold on the shirt on the back side to suggest this.

Draw fine folds according to the movement of the skirt. A three-dimensional look can be created through tighter overlapping.

The foot that's stepping forward is not exposed to light, so bathe it in shadow.

By not shading the heel of the shoe, you indicate that it's not exposed to light.

4 **Final touches**

Drawing folds on the skirt creates a three-dimensional effect. You can also add details to the school bag. Shade in the other side of the body to create a well-defined look.

Pose 6
Eye level
Diagonal view

Walking + Diagonal Angle

For this composition, a young man viewed diagonally has one hand in his pocket and a drink in the other. While perfecting this pose, keep the left and right legs' positions in mind.

Direction of light

Light

1 Sketching

Lengthen the calf to achieve the proper front-to-back balance in the legs. The gaze and line of sight are directed differently. Capturing the distinction is the challenge of this pose.

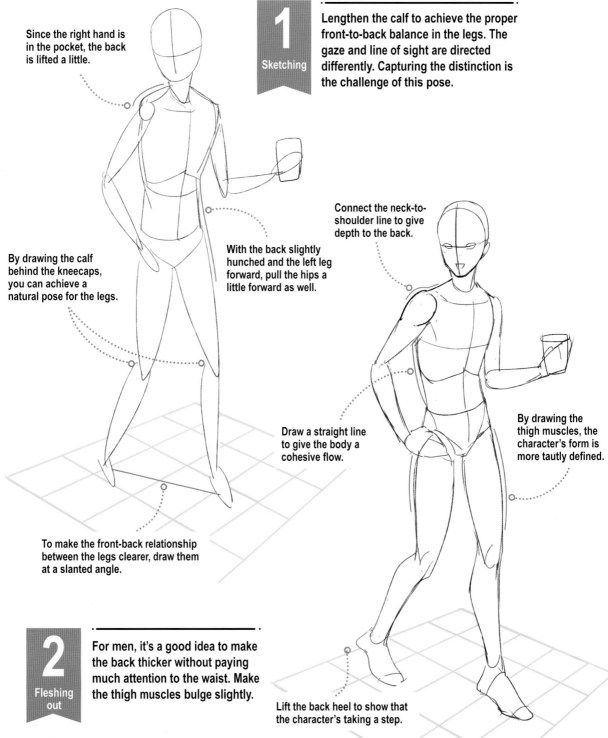

Since the right hand is in the pocket, the back is lifted a little.

By drawing the calf behind the kneecaps, you can achieve a natural pose for the legs.

With the back slightly hunched and the left leg forward, pull the hips a little forward as well.

Connect the neck-to-shoulder line to give depth to the back.

Draw a straight line to give the body a cohesive flow.

By drawing the thigh muscles, the character's form is more tautly defined.

To make the front-back relationship between the legs clearer, draw them at a slanted angle.

2 Fleshing out

For men, it's a good idea to make the back thicker without paying much attention to the waist. Make the thigh muscles bulge slightly.

Lift the back heel to show that the character's taking a step.

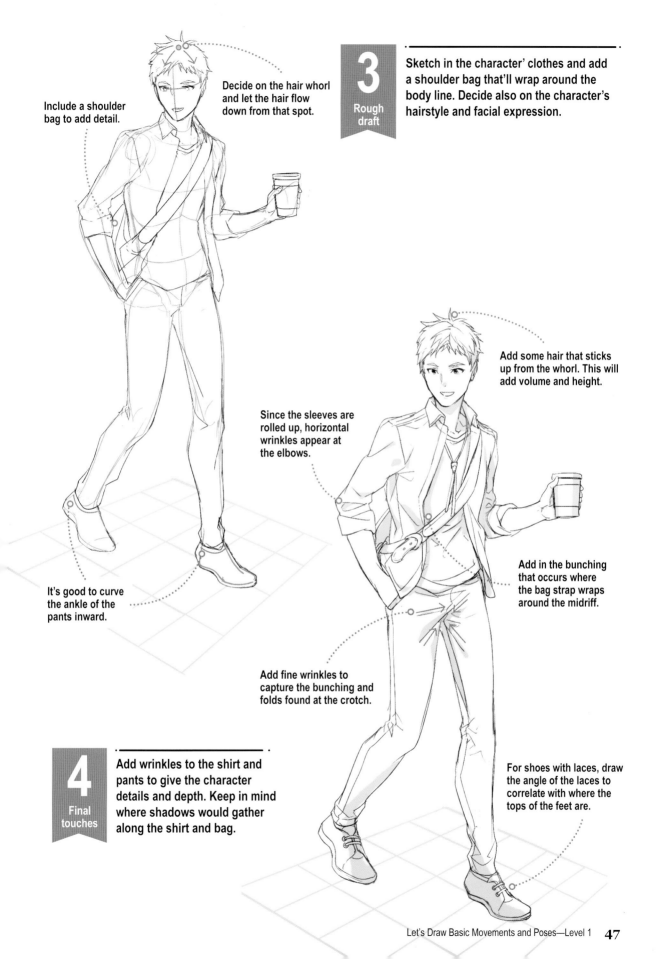

Include a shoulder bag to add detail.

Decide on the hair whorl and let the hair flow down from that spot.

3

Rough draft

Sketch in the character' clothes and add a shoulder bag that'll wrap around the body line. Decide also on the character's hairstyle and facial expression.

Add some hair that sticks up from the whorl. This will add volume and height.

Since the sleeves are rolled up, horizontal wrinkles appear at the elbows.

It's good to curve the ankle of the pants inward.

Add fine wrinkles to capture the bunching and folds found at the crotch.

Add in the bunching that occurs where the bag strap wraps around the midriff.

4

Final touches

Add wrinkles to the shirt and pants to give the character details and depth. Keep in mind where shadows would gather along the shirt and bag.

For shoes with laces, draw the angle of the laces to correlate with where the tops of the feet are.

Pose

7

Eye level
Side view

Walking + Looking Down

For this pose, a man is walking with his back slightly hunched. The angle of the neck and the direction of the center line need to appear natural here, so pay particular attention to that.

Direction of light

Light

When you draw the character looking downward, it gives the impression that he's deep in thought.

1

Sketching

Focus on the bulges and contours such as the roundness of the back, the angle of the neck and the tuck in the abdomen.

With the back hunched, the abdomen is drawn in.

Point the gaze diagonally downward according to the angle of the head.

You can express the hunched back by drawing the shoulders forward.

Express the hunched back by adding a curve.

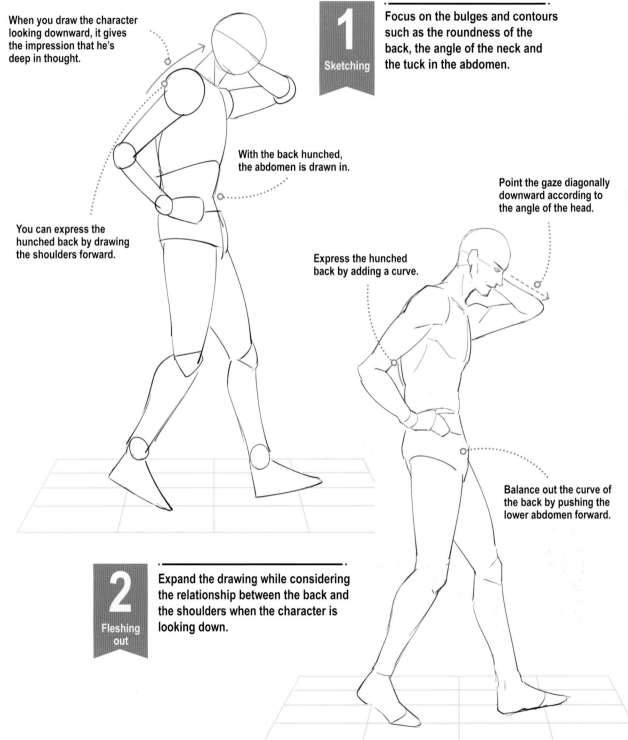

Balance out the curve of the back by pushing the lower abdomen forward.

2

Fleshing out

Expand the drawing while considering the relationship between the back and the shoulders when the character is looking down.

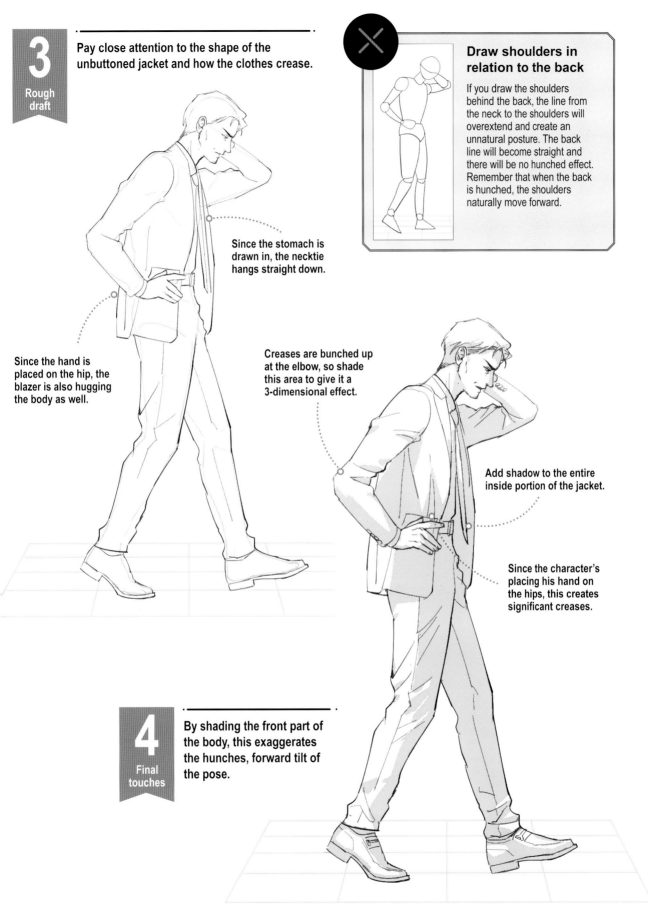

3

Rough draft

Pay close attention to the shape of the unbuttoned jacket and how the clothes crease.

Draw shoulders in relation to the back

If you draw the shoulders behind the back, the line from the neck to the shoulders will overextend and create an unnatural posture. The back line will become straight and there will be no hunched effect. Remember that when the back is hunched, the shoulders naturally move forward.

Since the stomach is drawn in, the necktie hangs straight down.

Since the hand is placed on the hip, the blazer is also hugging the body as well.

Creases are bunched up at the elbow, so shade this area to give it a 3-dimensional effect.

Add shadow to the entire inside portion of the jacket.

Since the character's placing his hand on the hips, this creates significant creases.

4

Final touches

By shading the front part of the body, this exaggerates the hunches, forward tilt of the pose.

Sitting on a Chair + Legs Crossed ①

Direction of light

Light

Here a woman's seated with crossed legs, her head in her hand. The key is in balancing the length and thickness of the legs. Also be aware of the position of the ground, seat and the back of the chair.

Because in this pose the character is tilting her neck, draw the face and the neck line diagonal to the body line.

Add a gap between the knees where the legs cross.

1
Sketching

Sketch with the assumption that the legs' and head's perspectives are the same. For this step of the sketch, keep the legs at the same length.

For a pose where the character is slouching into the backrest, draw the upper body leaning backward.

2
Fleshing out

Keep in mind the balance between the legs, while accentuating the graceful curvature of the body line.

In this pose, the left thigh appears large.

Since the right leg is on the ground, bring the leg forward by drawing it longer than the left leg.

Length and thickness tend to be uneven, especially under the kneecap.

Raise the heels slightly depending on the style of footwear you choose.

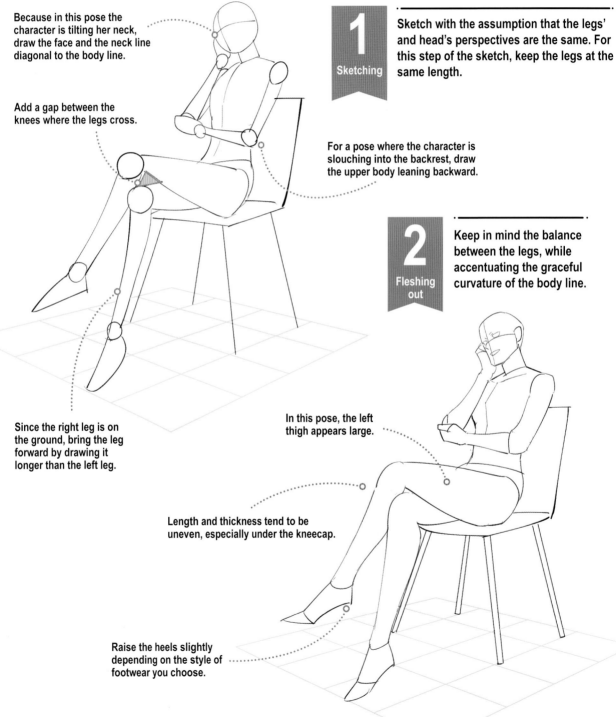

3

Rough draft

Clothing that has a tighter fit can give a sleeker, more polished and refined look to your illustration.

If you draw the collar three-dimensionally, you highlight the face and draw attention to the expression.

Express the bulge of the chest through the shape of the front of the shirt.

Creases gather toward the crotch along the movement of the legs crossed above.

Put your trousers on your thighs and knees to fit your body.

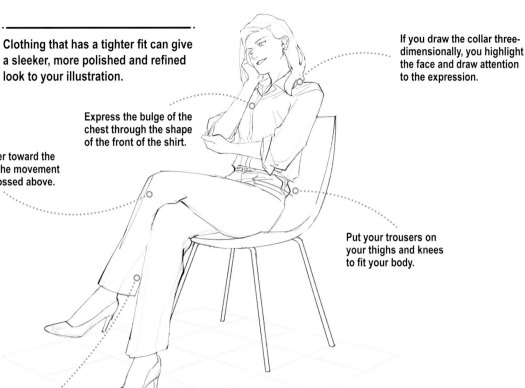

There's plenty of space under the knees. so leave a gap between the pant legs.

4

Final touches

The back of the body is covered in shadow. Add shading to the creases in the clothing as well.

Creases gather at the knee area.

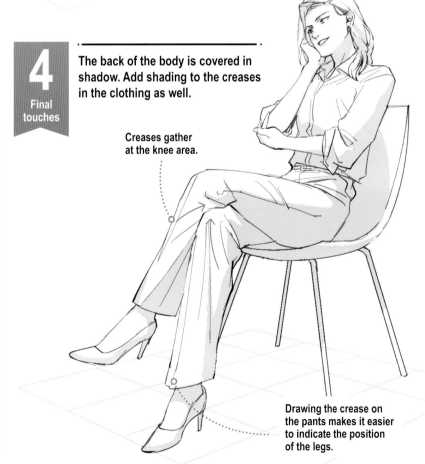

Drawing the crease on the pants makes it easier to indicate the position of the legs.

A CLOSER LOOK

Draw the chair after sketching the pose

If you draw the body according to the backrest or the chair, this might result in a too long torso or unnatural leg posture. It's much easier to balance the illustration's composition if you draw the character's pose first, then add the chair in later with greater accuracy.

Light

Pose

9

Eye level
Diagonal view

Sitting Upright with Good Posture

Here a robed man sits upright with his hands on his thighs. The key point is balancing the upper body's position with the spread legs.

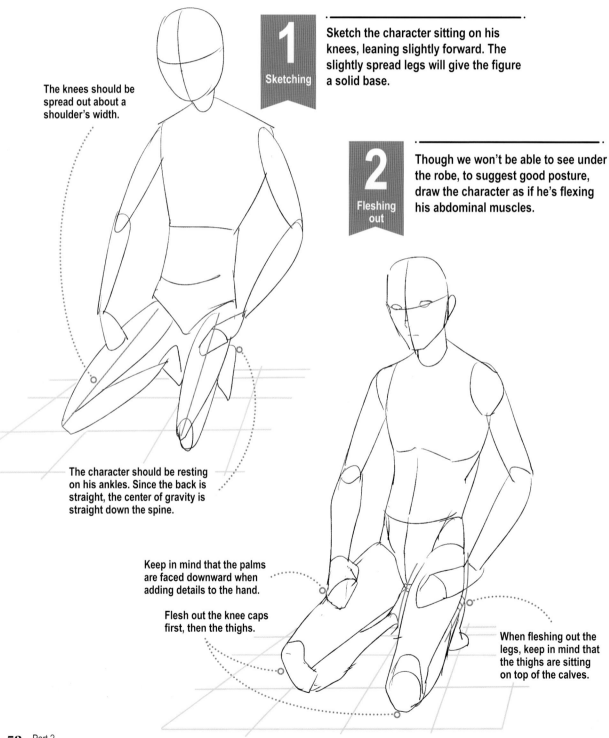

The knees should be spread out about a shoulder's width.

1 Sketching

Sketch the character sitting on his knees, leaning slightly forward. The slightly spread legs will give the figure a solid base.

2 Fleshing out

Though we won't be able to see under the robe, to suggest good posture, draw the character as if he's flexing his abdominal muscles.

The character should be resting on his ankles. Since the back is straight, the center of gravity is straight down the spine.

Keep in mind that the palms are faced downward when adding details to the hand.

Flesh out the knee caps first, then the thighs.

When fleshing out the legs, keep in mind that the thighs are sitting on top of the calves.

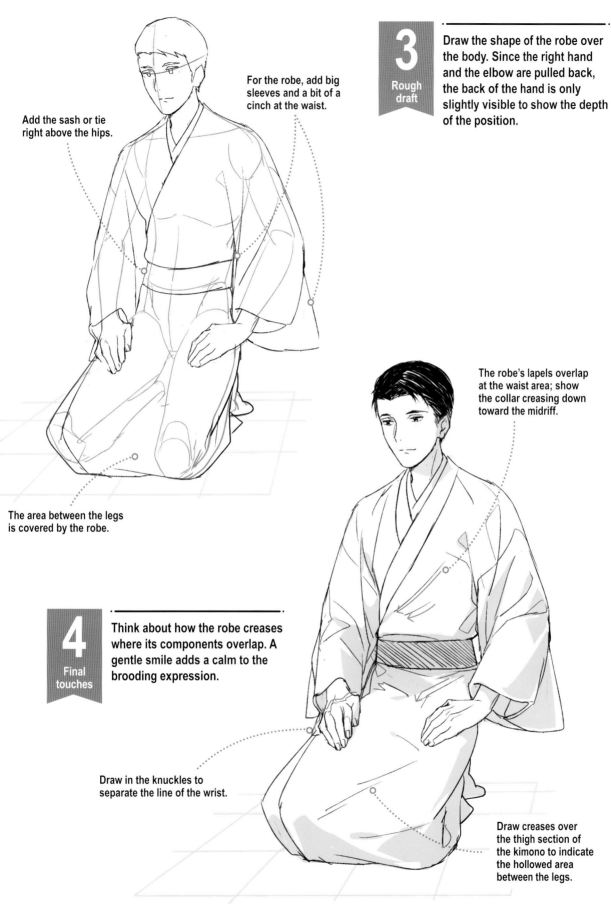

For the robe, add big sleeves and a bit of a cinch at the waist.

Add the sash or tie right above the hips.

3 Rough draft

Draw the shape of the robe over the body. Since the right hand and the elbow are pulled back, the back of the hand is only slightly visible to show the depth of the position.

The robe's lapels overlap at the waist area; show the collar creasing down toward the midriff.

The area between the legs is covered by the robe.

4 Final touches

Think about how the robe creases where its components overlap. A gentle smile adds a calm to the brooding expression.

Draw in the knuckles to separate the line of the wrist.

Draw creases over the thigh section of the kimono to indicate the hollowed area between the legs.

Sitting on Ground + Spreading Legs

For this composition, the character is sitting on the ground while using one hand to support their body weight. Let's pay attention to areas where body weigh is being distributed.

Direction of light

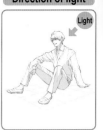

Light

If you lower the arm from the elbow, this gives the limb a relaxed feel.

1 Sketching

While sketching, think about where the distribution of the body weight and where the center of gravity is.

Draw the arm straight down to indicate that it's supporting the weight.

Below the knees, the left calf is longer to show that it's stretching forward.

Note that the right appears longer than the left side.

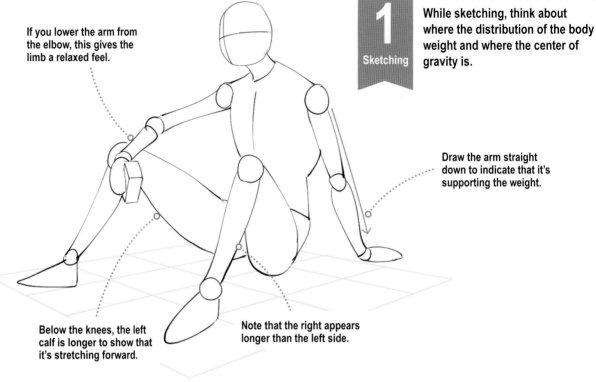

Keep in mind that force is being applied to the left arm, so add in some lines to indicate flexed muscles.

No force is placed on the right arm, so draw it slightly lower.

2 Fleshing out

Pay attention to the orientation of the arms and legs while fleshing out the character's muscles.

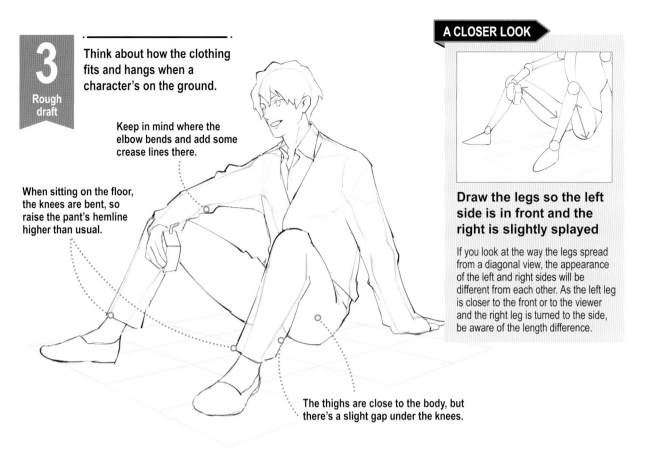

3
Rough draft

Think about how the clothing fits and hangs when a character's on the ground.

Keep in mind where the elbow bends and add some crease lines there.

When sitting on the floor, the knees are bent, so raise the pant's hemline higher than usual.

A CLOSER LOOK

Draw the legs so the left side is in front and the right is slightly splayed

If you look at the way the legs spread from a diagonal view, the appearance of the left and right sides will be different from each other. As the left leg is closer to the front or to the viewer and the right leg is turned to the side, be aware of the length difference.

The thighs are close to the body, but there's a slight gap under the knees.

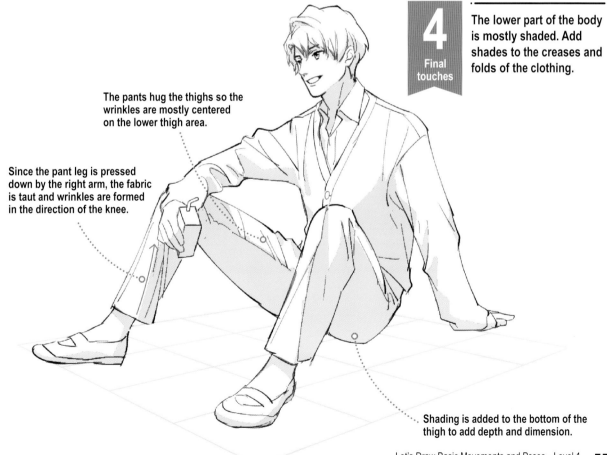

4
Final touches

The lower part of the body is mostly shaded. Add shades to the creases and folds of the clothing.

The pants hug the thighs so the wrinkles are mostly centered on the lower thigh area.

Since the pant leg is pressed down by the right arm, the fabric is taut and wrinkles are formed in the direction of the knee.

Shading is added to the bottom of the thigh to add depth and dimension.

How to Draw Different Character Types

The face and its expression, drawn according to the character's image and personality. is an important element that captures a character's individuality. Concoct an original character by combining various elements such as the size and position of the facial parts and the hairstyle.

Gallery of male characters

A sharp face is a key element as a template for building your character. Give him a crisply defined expression while switching up various facial features.

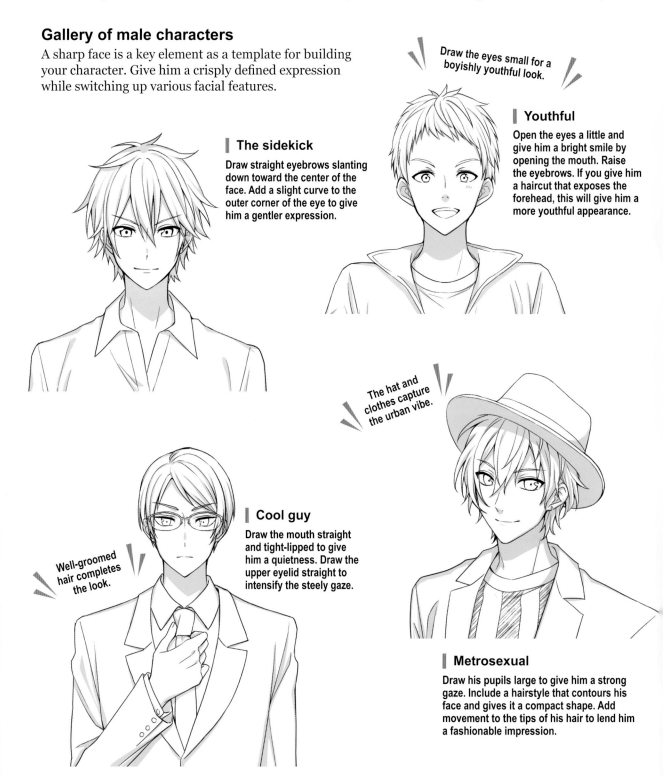

Draw the eyes small for a boyishly youthful look.

The sidekick

Draw straight eyebrows slanting down toward the center of the face. Add a slight curve to the outer corner of the eye to give him a gentler expression.

Youthful

Open the eyes a little and give him a bright smile by opening the mouth. Raise the eyebrows. If you give him a haircut that exposes the forehead, this will give him a more youthful appearance.

The hat and clothes capture the urban vibe.

Well-groomed hair completes the look.

Cool guy

Draw the mouth straight and tight-lipped to give him a quietness. Draw the upper eyelid straight to intensify the steely gaze.

Metrosexual

Draw his pupils large to give him a strong gaze. Include a hairstyle that contours his face and gives it a compact shape. Add movement to the tips of his hair to lend him a fashionable impression.

Gallery of female characters

Big eyes, small noses and small mouths, some lean on those basic elements. No matter what, think about how expression conveys personality.

Athletic type

Sharpen the lash lines and angle the eyebrows to give the character a defined look. Showing her teeth with a slight smile will lend her a bright and cheerful quality.

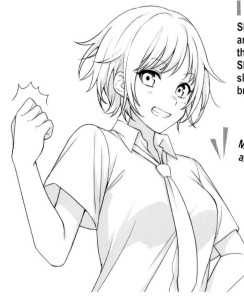

Make the uniform and tie androgynously boyish.

Accentuating the outer edges gives a cat-eyed look.

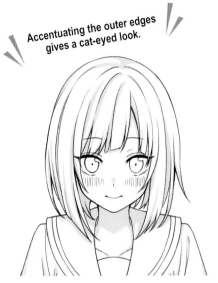

Cat-eyed look

Make her pupils big and sharpen the outer corners of the eyes. Flatten the eyebrows to indicate a strong-minded determination.

Trendy type

Give her a small face and enlarge the eyes. Drawing in accessories such as ribbons and scrunchies will add to the playful personality.

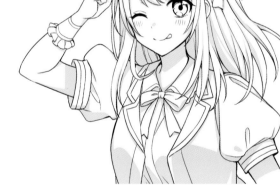

Highlight her shyness with flushed cheeks.

Pleasing presence

Lower the corners of the eyes and the bottom of the eyebrows to give her a gentle vibe. Along with her smile and closed eyes, add volume to her lashes to exaggerate the expression. The bouncy hair is also a key point.

Cultured

A downcast gaze will suggest her shyness. Give her a mysterious vibe by lowering the corner of her mouth so she's not openly conveying emotion.

More male faces

You can give your character wide long eyes and a flirtatious gaze or a swarthy mysterious sneer. It's up to you. Mix and match until you find the face that fits.

The long hair frames and highlights the face.

Smart & serious

Draw a sharp angle for the corner of his eyes as well as the eyebrows and add in a defined nose to give him a neat look. Accessories such as a pair of stylish silver-rimmed glasses are a plus!

Androgynous guy

If you draw the lashes downward on the outer corners of the eyes, you can create a clear distinction from the eyes of a female character. Draw the line of the nose firmly.

The flirt

Draw lashes on the inner and outer corners to widen his eyes. Give him a wide mouth and defined nose. Droopy eyes add to the playfully gentle vibe.

Mystery man

Hiding half of the face with bangs gives him a mysterious aura, making it hard to read his emotions. Draw his eyes narrowly and straighten the mouth to add to the mysteriousness.

Pay attention to the details of the tousled hair.

Tough guy

Adding a scrunch at the eyebrows creates a rugged appearance and a hard-to-approach vibe. Giving him strong eyes accentuates the effect.

More female faces

Making the eyes smaller and the nose longer lends a more mature look. Expanding your repertoire is essential; master the basics and branch out from there.

On trend

Emphasize the upper lashes and draw thin lines for the bottom ones. Draw a line for the bridge of the nose and shade in the bottom lip to bring out a more mature look.

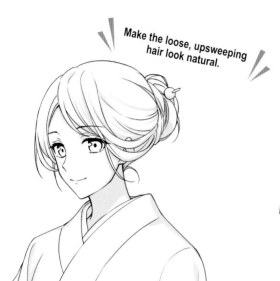

Make the loose, upsweeping hair look natural.

The natural look

Lower the eyebrows and the corners of the eyes. Draw a small nose for an elegant impression. If you put her hair up and show the nape, you can balance the modest and the demure.

Lower the corners of the eyes for a gentler expression.

Loose locks

The pupils are drawn in a square to show to accentuate the smile. Drawing her eyebrows in a flat horizontal yields, a serious yet gentle expression.

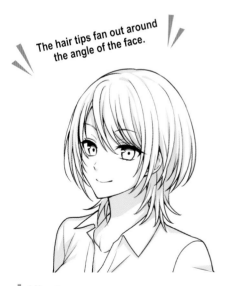

The hair tips fan out around the angle of the face.

Hipster

Raise the outer corner of the eyes to give a lively impression. Draw the nose and mouth small to create a compact face. Give her a fashionable haircut to complete the look.

Brainiac

Draw the eyes slightly larger than the male characters'. Raise her eyebrows to give an intellectual air, while adding a smile gives her a gentle, approachable quality.

Pose
11
Slightly high angle
Diagonal view

Standing on One Leg + Putting on a Shoe

Light

A specific one: here the character's standing on one leg, leaning against a wall as she pulls on a shoe. Think about how the center of gravity shifts when the character is leaning and balance the legs and arms accordingly.

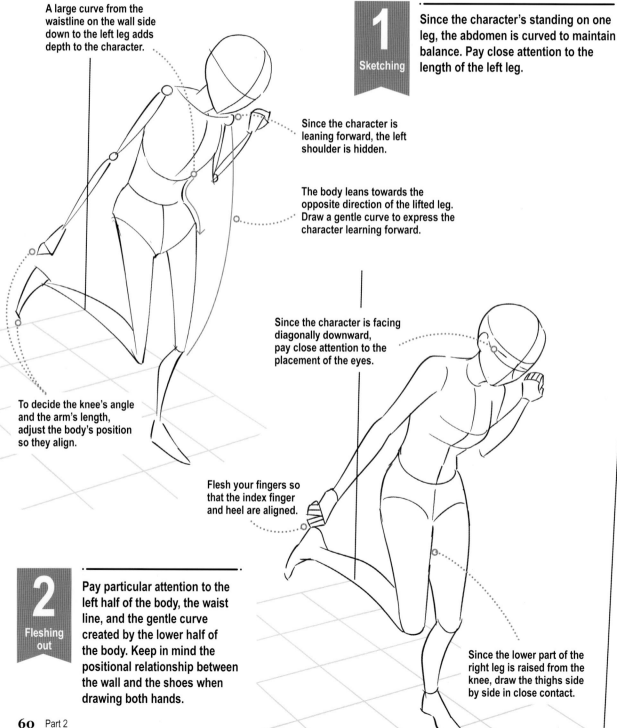

A large curve from the waistline on the wall side down to the left leg adds depth to the character.

1
Sketching

Since the character's standing on one leg, the abdomen is curved to maintain balance. Pay close attention to the length of the left leg.

Since the character is leaning forward, the left shoulder is hidden.

The body leans towards the opposite direction of the lifted leg. Draw a gentle curve to express the character learning forward.

Since the character is facing diagonally downward, pay close attention to the placement of the eyes.

To decide the knee's angle and the arm's length, adjust the body's position so they align.

Flesh your fingers so that the index finger and heel are aligned.

2
Fleshing out

Pay particular attention to the left half of the body, the waist line, and the gentle curve created by the lower half of the body. Keep in mind the positional relationship between the wall and the shoes when drawing both hands.

Since the lower part of the right leg is raised from the knee, draw the thighs side by side in close contact.

3

Rough draft

Draw the movement of the character's hair and skirt to match and suggest the upper body movement. Since the character's leaving for school in this illustration, give her a sleepy expression to add to the narrative.

Draw the bag diagonally according to the upper body to give it a natural placement.

Draw the hair flowing forward according to the angle of the face.

A CLOSER LOOK

To give perspective to the distance between the figure and the wall, view it from the front

If you're having trouble grasping the distance between the character and the wall, imagine them from the front. You then can see that since the left arm is leaning on the wall, this leaves a large gap between the wall and the lower body.

You can incorporate manga expressions like bubbles near the face to indicate sleepiness.

By putting a shadow under the chest, you can show the chest bulging and leaning forward.

Since the uniform is a pleated skirt, draw some space between the skirt and the body.

Draw the shoes the character is putting on according to the position of the hand you sketched.

By putting a shadow on the back side of the body, you can see that the character is leaning toward the wall

4

Final touches

Since plenty of light is shining on the right side of the character, balance it out with plenty of shading on the left side. Add details to the uniform design and her facial expression too.

PART 2

Pose

12

High angle
Diagonal view

Standing + Looking Up ②

This pose captures the moment when your characters stops and suddenly looks up. Pay attention to the position and orientation of the face and facial expression as well as the bend in the upper body.

Direction of light

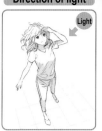

Light

Since the face is looking toward the sky, raise the chin and sketch the face so that the back of the head tilts backward.

1

Sketching

Because of the high angle, perspective is applied to the forward-leaning leg, especially below the knee toward the ankle. If the character's short, it's easier to see that we're looking down from above.

The upper body is stretched to show perspective.

Sketch the knees and ankles diagonal from each other to show the front-back relationship.

Make the direction of the hands clear by fleshing out the finger shapes.

From the waistline to the ankle, draw a gentle curve and show the separation of the upper and lower body.

Adjust the angle of the face and the position of the eyes so that the eyes are facing upward.

2

Fleshing out

Emphasize the roundness of the chest and hips. While thinking about the angle of the character's face, sketch it as if she's looking up.

Draw the line of the foot; the indentations on the backs of the knees and the bulges of the calves need to be clear.

Complete the lower body; be aware of the widening of the waist from the waistline.

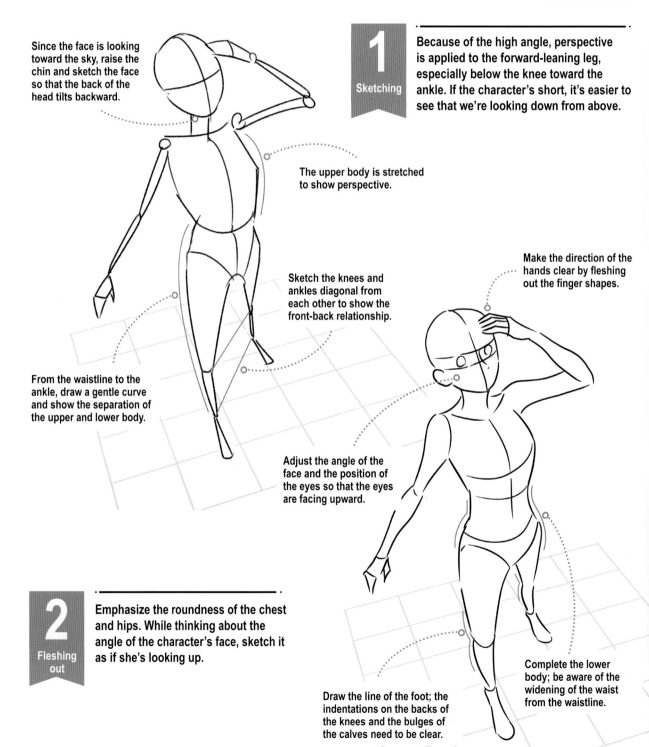

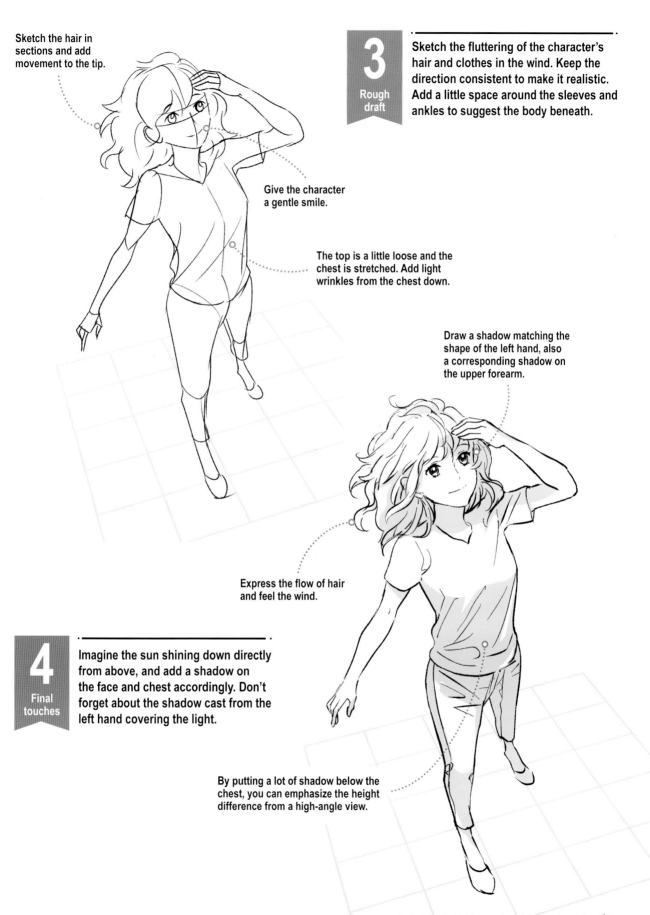

Sketch the hair in sections and add movement to the tip.

Sketch the fluttering of the character's hair and clothes in the wind. Keep the direction consistent to make it realistic. Add a little space around the sleeves and ankles to suggest the body beneath.

Give the character a gentle smile.

The top is a little loose and the chest is stretched. Add light wrinkles from the chest down.

Draw a shadow matching the shape of the left hand, also a corresponding shadow on the upper forearm.

Express the flow of hair and feel the wind.

4 Final touches

Imagine the sun shining down directly from above, and add a shadow on the face and chest accordingly. Don't forget about the shadow cast from the left hand covering the light.

By putting a lot of shadow below the chest, you can emphasize the height difference from a high-angle view.

PART 2

Direction of light

Light

| Pose |
| 13 |
| Slightly high angle |
| Diagonal view |

Standing + Tying Hair

Reaching back behind the head exposes the chest and midriff and poses a challenge in terms of the balance and positioning captured in the upper portions of the illustration.

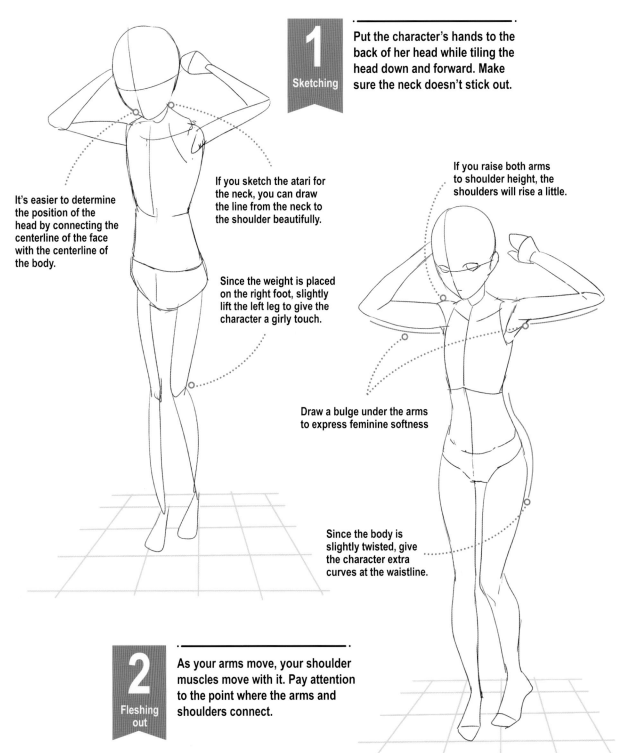

1 Sketching

Put the character's hands to the back of her head while tiling the head down and forward. Make sure the neck doesn't stick out.

It's easier to determine the position of the head by connecting the centerline of the face with the centerline of the body.

If you sketch the atari for the neck, you can draw the line from the neck to the shoulder beautifully.

Since the weight is placed on the right foot, slightly lift the left leg to give the character a girly touch.

If you raise both arms to shoulder height, the shoulders will rise a little.

Draw a bulge under the arms to express feminine softness

Since the body is slightly twisted, give the character extra curves at the waistline.

2 Fleshing out

As your arms move, your shoulder muscles move with it. Pay attention to the point where the arms and shoulders connect.

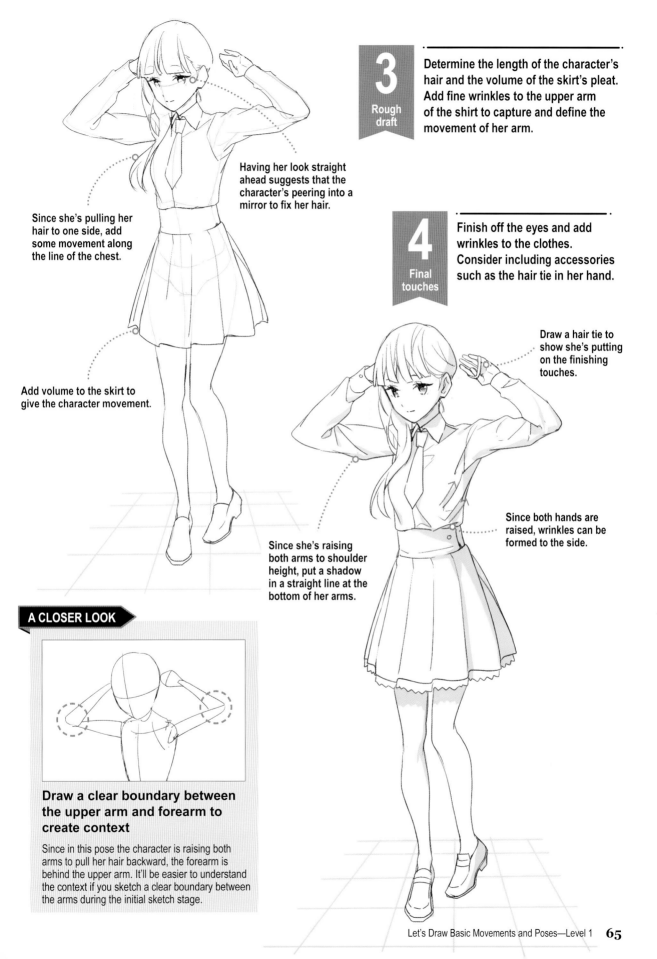

3
Rough draft

Determine the length of the character's hair and the volume of the skirt's pleat. Add fine wrinkles to the upper arm of the shirt to capture and define the movement of her arm.

Having her look straight ahead suggests that the character's peering into a mirror to fix her hair.

Since she's pulling her hair to one side, add some movement along the line of the chest.

Add volume to the skirt to give the character movement.

4
Final touches

Finish off the eyes and add wrinkles to the clothes. Consider including accessories such as the hair tie in her hand.

Draw a hair tie to show she's putting on the finishing touches.

Since both hands are raised, wrinkles can be formed to the side.

Since she's raising both arms to shoulder height, put a shadow in a straight line at the bottom of her arms.

A CLOSER LOOK

Draw a clear boundary between the upper arm and forearm to create context

Since in this pose the character is raising both arms to pull her hair backward, the forearm is behind the upper arm. It'll be easier to understand the context if you sketch a clear boundary between the arms during the initial sketch stage.

Walking + Looking Sideways

Now it's time to sketch a woman walking, seen from the side. Draw a straight spine and widen the stride to capture the depth of her left and right feet.

Direction of light

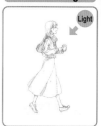

Light

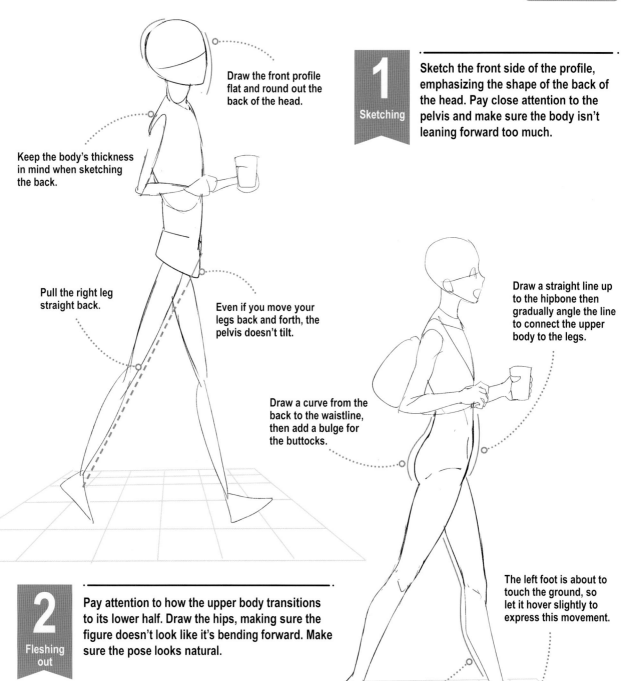

Draw the front profile flat and round out the back of the head.

1

Sketching

Sketch the front side of the profile, emphasizing the shape of the back of the head. Pay close attention to the pelvis and make sure the body isn't leaning forward too much.

Keep the body's thickness in mind when sketching the back.

Pull the right leg straight back.

Even if you move your legs back and forth, the pelvis doesn't tilt.

Draw a straight line up to the hipbone then gradually angle the line to connect the upper body to the legs.

Draw a curve from the back to the waistline, then add a bulge for the buttocks.

2

Fleshing out

Pay attention to how the upper body transitions to its lower half. Draw the hips, making sure the figure doesn't look like it's bending forward. Make sure the pose looks natural.

The left foot is about to touch the ground, so let it hover slightly to express this movement.

When drawing the legs, keep in mind the bulges at the thigh and calves and the indentation at the back of the knees.

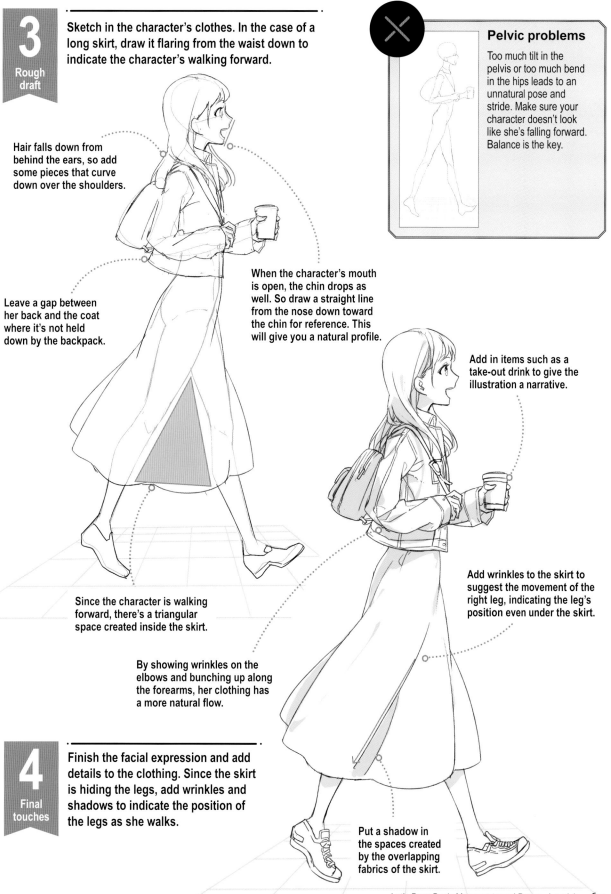

3

Rough draft

Sketch in the character's clothes. In the case of a long skirt, draw it flaring from the waist down to indicate the character's walking forward.

Pelvic problems

Too much tilt in the pelvis or too much bend in the hips leads to an unnatural pose and stride. Make sure your character doesn't look like she's falling forward. Balance is the key.

Hair falls down from behind the ears, so add some pieces that curve down over the shoulders.

Leave a gap between her back and the coat where it's not held down by the backpack.

When the character's mouth is open, the chin drops as well. So draw a straight line from the nose down toward the chin for reference. This will give you a natural profile.

Add in items such as a take-out drink to give the illustration a narrative.

Add wrinkles to the skirt to suggest the movement of the right leg, indicating the leg's position even under the skirt.

Since the character is walking forward, there's a triangular space created inside the skirt.

By showing wrinkles on the elbows and bunching up along the forearms, her clothing has a more natural flow.

4

Final touches

Finish the facial expression and add details to the clothing. Since the skirt is hiding the legs, add wrinkles and shadows to indicate the position of the legs as she walks.

Put a shadow in the spaces created by the overlapping fabrics of the skirt.

Running + Looking Sideways

Here a girl is seen from the side, she's running and wears an enthusiastic expression. Since the character's leaning slightly forward, keep that in mind when you sketch the upper body.

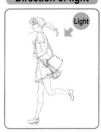

Light

1
Sketching

The upper body is leaning forward slightly and the chest sticks out. Using the position of the base of the thigh as a reference, sketch the remaining part of her legs.

2
Fleshing out

Add a slight roundness to the calves and thighs. Decide the position of the bag by thinking about where it'll balance the body best.

Because this is her profile, make the front side of the face flat.

The basic posture when running is to lean forward. So have the chest leaning slightly forward.

Draw a triangular shape from the elbows to the wrist to add depth to the arms. Add in muscle bulges to heighten the realism.

Even if the position of the hands holding onto the straps is different, draw the elbows sy around the same height.

Draw the raised leg at around this height. Be careful not to raise it too much or it'll look unnatural.

When sketching in the bag, consider the position of the buttocks as well.

The calf muscles are flexed from the running motion. Tighten the lines at the ankles.

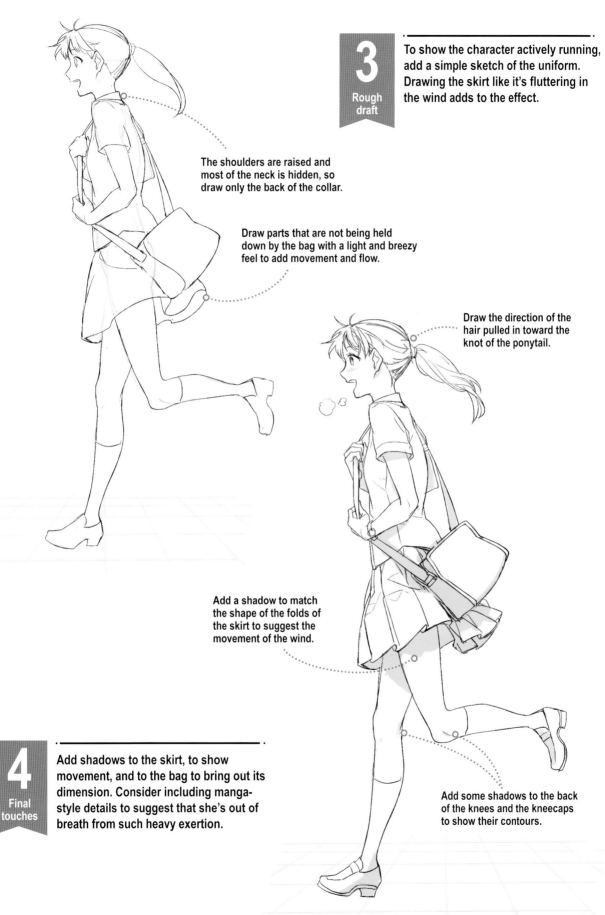

3 Rough draft

To show the character actively running, add a simple sketch of the uniform. Drawing the skirt like it's fluttering in the wind adds to the effect.

The shoulders are raised and most of the neck is hidden, so draw only the back of the collar.

Draw parts that are not being held down by the bag with a light and breezy feel to add movement and flow.

Draw the direction of the hair pulled in toward the knot of the ponytail.

Add a shadow to match the shape of the folds of the skirt to suggest the movement of the wind.

4 Final touches

Add shadows to the skirt, to show movement, and to the bag to bring out its dimension. Consider including manga-style details to suggest that she's out of breath from such heavy exertion.

Add some shadows to the back of the knees and the kneecaps to show their contours.

Pose

16

Eye level
Diagonal view

Running + In a Hurry

Late for work or school, to capture this character, pay attention to the depth of the front and back legs. Practice drawing the tightly clenched fists and the movement of the hair to create a dynamic pose.

Light

The front of the face is flat because the character's seen at an angle, but sketch in the center line as both eyes are visible.

1 Sketching

You can get a sense of perspective by drawing the front leg longer than the leg in the back. Suggest his hurried state by stretching the chest and clenching the fist.

2 Fleshing out

Lean figures require tightly defined shapes while bringing a slight roundness to the muscles and buttocks.

Curve the chest back slightly to give the sense of running in a hurry.

Don't raise the shoulders as the arms are weighted by the school bag. The arms don't stick straight out but are slightly curved.

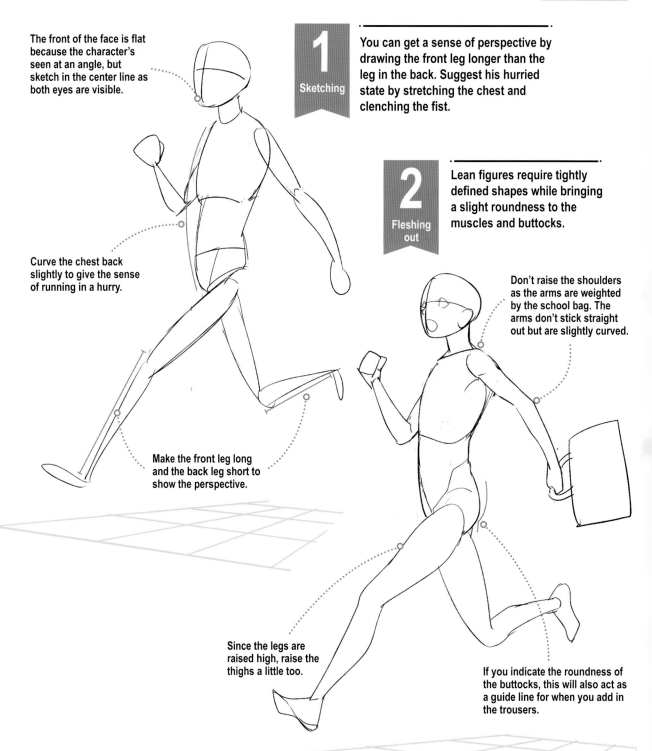

Make the front leg long and the back leg short to show the perspective.

Since the legs are raised high, raise the thighs a little too.

If you indicate the roundness of the buttocks, this will also act as a guide line for when you add in the trousers.

Let's give him an in-a-rush expression by drawing his eyes wide and the mouth open into a square shape.

The wrinkles on the front leg of the pants are mostly gathered at the upper thigh.

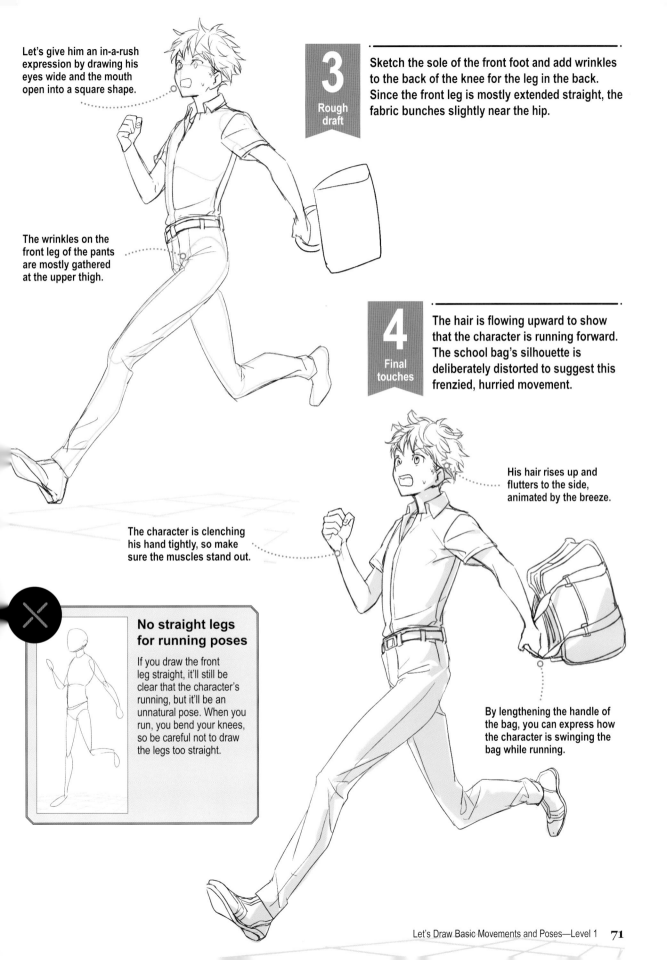

3
Rough draft

Sketch the sole of the front foot and add wrinkles to the back of the knee for the leg in the back. Since the front leg is mostly extended straight, the fabric bunches slightly near the hip.

4
Final touches

The hair is flowing upward to show that the character is running forward. The school bag's silhouette is deliberately distorted to suggest this frenzied, hurried movement.

His hair rises up and flutters to the side, animated by the breeze.

The character is clenching his hand tightly, so make sure the muscles stand out.

No straight legs for running poses

If you draw the front leg straight, it'll still be clear that the character's running, but it'll be an unnatural pose. When you run, you bend your knees, so be careful not to draw the legs too straight.

By lengthening the handle of the bag, you can express how the character is swinging the bag while running.

Light

Pose

17

Slightly high angle

Diagonal view

Sitting on a Chair + Legs Crossed ②

Here's a pose you'll want to master: a man leaning back on the chair with his legs crossed, his left foot resting on his right knee. The torso should suggest the depth of the chair and the shape of the backrest.

1

Sketching

Sketch the upper body with an awareness of the backrest. For a cross-legged pose, think of it as if you are connecting the sole of the foot with the knee. Keep the balance between the legs in mind.

Curve the back and abdomen along the line of the back of the chair.

Balance both legs by imagining the inverted triangle that connects the sole of one foot and both knees.

Place the elbows near the upper body as the character's leaning back.

One shoulder is slightly higher than the other because it's propped up. The other shoulder is lower to make the arm look relaxed.

Since the thigh is hanging, add a bit of a bulge to it.

2

Fleshing out

Flesh out the back of the character's thigh, a part that's not visible when the legs are together. Determine the character's line of sight in this step also.

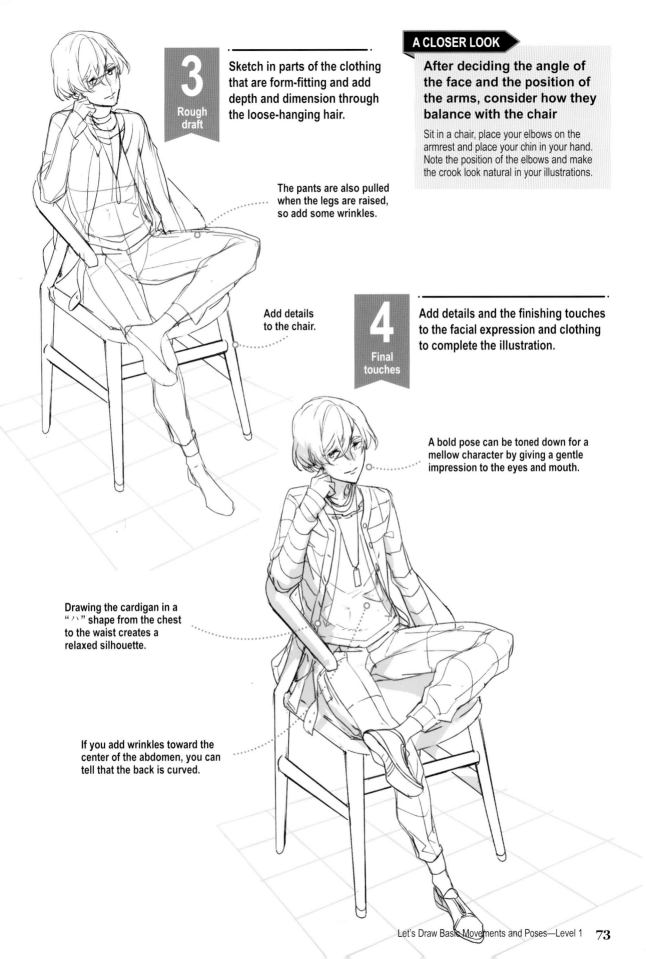

3
Rough draft

Sketch in parts of the clothing that are form-fitting and add depth and dimension through the loose-hanging hair.

The pants are also pulled when the legs are raised, so add some wrinkles.

Add details to the chair.

A CLOSER LOOK

After deciding the angle of the face and the position of the arms, consider how they balance with the chair

Sit in a chair, place your elbows on the armrest and place your chin in your hand. Note the position of the elbows and make the crook look natural in your illustrations.

4
Final touches

Add details and the finishing touches to the facial expression and clothing to complete the illustration.

A bold pose can be toned down for a mellow character by giving a gentle impression to the eyes and mouth.

Drawing the cardigan in a " ﾉ丶 " shape from the chest to the waist creates a relaxed silhouette.

If you add wrinkles toward the center of the abdomen, you can tell that the back is curved.

Let's Draw Basic Movements and Poses—Level 1 **73**

Pose

18

Slightly high angle

Diagonal view

Squatting + Looking at a Camera

A young woman checks her photos through the camera's screen. For this pose, think about the balance between the figure and the camera as seen from a diagonal view.

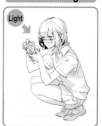

Light

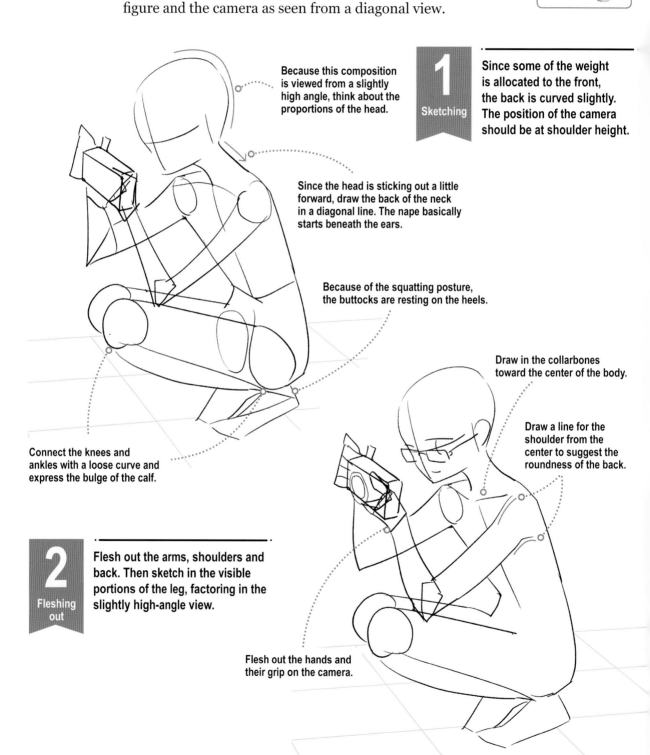

Because this composition is viewed from a slightly high angle, think about the proportions of the head.

1

Sketching

Since some of the weight is allocated to the front, the back is curved slightly. The position of the camera should be at shoulder height.

Since the head is sticking out a little forward, draw the back of the neck in a diagonal line. The nape basically starts beneath the ears.

Because of the squatting posture, the buttocks are resting on the heels.

Draw in the collarbones toward the center of the body.

Connect the knees and ankles with a loose curve and express the bulge of the calf.

Draw a line for the shoulder from the center to suggest the roundness of the back.

2

Fleshing out

Flesh out the arms, shoulders and back. Then sketch in the visible portions of the leg, factoring in the slightly high-angle view.

Flesh out the hands and their grip on the camera.

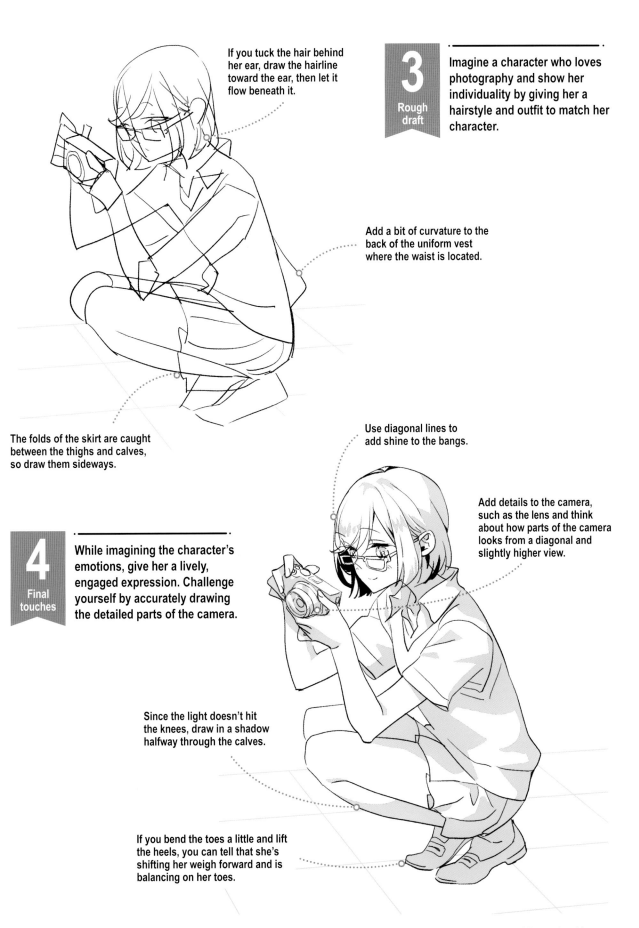

If you tuck the hair behind her ear, draw the hairline toward the ear, then let it flow beneath it.

3
Rough draft

Imagine a character who loves photography and show her individuality by giving her a hairstyle and outfit to match her character.

Add a bit of curvature to the back of the uniform vest where the waist is located.

The folds of the skirt are caught between the thighs and calves, so draw them sideways.

Use diagonal lines to add shine to the bangs.

4
Final touches

While imagining the character's emotions, give her a lively, engaged expression. Challenge yourself by accurately drawing the detailed parts of the camera.

Add details to the camera, such as the lens and think about how parts of the camera looks from a diagonal and slightly higher view.

Since the light doesn't hit the knees, draw in a shadow halfway through the calves.

If you bend the toes a little and lift the heels, you can tell that she's shifting her weigh forward and is balancing on her toes.

Pose	
19	
Slightly high angle	
Diagonal view	

Sitting + Holding a Fan

Here a character sits on the floor fanning herself, with her legs stretched out. Pay attention to the legs and how the arms and shoulders are drawn when leaning on one arm.

Direction of light

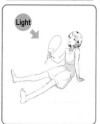
Light

Tilting her head backward and raising her chin frames the sluggish expression.

1 Sketching
Draw the open legs in a shape of a vertical triangle. Since she's resting her body on one arm, the shoulder should be raised.

Since she's sitting with her hips shifted forward, draw the curve below the waistline to connect with the legs.

Since she's using her left arm to support her weight, raise the left shoulder.

Sketch the back, rounding it out.

Draw the lower body while imagining a long vertical triangle connecting the pelvis with the tips of both feet.

The position of the left shoulder is raised, so the curve of the left collarbone is also clearly visible.

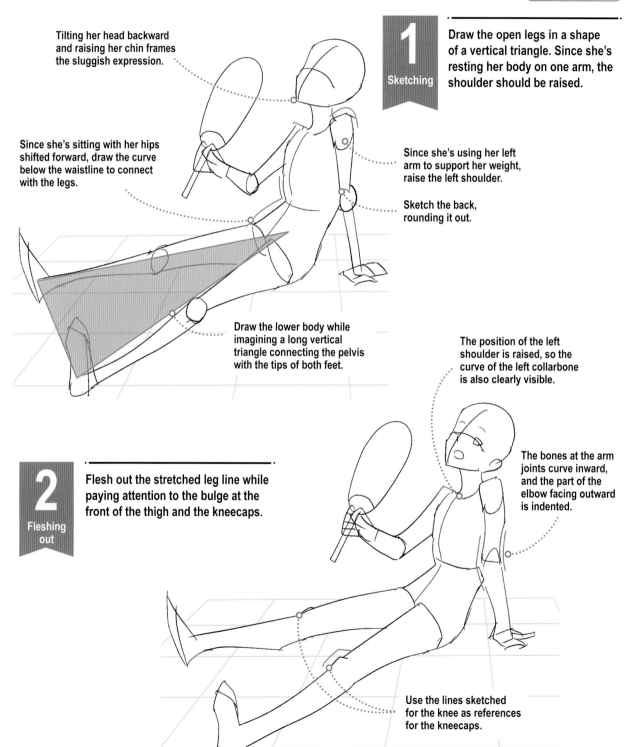

The bones at the arm joints curve inward, and the part of the elbow facing outward is indented.

2 Fleshing out
Flesh out the stretched leg line while paying attention to the bulge at the front of the thigh and the kneecaps.

Use the lines sketched for the knee as references for the kneecaps.

3

Rough draft

A sleeveless summer dress suits the pose; draw a wavy shape over the thighs to elicit a three-dimensional effect.

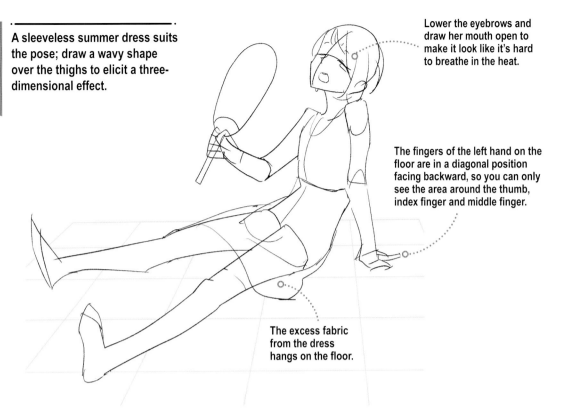

Lower the eyebrows and draw her mouth open to make it look like it's hard to breathe in the heat.

The fingers of the left hand on the floor are in a diagonal position facing backward, so you can only see the area around the thumb, index finger and middle finger.

The excess fabric from the dress hangs on the floor.

4

Final touches

Add sweat to the face, arms and legs. Include a shadow on the stomach and back to add depth and dimension.

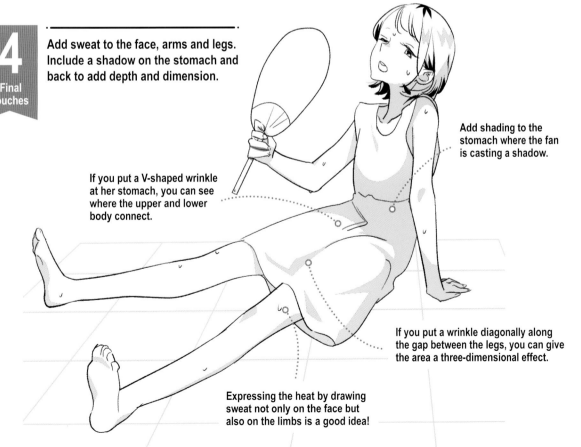

Add shading to the stomach where the fan is casting a shadow.

If you put a V-shaped wrinkle at her stomach, you can see where the upper and lower body connect.

If you put a wrinkle diagonally along the gap between the legs, you can give the area a three-dimensional effect.

Expressing the heat by drawing sweat not only on the face but also on the limbs is a good idea!

Akariko

HP ▶ http://akarinngotya.jimdo.com/
pixiv ▶ https://www.pixiv.net/member.php?id=4543768

Interview

What was the hardest thing when you first started drawing?

I wasn't good at drawing characters in motion. I could only draw characters with fixed poses.

How did you overcome that difficulty?

I copied my favorite manga where you rarely have characters in fixed poses. So it was good practice for mastering a range of increasingly complex poses.

If you were asked, "Please teach me how to draw," what would be your first advice?

I'd say to copy your favorite illustration and then copy it again. From my personal experience, copying was the best way to improve my skills. In my case, it wasn't about making exact copies, but rather drawing whatever was easier for me or the scenes I liked. . . . That's an essential element: have fun, no matter what you're sketching.

By the way, who's your favorite illustrator?

There are too many people to mention. . . . However, when I aspired to become an illustrator, I was particularly influenced by Kouhaku Kuroboshi and Hinata Takeda. I still love their work very much.

When you're drawing, what's the thing you focus on most?

Balance: in the facial parts, balance in the body, color balance, shading balance, everywhere. There's a lot I consider, but balance is what sets apart a great illustration.

PART 3

Let's Draw Basic Movements and Poses

Level 2

For some, this is the hard part, but also the fun part: learning to draw credible, memorable, naturally rendered movements and poses. It takes practice, but it's essential work to lift your characters to that next level.

Pose

20

Eye level
Straight view

Standing + Reaching a Hand Out ②

Hey, wait a minute! Stop! The forward-protruding hand with the curved, extended fingers is coming right at the viewer and is the key to mastering this pose.

Light

1

Sketching

Raising his arm up to shoulder length and extending his hand to the front, perspective comes into play with your character's the protruding hand.

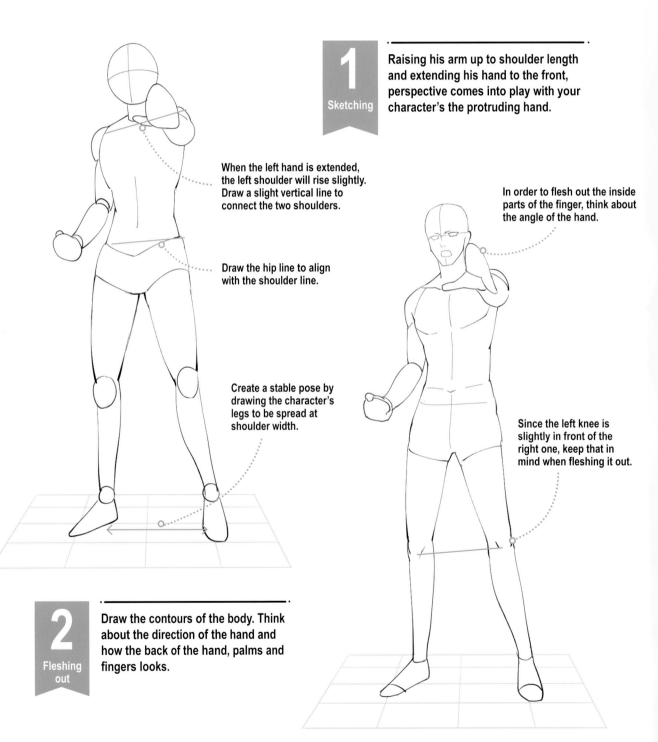

When the left hand is extended, the left shoulder will rise slightly. Draw a slight vertical line to connect the two shoulders.

Draw the hip line to align with the shoulder line.

Create a stable pose by drawing the character's legs to be spread at shoulder width.

In order to flesh out the inside parts of the finger, think about the angle of the hand.

Since the left knee is slightly in front of the right one, keep that in mind when fleshing it out.

2

Fleshing out

Draw the contours of the body. Think about the direction of the hand and how the back of the hand, palms and fingers looks.

If you draw the mouth in a square shape, you can capture the character speaking passionately.

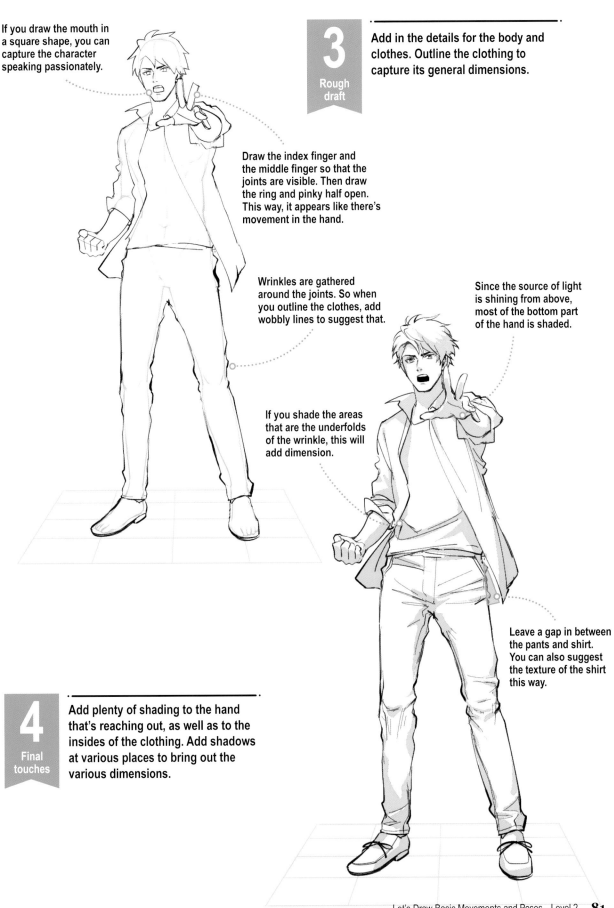

3 Rough draft

Add in the details for the body and clothes. Outline the clothing to capture its general dimensions.

Draw the index finger and the middle finger so that the joints are visible. Then draw the ring and pinky half open. This way, it appears like there's movement in the hand.

Wrinkles are gathered around the joints. So when you outline the clothes, add wobbly lines to suggest that.

Since the source of light is shining from above, most of the bottom part of the hand is shaded.

If you shade the areas that are the underfolds of the wrinkle, this will add dimension.

4 Final touches

Add plenty of shading to the hand that's reaching out, as well as to the insides of the clothing. Add shadows at various places to bring out the various dimensions.

Leave a gap in between the pants and shirt. You can also suggest the texture of the shirt this way.

Standing + Carrying Something on the Shoulder

For this composition, a man carries a large box over his shoulder. In order to capture this pose with the right sense of balance, pay close attention to which side the body is leaning.

Direction of light

Light

Once you've decided on how the body's learning, sketch the box in according to the body's orientation.

1

Sketching

In order to show the box being grasped firmly, pay attention to the shoulder's angle as well as the direction the body is leaning.

Place the box on the left arm and lower the right arm.

For the side that's not carrying the box, draw it drooping downward.

In order to balance the box, the upper half of the body is leaning.

Indicate the contours of the side of the body by drawing a sharp curve at the waistline.

Create a firm stance by placing the legs at shoulder length and face the toes outward.

2

Fleshing out

Add in the muscles. Draw the shoulders wide and imagine the main body as an inverted triangle.

3

Rough
draft

Work clothes are characterized by a loose silhouette so that they're easy to move in. You can also add a bandanna to his head for that extra touch!

If you draw the fit of the clothing one size larger at the legs, arms and abdomen, you'll suggest its looseness.

Since the fabric's soft, it gathers at the hem.

Drawing the eyes in a straight line adds to the character's youthful qualities.

A CLOSER LOOK

Parallel to the arm's angle

With the shoulder and upper arm involved, the line of the box should be parallel to the arm to make the pose look natural.

There's no light on the box so add shadows there.

The wrinkles form near the arm that's holding the box.

4

Final touches

A strong shadow is cast by the box. Add wrinkles to the clothes to create a greater sense of dimension.

By adding horizontal wrinkles at the ankle, you can express how the wrinkles are gathered at the bottom of the pants.

Pose
22
Eye level
Straight view

Running + Front View

Here a young woman is running straight toward the viewer. Focus on drawing the dynamic movements in the limbs.

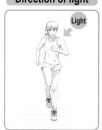

Light

1
Sketching

It's more difficult to capture depth with a frontal view as opposed to a diagonal view. Use the legs and arms to create layers of depth.

The right arm is pulled back so draw it a little shorter than usual.

2
Fleshing out

Flesh out the sketch, drawing attention to the figure's musclarity and flexibility.

The left arm is in front so draw it longer than the right side.

Since the right leg is lifted up, raise the right knee above the left knee.

The upper and lower body are twisted in opposite directions. Draw the side that's in front slightly larger.

Capture the character's strength by showing the tense flexing of the muscle.

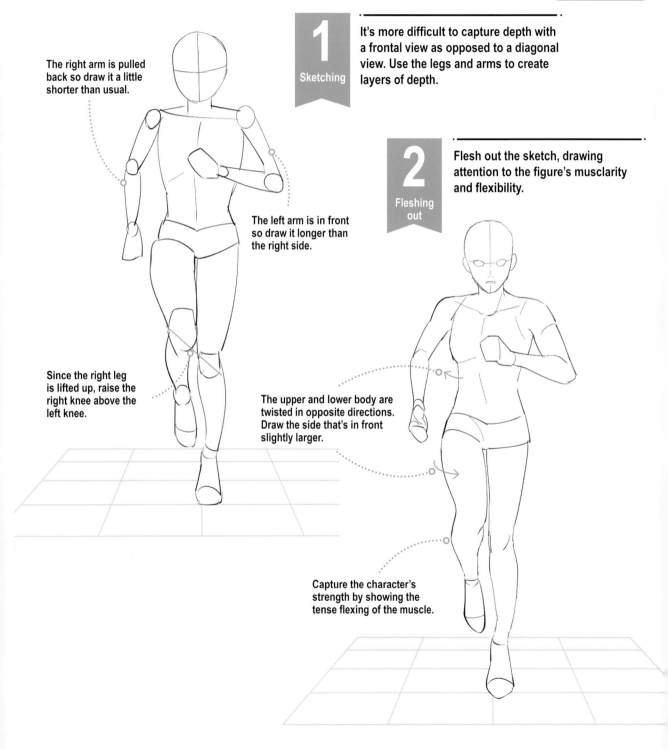

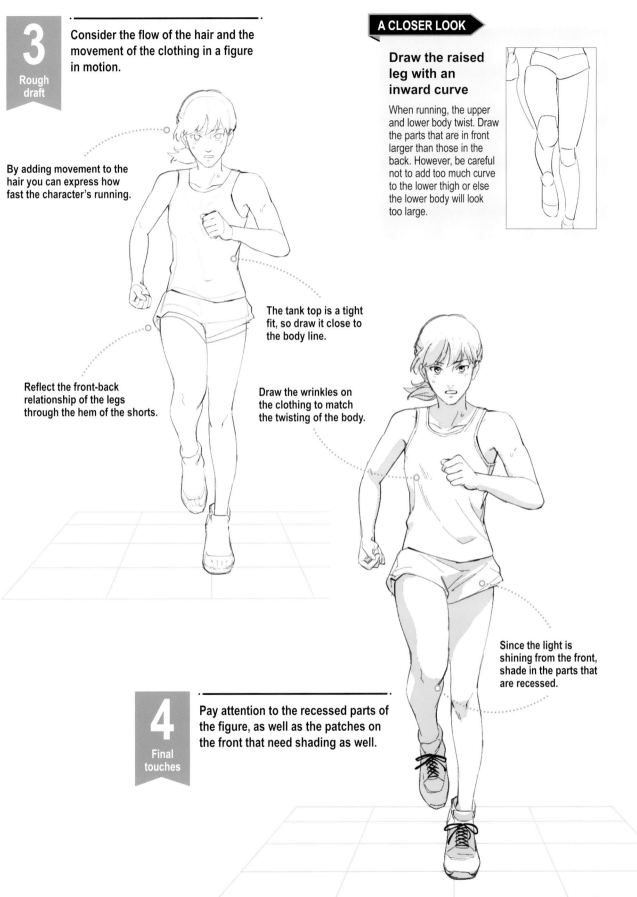

3
Rough draft

Consider the flow of the hair and the movement of the clothing in a figure in motion.

By adding movement to the hair you can express how fast the character's running.

Reflect the front-back relationship of the legs through the hem of the shorts.

The tank top is a tight fit, so draw it close to the body line.

Draw the wrinkles on the clothing to match the twisting of the body.

Draw the raised leg with an inward curve

When running, the upper and lower body twist. Draw the parts that are in front larger than those in the back. However, be careful not to add too much curve to the lower thigh or else the lower body will look too large.

Since the light is shining from the front, shade in the parts that are recessed.

4
Final touches

Pay attention to the recessed parts of the figure, as well as the patches on the front that need shading as well.

Pose
23
Slightly low angle
Diagonal view

Running + Back View

The line of perspective and the center of gravity are key factors to consider when drawing a figure running away. Take the time to master illustrating dynamic muscles.

Direction of light

Light

1
Sketching

At this preliminary, try to capture the proper perspective. Draw the leg that's in the back larger and the one in front smaller.

Since the character is leaning forward, the neck isn't visible. Pay close attention to the position of the head.

Create a sense of speed by having the character lean forward.

Draw the limbs at a sharp angle to suggest the extension of running fast.

Since there's a dramatic perspective in this pose, make the feet extra large.

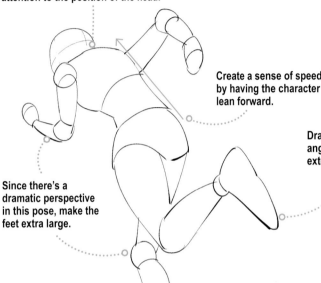

Though the back is bent, don't draw the upper body too small. Be sure to capture the bulky musculature of the physique.

2
Fleshing out

In order to express the character running at full force, pay particular attention to the flexing muscles.

Since the character's weight is on the right leg, drawing firm, taut muscles for the calves.

The foot on the ground shows the Achilles tendon stretched out.

Tight-fitting clothes add to the dynamic body line and accentuate the compact movements of the figure.

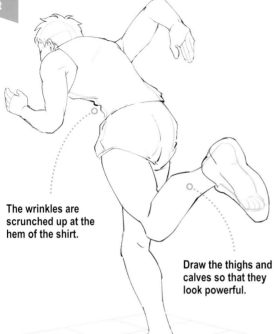

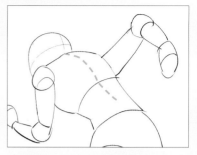

Draw a dotted line down the back to create a median point

This makes it easier to capture the contour of the spine and the arch of the back overall.

The wrinkles are scrunched up at the hem of the shirt.

Draw the thighs and calves so that they look powerful.

By adding sweat drops behind him, you suggest the speed.

Shade in the wrinkles gathered around the crotch and hem for added dimension.

Since the light source emanates from a direct angle, the shaded areas are minimal. Draw in effects such as pieces of hair sticking up and sweat drops to add dynamism to the pose.

Add shadows at the thigh to express the muscles flexing.

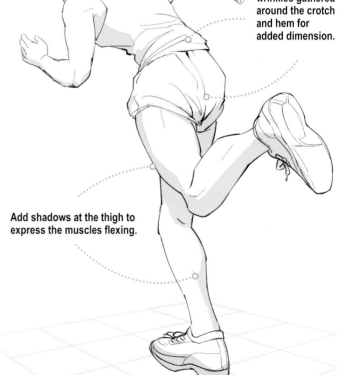

Pose

24

High angle
Diagonal view

Sitting on a Chair + Looking Straight Ahead

For this composition, we'll be drawing a man sitting on a bench with his legs spread apart and resting his arms on his legs. Let's consider the balance between the upper and lower body while drawing this composition from a high angle.

Direction of light

Light

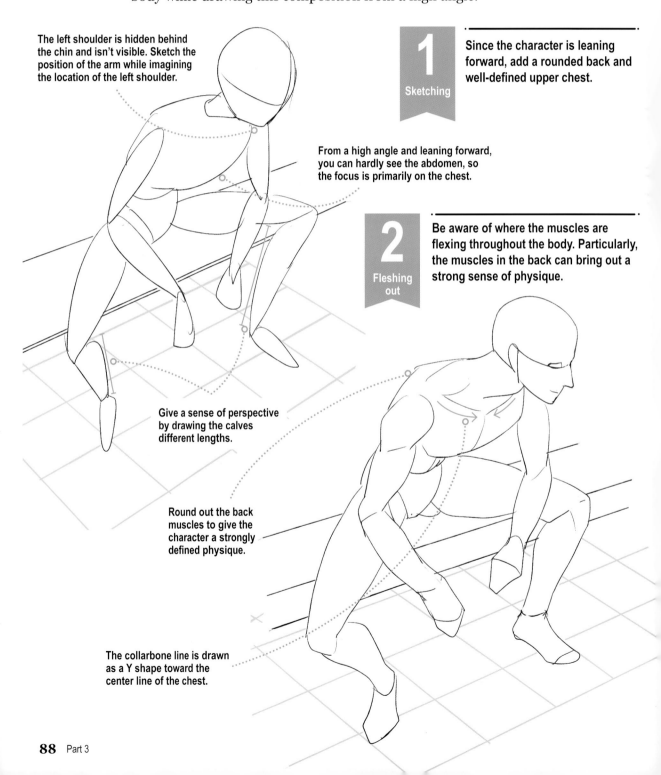

The left shoulder is hidden behind the chin and isn't visible. Sketch the position of the arm while imagining the location of the left shoulder.

1

Sketching

Since the character is leaning forward, add a rounded back and well-defined upper chest.

From a high angle and leaning forward, you can hardly see the abdomen, so the focus is primarily on the chest.

2

Fleshing out

Be aware of where the muscles are flexing throughout the body. Particularly, the muscles in the back can bring out a strong sense of physique.

Give a sense of perspective by drawing the calves different lengths.

Round out the back muscles to give the character a strongly defined physique.

The collarbone line is drawn as a Y shape toward the center line of the chest.

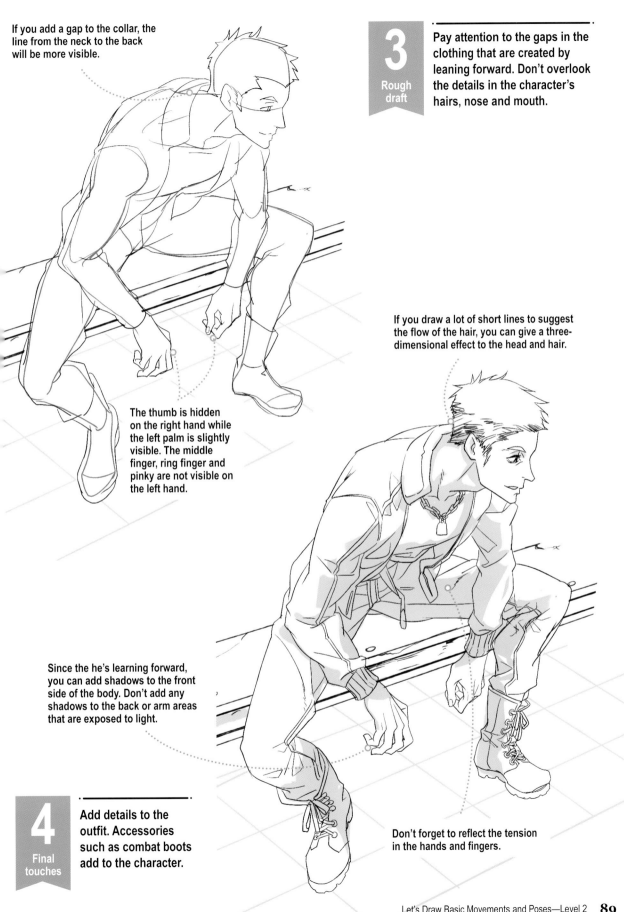

If you add a gap to the collar, the line from the neck to the back will be more visible.

3 Rough draft

Pay attention to the gaps in the clothing that are created by leaning forward. Don't overlook the details in the character's hairs, nose and mouth.

If you draw a lot of short lines to suggest the flow of the hair, you can give a three-dimensional effect to the head and hair.

The thumb is hidden on the right hand while the left palm is slightly visible. The middle finger, ring finger and pinky are not visible on the left hand.

Since the he's learning forward, you can add shadows to the front side of the body. Don't add any shadows to the back or arm areas that are exposed to light.

4 Final touches

Add details to the outfit. Accessories such as combat boots add to the character.

Don't forget to reflect the tension in the hands and fingers.

Sitting on the Floor + Curling Up

Here a character curls up on the floor. You can suggest the character's small figure by making the legs around the same size as the upper body.

Direction of light

Light

Make sure not to draw the shoulders too wide. Keep in mind the character's slender build.

1 Sketching

Curve the upper body to match the chin leaning on the knees. Since the character's holding her knees with both hands, draw the legs close to each other.

Since the character is resting her chin on her knees, decide on the face's direction and draw the crosshairs to show the direction the character's facing.

Since the character is sitting on the floor, the body appears shrunken. Indicate that with a rounded back.

Draw a small gap between the knees to accentuate the sense of curling up.

Draw the thighs while being aware of their connection with the kneecap. Draw a circle to aid in capturing the buttocks' curve.

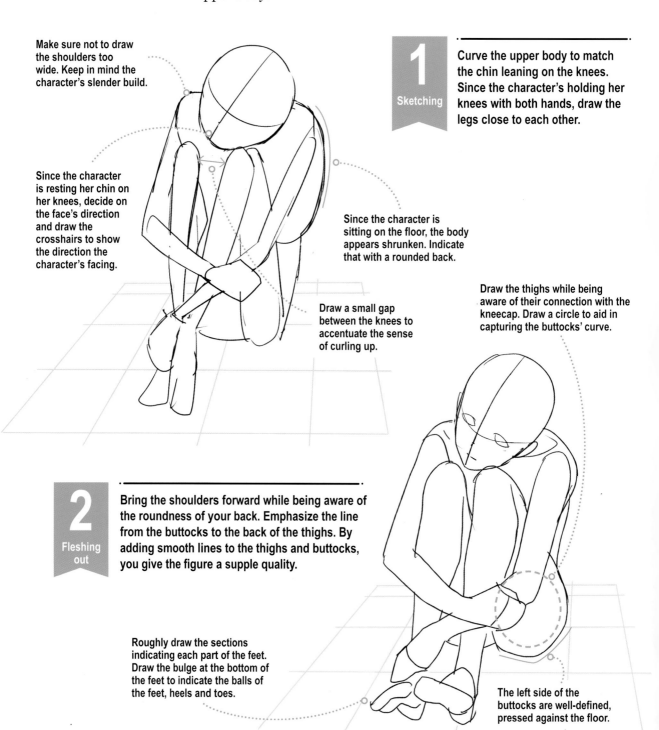

2 Fleshing out

Bring the shoulders forward while being aware of the roundness of your back. Emphasize the line from the buttocks to the back of the thighs. By adding smooth lines to the thighs and buttocks, you give the figure a supple quality.

Roughly draw the sections indicating each part of the feet. Draw the bulge at the bottom of the feet to indicate the balls of the feet, heels and toes.

The left side of the buttocks are well-defined, pressed against the floor.

If you draw the bangs separately in front and on the sides, you'll get natural-looking pieces and flow.

3
Rough draft

You can see the whorl of the hair because the character is tilting her head. Give her an oversized outfit to emphasize the balled-up shape of the body.

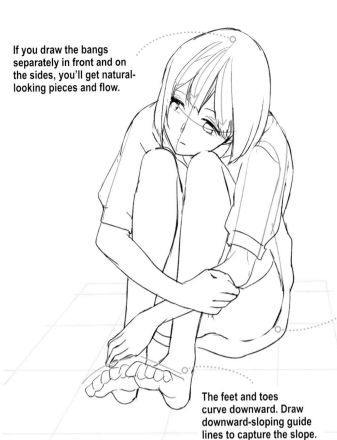

The outline of the buttocks is hidden by the oversized shirt.

The feet and toes curve downward. Draw downward-sloping guide lines to capture the slope.

4
Final touches

Shade in the parts of the face and knees that are hidden from the light as well as the bottoms of the feet.

Make the hair flow to match the angle of her tilted head.

Since the legs and arms are in front, shade in the chest, the back of the thighs and around the waist.

A CLOSER LOOK

Use an oval as your guide

The entire body should basically fit inside an egg shape, to capture the proper width. The curled-up feet should barely be sticking out of its perimeter.

Express the oversized T-shirt by adding long wrinkles. You can also add in folds to the fabric to heighten the sense of realism.

Sitting on a Chair + Resting Chin on Hand ①

Now it's time to draw a character sitting at the desk resting her chin in her hand. Make sure that her legs and the desk legs are parallel with each other to capture the proper sense of depth.

Direction of light

Light

Draw the tip of the fingers to align with the position of the character's eyes and the position of the chin couched in the palm.

Sketch the desk, giving as sense of the front-to-back perspective.

1 Sketching

Sketch the desk spreading from the back to the front. Pay attention to the base of the desk and sketch the character within it accordingly.

The character is leaning on the desk so her upper body leans a little. Make sure to draw her back slightly rounded.

2 Fleshing out

The center of gravity of the upper body shifts to the right. Draw a thigh line from the hips, keeping in mind the shape of the seat.

Draw a line from the back to the buttocks spreading the shape to make it appear seated deep in the chair.

Draw the left arm directed toward the gap between the right arm and the upper body. Be aware of the triangle that's created.

The left and right legs appear to overlap, so there's no gap in the thighs.

Make the back of the thigh linear to match the seating surface of the chair.

The toes face inward; be sure to emphasize the bulge of the calf.

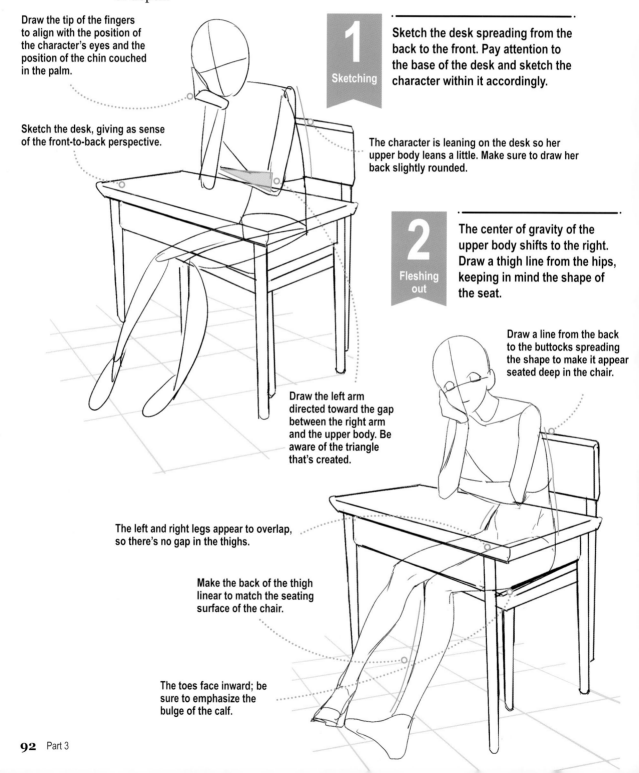

3

Rough draft

Sketch in the silhouette of the skirt to align with the legs. The flow of the hair needs to match the tilt of the head.

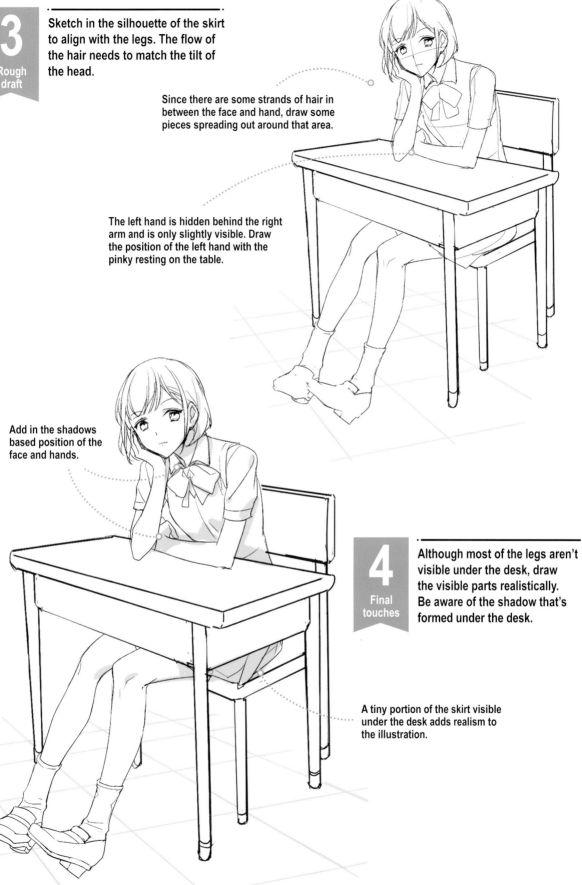

Since there are some strands of hair in between the face and hand, draw some pieces spreading out around that area.

The left hand is hidden behind the right arm and is only slightly visible. Draw the position of the left hand with the pinky resting on the table.

Add in the shadows based position of the face and hands.

4

Final touches

Although most of the legs aren't visible under the desk, draw the visible parts realistically. Be aware of the shadow that's formed under the desk.

A tiny portion of the skirt visible under the desk adds realism to the illustration.

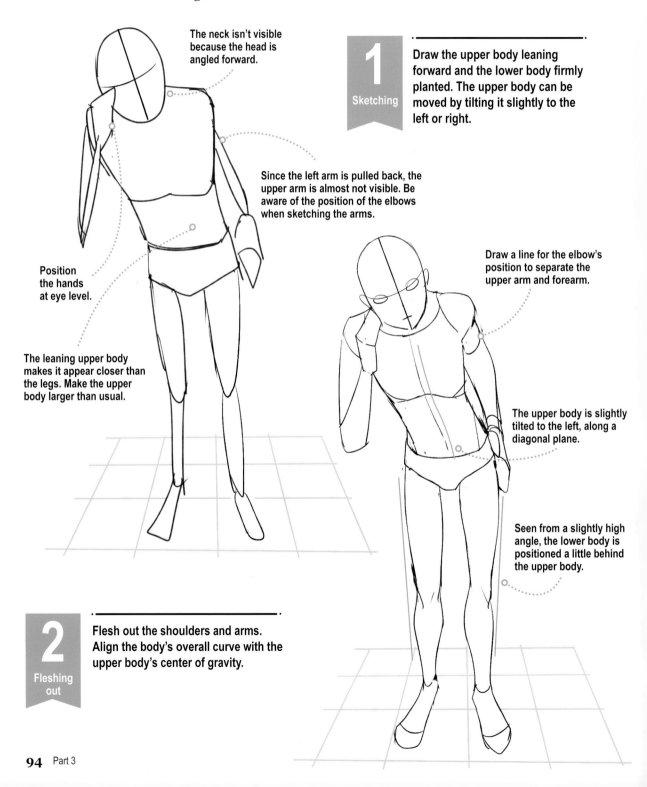

Pose

27

Slightly high angle

Straight view

Standing + Peering Through Glasses

A man peeks over the top of his sunglasses. To capture this pose, pay attention to how the upper body looks from the front while leaning forward.

Direction of light

Light

The neck isn't visible because the head is angled forward.

Since the left arm is pulled back, the upper arm is almost not visible. Be aware of the position of the elbows when sketching the arms.

Position the hands at eye level.

The leaning upper body makes it appear closer than the legs. Make the upper body larger than usual.

1

Sketching

Draw the upper body leaning forward and the lower body firmly planted. The upper body can be moved by tilting it slightly to the left or right.

Draw a line for the elbow's position to separate the upper arm and forearm.

The upper body is slightly tilted to the left, along a diagonal plane.

Seen from a slightly high angle, the lower body is positioned a little behind the upper body.

2

Fleshing out

Flesh out the shoulders and arms. Align the body's overall curve with the upper body's center of gravity.

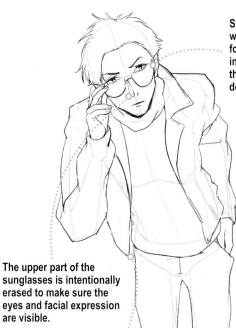

Sketch in the clothing to align with the character leaning forward. Worry about shading in the sunglasses later. Draw the rims of the glasses so they don't block his eyes.

3

Rough draft

While leaning forward, the character's clothes crease. Don't worry about filling in the glasses; draw the rims in a position where they don't obscure the eyes.

4

Final touches

Draw wrinkles according to the movement of the body leaning forward. By angling the eyebrows, you can capture the character's look of suspicion.

The upper part of the sunglasses is intentionally erased to make sure the eyes and facial expression are visible.

Since the jacket is unzipped, have it hanging loosely open and not fit to the body.

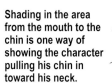

Shading in the area from the mouth to the chin is one way of showing the character pulling his chin in toward his neck.

With his hand in the pants pocket, the jacket scrunches up, so there will be more wrinkles and contours around the waist.

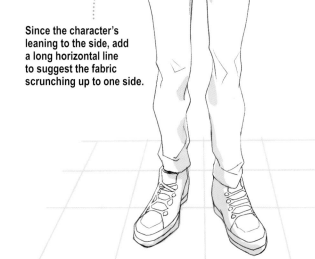

Since the character's leaning to the side, add a long horizontal line to suggest the fabric scrunching up to one side.

A CLOSER LOOK

To understand why the neck is missing, look at the composition from the side

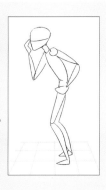

If you look at the composition from the side, you can see that the face and neck overlap. From this angle, it's easier to understand why the neck isn't visible when seen from above. You can understand poses better by exploring them from different angles and perspectives.

Pose 28

High angle
Diagonal view

Standing + Sweeping

A woman gently sweeps the floor with a broom. The key here is thinking about the balance between the broom and the body. Consider, in particular, the position of the hand holding the broom and the placement of the legs.

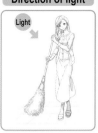

Light

As we sweep, the upper body twists a little so the right shoulder and upper arm are pulled backwards.

Note that when we hold a broom, the hands are reverse with the top and bottom.

It's OK to sketch in the broom roughly at this stage. It is good to decide the length of the broom after finishing the character's basic shape.

1 Sketching

We generally hold a broom with one hand on top and the other hand toward the bottom. The right leg is pulled back, partially hidden by the left.

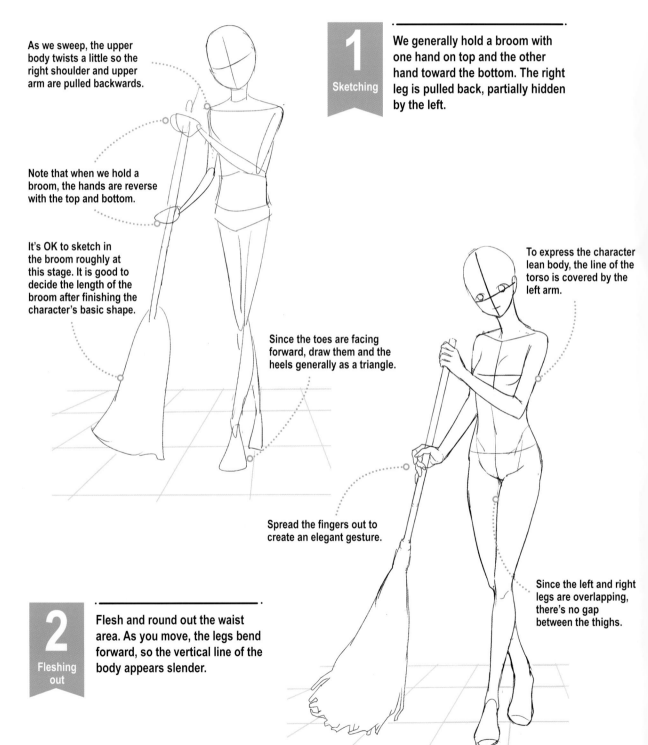

To express the character lean body, the line of the torso is covered by the left arm.

Since the toes are facing forward, draw them and the heels generally as a triangle.

Spread the fingers out to create an elegant gesture.

Since the left and right legs are overlapping, there's no gap between the thighs.

2 Fleshing out

Flesh and round out the waist area. As you move, the legs bend forward, so the vertical line of the body appears slender.

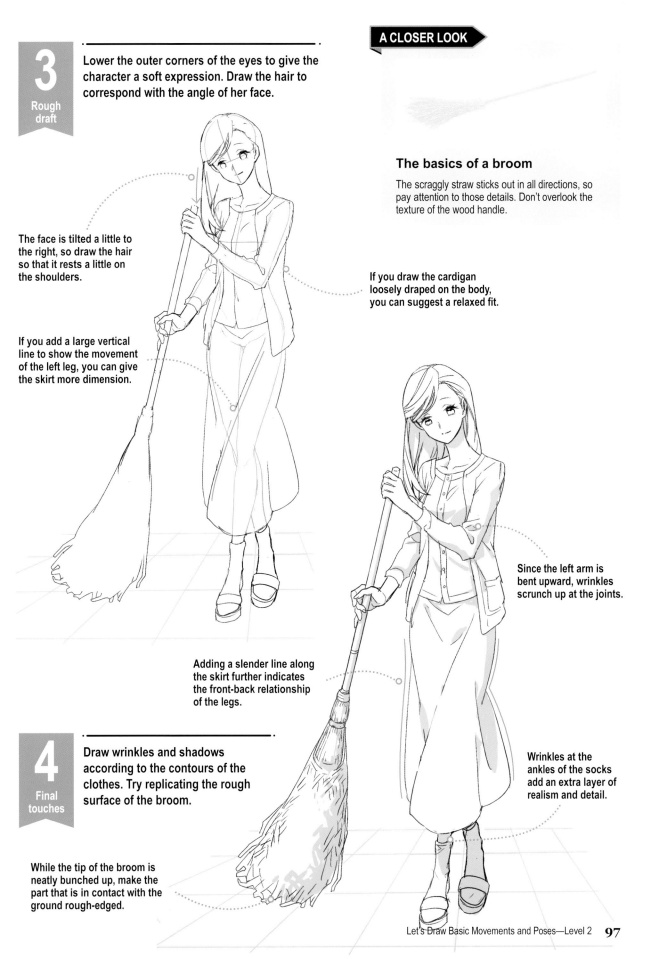

3

Rough draft

Lower the outer corners of the eyes to give the character a soft expression. Draw the hair to correspond with the angle of her face.

The basics of a broom

The scraggly straw sticks out in all directions, so pay attention to those details. Don't overlook the texture of the wood handle.

The face is tilted a little to the right, so draw the hair so that it rests a little on the shoulders.

If you draw the cardigan loosely draped on the body, you can suggest a relaxed fit.

If you add a large vertical line to show the movement of the left leg, you can give the skirt more dimension.

Since the left arm is bent upward, wrinkles scrunch up at the joints.

Adding a slender line along the skirt further indicates the front-back relationship of the legs.

4

Final touches

Draw wrinkles and shadows according to the contours of the clothes. Try replicating the rough surface of the broom.

Wrinkles at the ankles of the socks add an extra layer of realism and detail.

While the tip of the broom is neatly bunched up, make the part that is in contact with the ground rough-edged.

Standing + Holding Flowers

Here a woman holds a bouquet in both hands, smelling the flowers. For this pose, be aware of how her arms look when viewed from the side.

Direction of light

Light

1

Sketching

By emphasizing the line from the chin to the neck, the tilt of the head is more apparent. Show the back shoulder slightly intruding.

Draw the front of the face flat and the back of the head round.

Sketch in the flowers, giving the bouquet height and volume.

For a side view, draw the back shoulder after sketching the line of the left shoulder and the left half of the body.

Since the face is facing upward you can draw the eyelid line diagonally upward.

The upper body is slightly bent back so the front surface of the body is almost flat. Draw the lower body line straight down from the abdomen.

While drawing a gentle curve from the back to the waist, make the buttocks rounded.

2

Fleshing out

The upper body is bent slightly, so emphasize the line of the buttocks from the waistline.

Since the left leg is bent lightly, draw the curve for the calf.

3

Rough draft

Now decide on the clothes and hairstyle. Since the apron is tied at the waist, draw the clothes so that they're hugging the waistline.

Loose silhouettes on the sleeves of the tops emphasizes the thinness of the arms.

The bend of the left knee creates a bulge in the apron. Draw a line to indicate the flowing fabric between the legs.

Since the knot is tied into a ribbon, you can indicate this by drawing a long triangle.

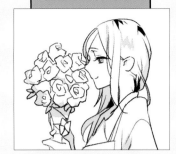

Sniffing the flowers with an enchanted expression

Try drawing the pose with the woman facing the bouquet. Change it up by showing her enjoying the scent of the flowers with an enchanted expression.

The right eye is hidden, but you can make it stand out by drawing the tip of the lashes.

Don't draw the stems of the flowers, but make them a dense cluster to look like a bouquet.

4

Final touches

Refine the details such as hair, clothes and flowers. Take extra time with the blissful expression to achieve the right impact.

There's a looseness to the fabric between the left and right legs, so shade in this section to give it dimension.

Draw a wrinkle on the apron along the line where the left leg is.

Mae the outer ankle slender as it's flexed backward.

Pose

30

Low angle
Diagonal view

Standing + Painting

For this pose, a young woman paints on a standing canvas. Pay close attention to the perspective and the distance between the character and the easel.

Light

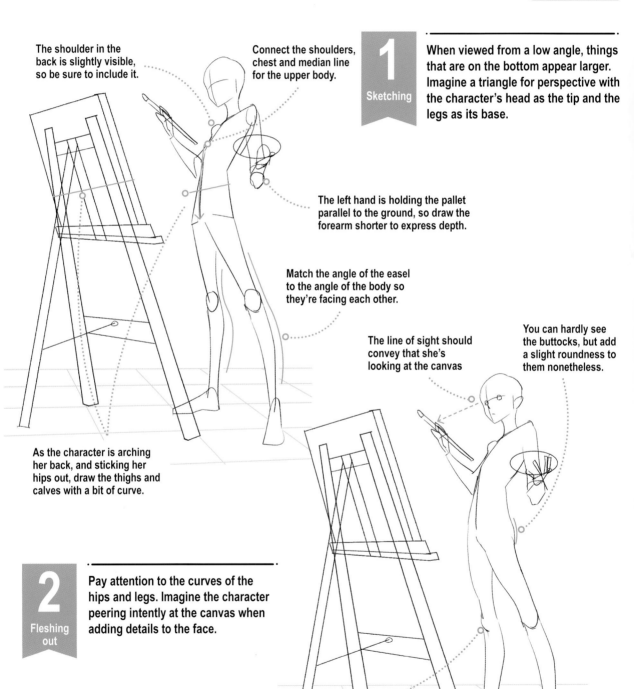

The shoulder in the back is slightly visible, so be sure to include it.

Connect the shoulders, chest and median line for the upper body.

1

Sketching

When viewed from a low angle, things that are on the bottom appear larger. Imagine a triangle for perspective with the character's head as the tip and the legs as its base.

The left hand is holding the pallet parallel to the ground, so draw the forearm shorter to express depth.

Match the angle of the easel to the angle of the body so they're facing each other.

You can hardly see the buttocks, but add a slight roundness to them nonetheless.

The line of sight should convey that she's looking at the canvas

As the character is arching her back, and sticking her hips out, draw the thighs and calves with a bit of curve.

2

Fleshing out

Pay attention to the curves of the hips and legs. Imagine the character peering intently at the canvas when adding details to the face.

Note that the thighs and ankles are not straight. Draw the bulge of the kneecaps and the curves of the legs.

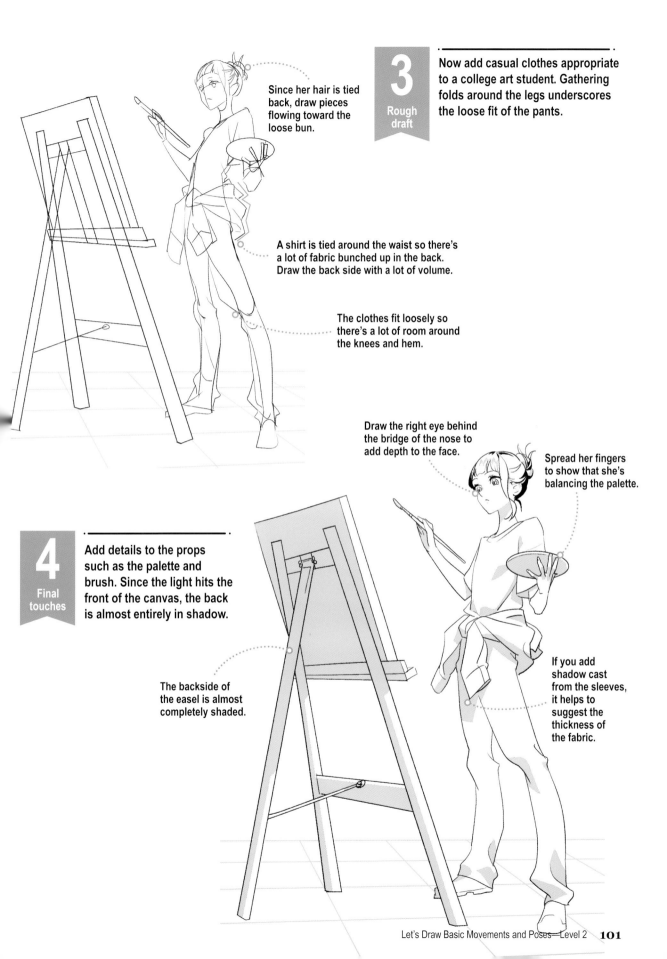

Since her hair is tied back, draw pieces flowing toward the loose bun.

3

Rough draft

Now add casual clothes appropriate to a college art student. Gathering folds around the legs underscores the loose fit of the pants.

A shirt is tied around the waist so there's a lot of fabric bunched up in the back. Draw the back side with a lot of volume.

The clothes fit loosely so there's a lot of room around the knees and hem.

Draw the right eye behind the bridge of the nose to add depth to the face.

Spread her fingers to show that she's balancing the palette.

4

Final touches

Add details to the props such as the palette and brush. Since the light hits the front of the canvas, the back is almost entirely in shadow.

The backside of the easel is almost completely shaded.

If you add shadow cast from the sleeves, it helps to suggest the thickness of the fabric.

Pose
31
Slightly high angle
Diagonal view

Walking into the Wind

Here a woman walks into the wind, shielding herself from the breeze. Pay attention to the perspective of the left and right feet to capture her forward momentum.

Direction of light

Light

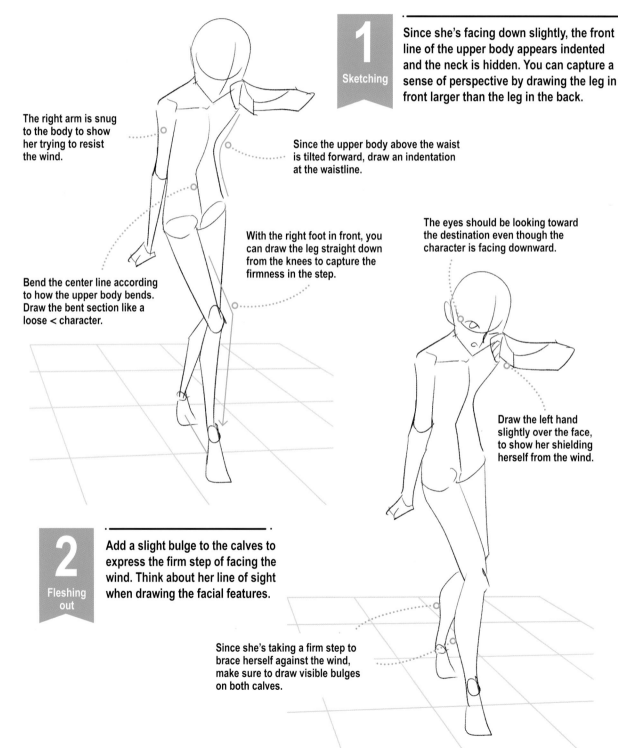

1 Sketching

Since she's facing down slightly, the front line of the upper body appears indented and the neck is hidden. You can capture a sense of perspective by drawing the leg in front larger than the leg in the back.

The right arm is snug to the body to show her trying to resist the wind.

Since the upper body above the waist is tilted forward, draw an indentation at the waistline.

With the right foot in front, you can draw the leg straight down from the knees to capture the firmness in the step.

The eyes should be looking toward the destination even though the character is facing downward.

Bend the center line according to how the upper body bends. Draw the bent section like a loose < character.

Draw the left hand slightly over the face, to show her shielding herself from the wind.

2 Fleshing out

Add a slight bulge to the calves to express the firm step of facing the wind. Think about her line of sight when drawing the facial features.

Since she's taking a firm step to brace herself against the wind, make sure to draw visible bulges on both calves.

3

Rough draft

When sketching the folds of the clothes, consider both the contours of the body parts as well as the wind pressing against her. The movement of the hair is an important detail.

Draw winkles on the clothes to show the strong breeze.

Draw the hair blowing back and away in the wind.

Since the left arm is raised up, add a large gap between the clothes and the body under the armpits.

When facing the wind, the clothes generally flutter backward.

A CLOSER LOOK

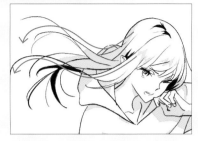

Make the hair flow from the whorl to the tips

Long fluttering hair doesn't move just at the ends. Use a sinuous twist to capture the throughline of the flowing tresses.

The left eye is tightly shut while the right eye peers straight ahead.

4

Final touches

Give the character a firm-set expression to show her effort in resisting the wind. Draw the hair blowing in the wind to make the scene even more realistic.

There's almost no shadow on the front leg. If you shade in the leg that's in the back, you can better show the front-back relationship between the legs.

You can see only her thumb and index finger on the right hand.

Pose
32

High angle
Straight view

Sitting on a Chair +
Drawing a Line with a Ruler

Here a young woman sits at a desk drawing a straight line using a ruler. For this pose, think about the placement of the hand holding the pen and ruler seen from a high angle.

Direction of light

Light

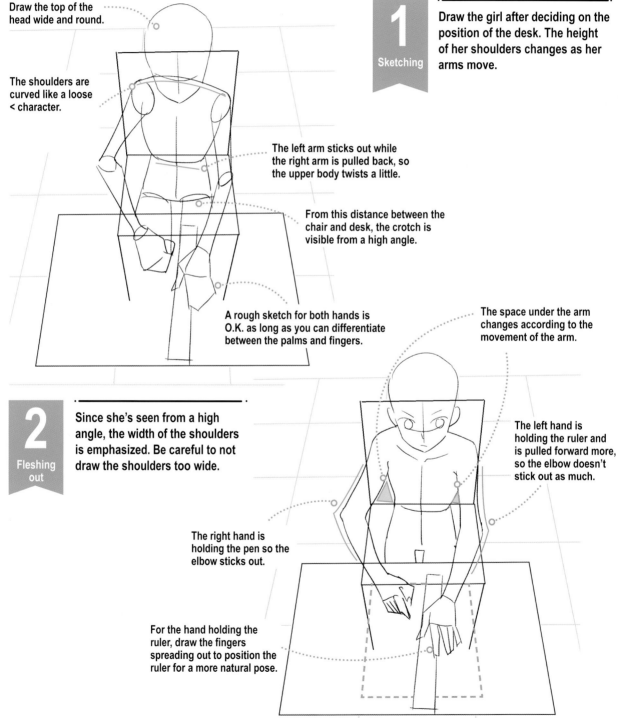

1

Sketching

Draw the girl after deciding on the position of the desk. The height of her shoulders changes as her arms move.

Draw the top of the head wide and round.

The shoulders are curved like a loose < character.

The left arm sticks out while the right arm is pulled back, so the upper body twists a little.

From this distance between the chair and desk, the crotch is visible from a high angle.

A rough sketch for both hands is O.K. as long as you can differentiate between the palms and fingers.

The space under the arm changes according to the movement of the arm.

2

Fleshing out

Since she's seen from a high angle, the width of the shoulders is emphasized. Be careful to not draw the shoulders too wide.

The left hand is holding the ruler and is pulled forward more, so the elbow doesn't stick out as much.

The right hand is holding the pen so the elbow sticks out.

For the hand holding the ruler, draw the fingers spreading out to position the ruler for a more natural pose.

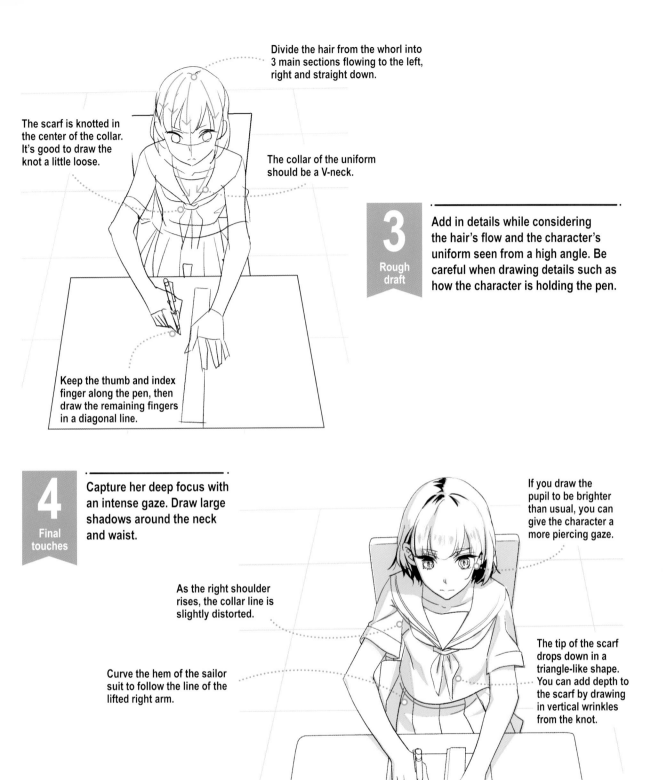

Divide the hair from the whorl into 3 main sections flowing to the left, right and straight down.

The scarf is knotted in the center of the collar. It's good to draw the knot a little loose.

The collar of the uniform should be a V-neck.

3
Rough draft

Add in details while considering the hair's flow and the character's uniform seen from a high angle. Be careful when drawing details such as how the character is holding the pen.

Keep the thumb and index finger along the pen, then draw the remaining fingers in a diagonal line.

4
Final touches

Capture her deep focus with an intense gaze. Draw large shadows around the neck and waist.

If you draw the pupil to be brighter than usual, you can give the character a more piercing gaze.

As the right shoulder rises, the collar line is slightly distorted.

The tip of the scarf drops down in a triangle-like shape. You can add depth to the scarf by drawing in vertical wrinkles from the knot.

Curve the hem of the sailor suit to follow the line of the lifted right arm.

Pose

33

Slightly low angle

Straight view

Squatting

A man at a flower shop crouches down to check on a bouquet. Focus on how to draw the legs in a crouching position as well as how to draw the bucket in front of the man.

Direction of light

1 Sketching

Since the character is crouching with his legs open, his weight is shifted to the rear and his back is stretched.

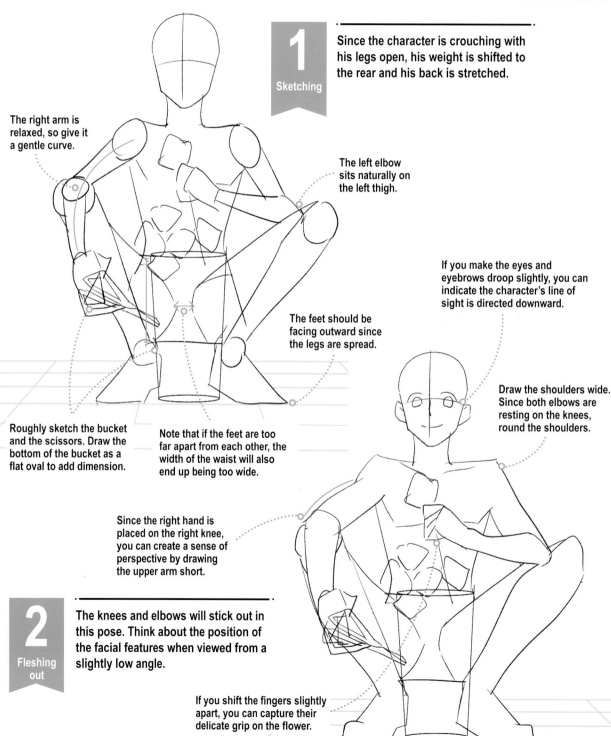

The right arm is relaxed, so give it a gentle curve.

The left elbow sits naturally on the left thigh.

If you make the eyes and eyebrows droop slightly, you can indicate the character's line of sight is directed downward.

The feet should be facing outward since the legs are spread.

Draw the shoulders wide. Since both elbows are resting on the knees, round the shoulders.

Roughly sketch the bucket and the scissors. Draw the bottom of the bucket as a flat oval to add dimension.

Note that if the feet are too far apart from each other, the width of the waist will also end up being too wide.

Since the right hand is placed on the right knee, you can create a sense of perspective by drawing the upper arm short.

2 Fleshing out

The knees and elbows will stick out in this pose. Think about the position of the facial features when viewed from a slightly low angle.

If you shift the fingers slightly apart, you can capture their delicate grip on the flower.

 3

Rough draft

Decide on the hairstyle and clothes to match the scenario. Incorporating details such as an apron will add clarity and narrative to the character.

The space beneath the crouch

Show the body weight supported with both feet so it's properly balanced. Also pay attention to the orientation of the spine. In this position, it's hard to keep the back perfectly straight. It's natural to be slightly hunched.

The sleeves are rolled up to the elbows. Draw them slightly above the elbows so it's easier to see the boundary between the upper arms and forearms.

Imagine the character as a flower shop employee and give him an apron.

The space between the ankle and pants is shifted outward because of the squatting pose.

If the line of sight is pointing down, draw the eyes also cast downward.

Since we're viewing from a slightly low angle, draw the chin and mouth a bit wider.

4

Final touches

Shade in areas such as the legs where the bucket covers, under the knees and where the arms overlap. Finish up by adding details to the flowers and bucket.

Draw in the flowers' details to your liking. Try drawing them seen from various angles to add dimension.

Draw the hem of the trousers in a tube-like shape and shade the inside parts to add dimension.

The bucket is positioned in front covering up the legs, so draw a shadow around the buttocks.

How to Draw Various Hairstyles

A character's hairstyle is a defining feature. Practice the various styles to give your character a distinctive look!

Various hairstyles for female characters

Smooth and soft-textured hair is just the beginning. Create a basic shape then embellish from there.

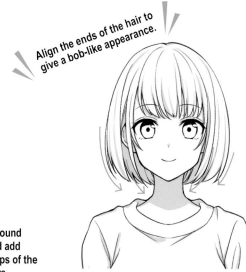

Align the ends of the hair to give a bob-like appearance.

Bob cut

From the whorl to the tip, give the hair a little puff to add volume. Curve the tips inward as if the hair is gathering toward one area.

Short hair

Make the pieces around the face longer and add movement to the tips of the hair around the ears.

Curly hair naturally adds volume and bounce.

Wavy hair

For straight hair, the tips will end right below the collarbone. If you want to add waves, the hair will rest on the shoulders.

Sweep the bangs under for a more three-dimensional look.

Irregular bangs and ends give a more casual look.

One-length cut

Hair pieces appear longer on the outer layers and shorter in the inner layers. Align the ends of the hair so they're the same length. This cut gives a more mature look than a bob.

Medium-length

Extend the hair past the chin line. Add short bangs to give the character a youthful impression.

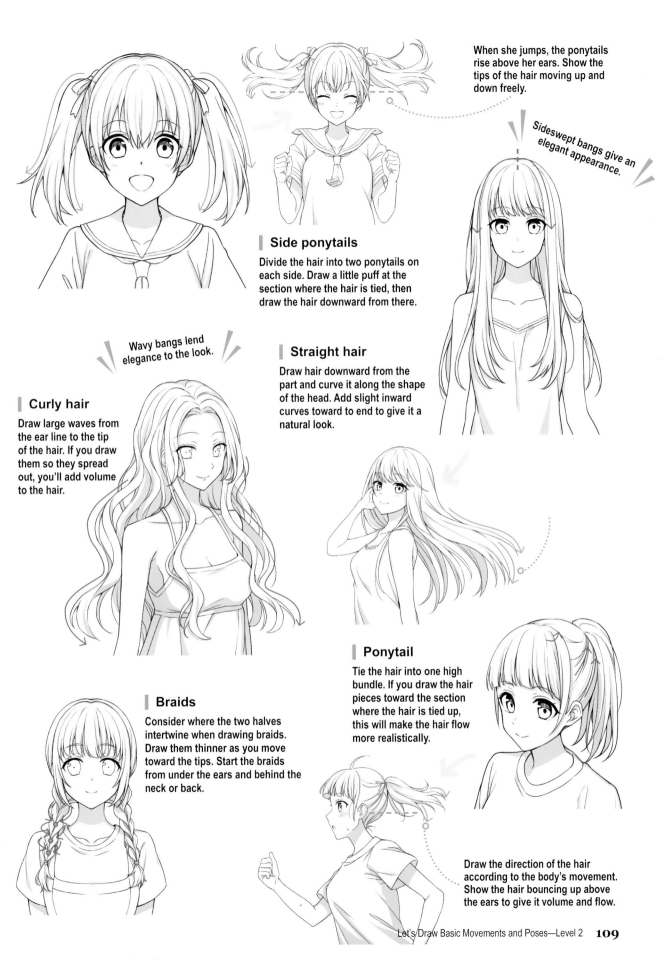

When she jumps, the ponytails rise above her ears. Show the tips of the hair moving up and down freely.

Sideswept bangs give an elegant appearance.

Side ponytails

Divide the hair into two ponytails on each side. Draw a little puff at the section where the hair is tied, then draw the hair downward from there.

Wavy bangs lend elegance to the look.

Straight hair

Draw hair downward from the part and curve it along the shape of the head. Add slight inward curves toward to end to give it a natural look.

Curly hair

Draw large waves from the ear line to the tip of the hair. If you draw them so they spread out, you'll add volume to the hair.

Ponytail

Tie the hair into one high bundle. If you draw the hair pieces toward the section where the hair is tied up, this will make the hair flow more realistically.

Braids

Consider where the two halves intertwine when drawing braids. Draw them thinner as you move toward the tips. Start the braids from under the ears and behind the neck or back.

Draw the direction of the hair according to the body's movement. Show the hair bouncing up above the ears to give it volume and flow.

Various hairstyles for male characters

Change the volume and texture of the hair to add visual variety. Be sure to factor in the size and shape of the head.

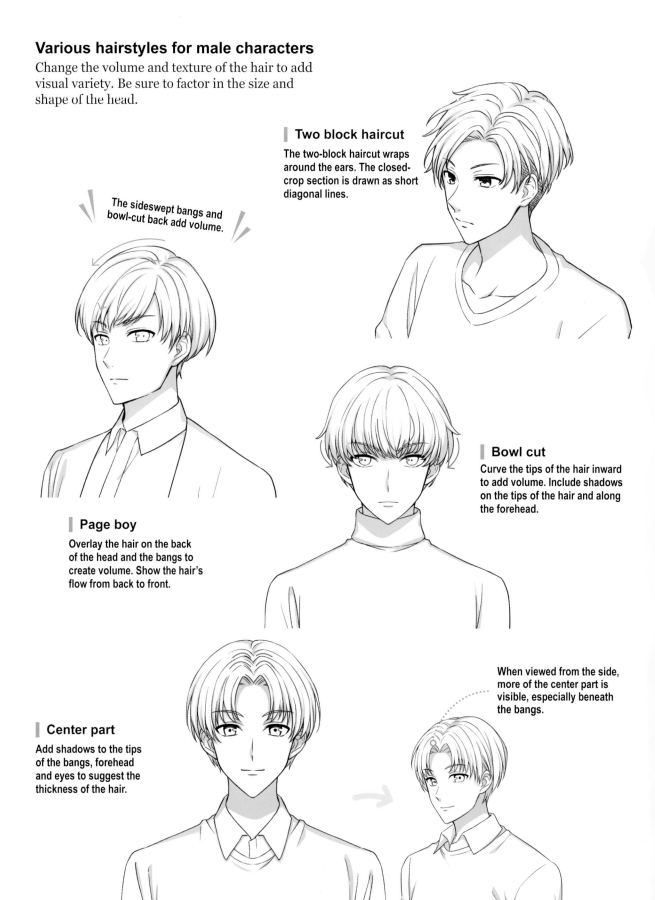

Two block haircut

The two-block haircut wraps around the ears. The closed-crop section is drawn as short diagonal lines.

The sideswept bangs and bowl-cut back add volume.

Page boy

Overlay the hair on the back of the head and the bangs to create volume. Show the hair's flow from back to front.

Bowl cut

Curve the tips of the hair inward to add volume. Include shadows on the tips of the hair and along the forehead.

Center part

Add shadows to the tips of the bangs, forehead and eyes to suggest the thickness of the hair.

When viewed from the side, more of the center part is visible, especially beneath the bangs.

Punk rock hair

The tip of the hair pieces point up. Draw some pieces behind the ears and neck to make it look realistic.

Capture the hair's flow over the top of the head and around the ears.

Loose locks

Curve the tips to give the hair movement while paying attention to the way the hair parts.

You can pull the hair behind one ear to give a clearer view of the face.

For a natural look, be aware of the layers that extend from the whorls.

Smooth and sleek

Sweep the bangs to the side and draw the pieces to contour the face for a gentle impression.

Random strands add a sense of motion and volume.

Loose and long

Part the hair at the center and add loose ruffles to the ends.

Indicate the smoothness of the hair by tilting his head to the side.

You can play around with his hair like drawing him pulling it to one side.

Pose
34
Low angle
Diagonal view

Standing + Waving

For this pose, a woman waves to someone while standing behind a fence. Think about the spacial relationship between the figure and the fence as well as her loose grip on the rail.

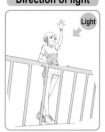

Direction of light

Light

Since she's seen from a diagonal, the shoulder in back is mostly hidden.

The lower abdomen lightly touches the fence, so draw the upper body with a slightly arched back.

Determine the angle of the arm by considering the position of the elbow joint and align it with the height of the fence.

1
Sketching

First decide the location of the fence then draw the character to align with the fence's perspective. Make sure you know which body parts are touching the fence before deciding on a pose for the entire figure.

Draw the leg longer since she's being viewed from a low angle.

The character is waving to someone in the distance, so have her looking straight ahead.

Note that if you draw the soles parallel to each other, it will appear that only the legs are facing sideways. Draw them diagonally for a more natural look.

Draw the left arm so that it's narrower from the shoulder to the elbow.

Keep in mind the bulge and curves of the hips and calves.

In this pose, the character is leaning back and puffing out her chest.

2
Fleshing out

Here the emphasis is on the lower body. Pay close attention to the curves around the waist. When sketching the face, imagine whom the character's calling out to in the distance.

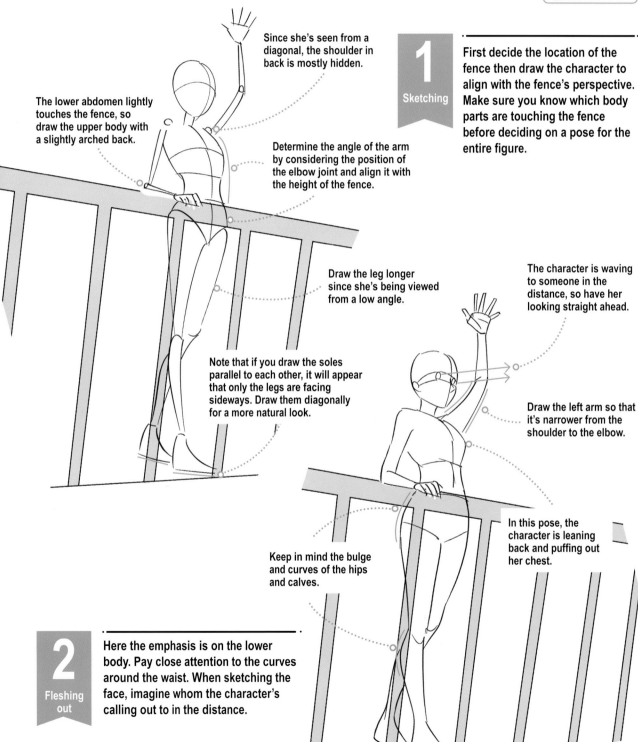

3

Rough draft

Exaggerate the character's facial expression to show that she's calling out to someone in the distance.

Don't forget to draw the hair in the back

Since she's smiling at someone far away, show her mouth and eyes wide open.

There's an excess of fabric on the underside of the raised arm.

Add in a little extra space around the thighs.

✕

Make sure the fence doesn't shift from the position of the character's hands and feet

If you decide the position of the fence without paying attention to where the arms and legs are, you might end up with the arms hanging over the rail and the leg sticking out in a funny position. be sure to When drawing the fence, think about the character's position as well.

Since the character's raising her arm, the fabric is being pulled under the chest. Draw in wrinkles to indicate this.

The neck's under the head, so add a large shadow there.

4

Final touches

Think about where the shadows are cast on areas such as the neck and abdomen, when viewed from a low angle. Add details such as a watch and sneakers.

Add shadows and wrinkles along the crotch.

Drawing in shadows under the chest makes it easier to convey the contours.

Add depth and perspective by shading the leg in the back.

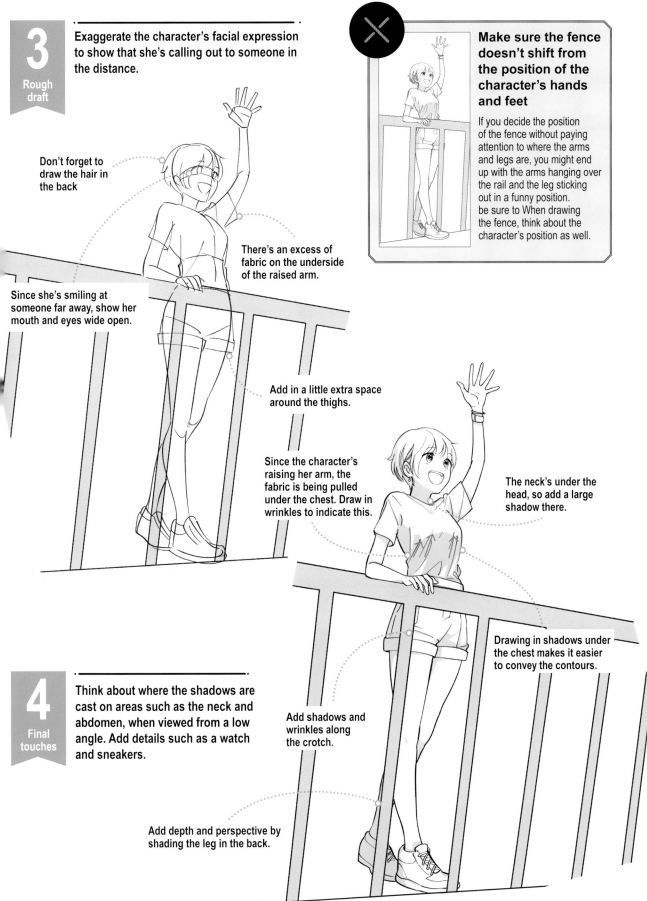

Morning Stretch

Pose

35

High angle
Diagonal view

A stretching pose can be tricky at first but focus on the upward motion. Include a sleepy expression to convey the situation.

Light

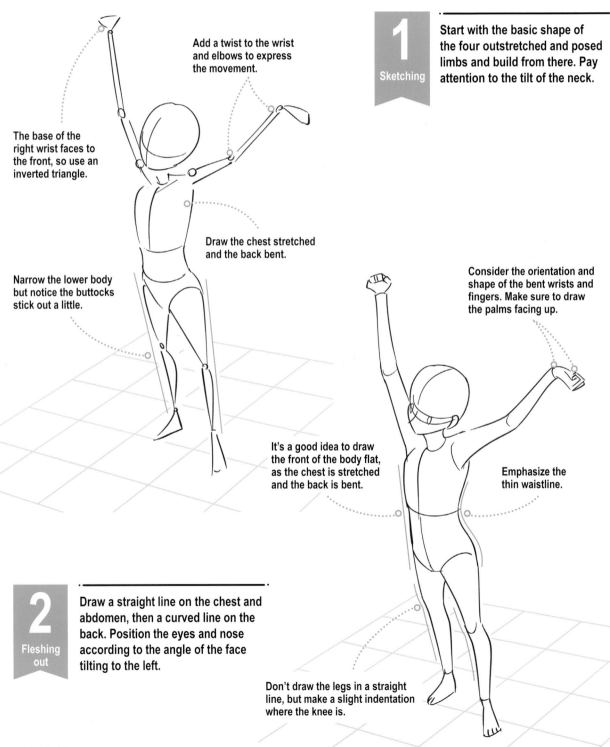

1 Sketching — Start with the basic shape of the four outstretched and posed limbs and build from there. Pay attention to the tilt of the neck.

Add a twist to the wrist and elbows to express the movement.

The base of the right wrist faces to the front, so use an inverted triangle.

Draw the chest stretched and the back bent.

Narrow the lower body but notice the buttocks stick out a little.

Consider the orientation and shape of the bent wrists and fingers. Make sure to draw the palms facing up.

It's a good idea to draw the front of the body flat, as the chest is stretched and the back is bent.

Emphasize the thin waistline.

2 Fleshing out — Draw a straight line on the chest and abdomen, then a curved line on the back. Position the eyes and nose according to the angle of the face tilting to the left.

Don't draw the legs in a straight line, but make a slight indentation where the knee is.

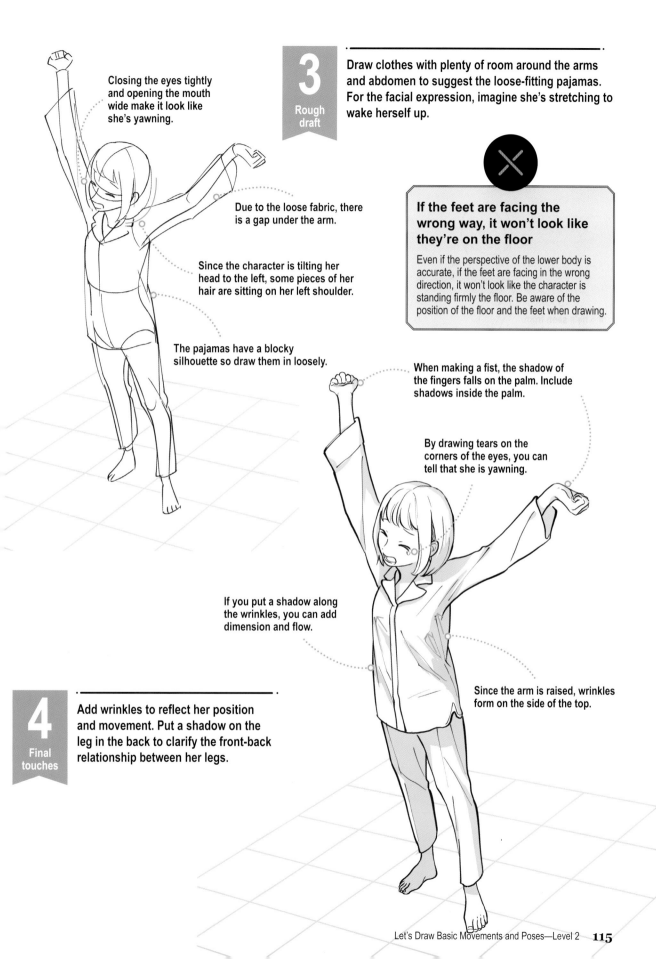

Closing the eyes tightly and opening the mouth wide make it look like she's yawning.

Due to the loose fabric, there is a gap under the arm.

Since the character is tilting her head to the left, some pieces of her hair are sitting on her left shoulder.

The pajamas have a blocky silhouette so draw them in loosely.

3

Rough draft

Draw clothes with plenty of room around the arms and abdomen to suggest the loose-fitting pajamas. For the facial expression, imagine she's stretching to wake herself up.

If the feet are facing the wrong way, it won't look like they're on the floor

Even if the perspective of the lower body is accurate, if the feet are facing in the wrong direction, it won't look like the character is standing firmly the floor. Be aware of the position of the floor and the feet when drawing.

When making a fist, the shadow of the fingers falls on the palm. Include shadows inside the palm.

By drawing tears on the corners of the eyes, you can tell that she is yawning.

If you put a shadow along the wrinkles, you can add dimension and flow.

4

Final touches

Add wrinkles to reflect her position and movement. Put a shadow on the leg in the back to clarify the front-back relationship between her legs.

Since the arm is raised, wrinkles form on the side of the top.

Walking + Hands in Pockets

Here a man walks while leaning slightly forward. He has both hands in his pockets and you can see that he's deep in thought.

Direction of light

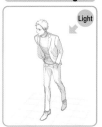

Light

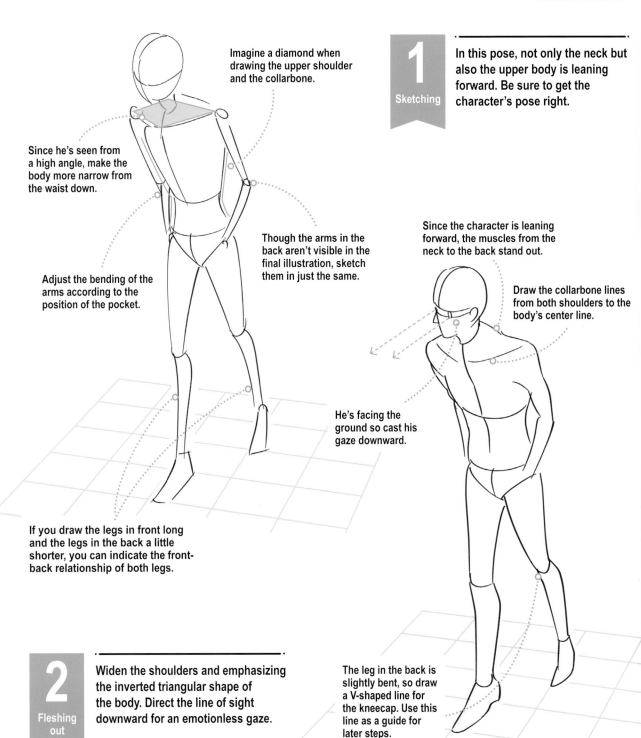

Imagine a diamond when drawing the upper shoulder and the collarbone.

Since he's seen from a high angle, make the body more narrow from the waist down.

Adjust the bending of the arms according to the position of the pocket.

Though the arms in the back aren't visible in the final illustration, sketch them in just the same.

1

Sketching

In this pose, not only the neck but also the upper body is leaning forward. Be sure to get the character's pose right.

Since the character is leaning forward, the muscles from the neck to the back stand out.

Draw the collarbone lines from both shoulders to the body's center line.

He's facing the ground so cast his gaze downward.

If you draw the legs in front long and the legs in the back a little shorter, you can indicate the front-back relationship of both legs.

2

Fleshing out

Widen the shoulders and emphasizing the inverted triangular shape of the body. Direct the line of sight downward for an emotionless gaze.

The leg in the back is slightly bent, so draw a V-shaped line for the kneecap. Use this line as a guide for later steps.

3

Rough draft

Try to imagine the character's isolation and show it in his facial expression. Also, think about the shape of the jacket when the front is open.

By lowering the corner of the mouth, the character will have an emotionless gaze, furthering his sense of isolation.

Since the character is putting his hands in his pockets, this distorts the hem of the jacket.

Since the front of the jacket is open, draw the inside parts of it as well.

A CLOSER LOOK

When you put your hands in your pockets, horizontal lines appear along the front of the pants

The front of the pants becomes tauter where the lines form. The forward and backward motion of the legs then alters the look and configuration of the wrinkles.

Due to the forward-leaning posture, the area below the chest is shaded.

The jacket is made of a more solid fabric, so draw the wrinkles larger.

The hand in the pocket makes it difficult for wrinkles to form on the chest. Gather the excess fabric around the abdomen.

The front of the thighs is exposed to light, so draw a large shadow below the knees to add dimension.

4

Final touches

Add wrinkles and shadows to match the texture of the clothing. Finish up by giving the character defined facial features such as a long nose and eyebrows close to the eyes.

Pose

37

High angle
Diagonal view

Standing + Leaning on the Wall

This character leans against the wall with both hands in her pockets. While drawing, pay attention to the areas and body parts where the character is allocating her weight.

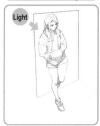

Light

1

Sketching

Sketch the floor and the wall first, then since the shoulder blades and left foot are touching the wall, align those parts to the surface.

To make the character look like she's leaning back, align the back line to the wall.

There's a gap between the wall, waist and back. Keep this in mind when sketching.

Because of the high angle, move the facial features to the bottom of the face.

Below the knees, the legs is held up against the wall. Sketch this part with that perspective in mind.

Since the shoulders are relaxed, draw them sloping slightly downward.

The left foot is resting on the wall, so the right foot is supporting the body weight.

2

Fleshing
out

Keeping in mind the various curves of the body when fleshing out this pose.

The line connecting the waist to the thighs is curved so round it out.

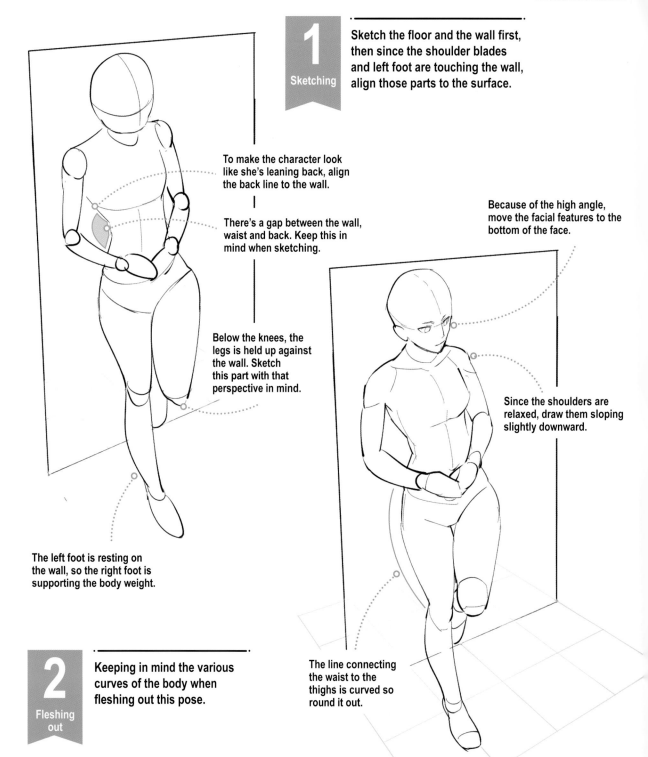

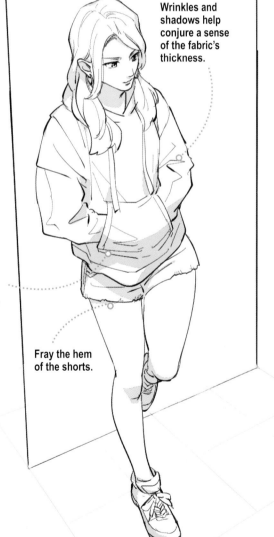

3

Rough draft

Oversized hoodies are loose and not form-fitting, so pay attention to the silhouette.

Draw the hair curving over the shoulders.

The hoodie has a loose silhouette, so you can draw the excess fabric to express the size.

4

Final touches

Draw in the folds of the clothes created by the character's movement.

Wrinkles and shadows help conjure a sense of the fabric's thickness.

Since the hands are inside the hoodie, draw a large shadow under the bottom half of the pocket.

Fray the hem of the shorts.

A CLOSER LOOK

Note that the character is supported at three points: shoulders, wall and the foot on the ground

From the side, you can see the positional relationship between the wall and the character. It's easy to think that the left food is supporting all the weight, but don't forget about the right foot on the ground.

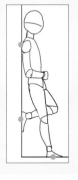

Standing + Putting on a Shirt

For this pose, a man is putting on his jacket. The frozen-in-time moment has a photographic quality to it you'll want to capture perfectly.

Direction of light

1 **Sketching**

The shoulder width is emphasized because of the high angle, and the upper body is shaped like an inverted triangle. Since the chest is slightly puffed up, the arms are raised.

The head appears bigger because of the high angle. The eyes are positioned lower.

Since the man is putting on the jacket, raise the arm to shoulder height.

Think of the upper body as an inverted triangle.

Draw the right leg along the center of gravity.

Since perspective is applied from the thighs to the ankles, draw the legs below the knees shorter.

Lifting the arm to shoulder height raises the shoulder muscles as well.

Since the shirt is coveri... the hand, only the thum... is visible.

Adding a pectoral muscle line will help you later when drawing the inner wrinkles.

Just a rough sketch of the shirt at this stage is fine.

2 **Fleshing out**

Emphasize the thickness of the chest and the thinning of the waistline. Don't forget to add stretch to the thighs and calves.

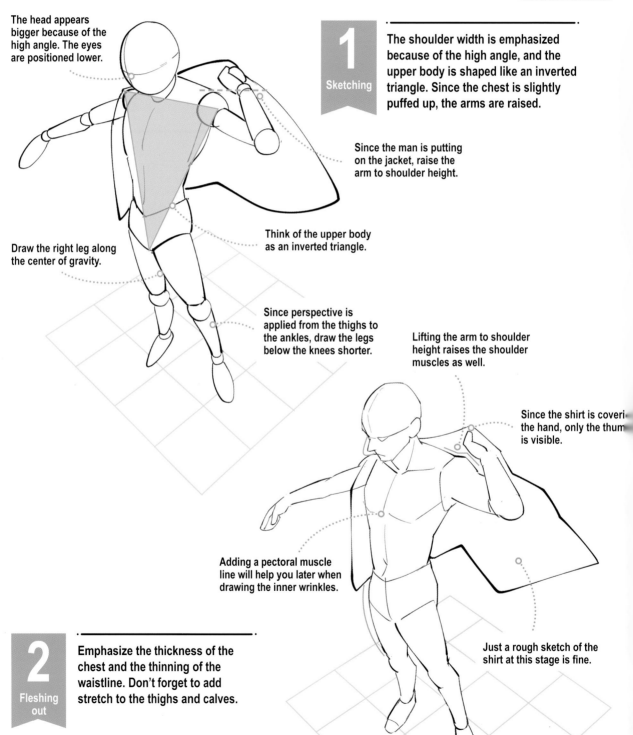

3

Rough draft

Give the character a perfect fitting tanktop to bring out his physique. At this stage, bring out the silhouette of the shirt.

The neck muscles emerge from under the ears and trail down toward the collarbones.

Use the line of sight as a reference to draw the bangs.

The right hand is pulled through the sleeves, so give it a relaxed look.

The upper arm is drawn thicker, so it looks more muscular.

Defining the chest by drawing the upper body line

When seen from eye level, the male figure is generally straight. However, when viewed from above, the body is narrower as it moves farther away from the point of view. Convey a tight and muscular body by tapering the character's waist and midriff.

Bring out the shirt's dimension by adding wrinkles layered over each other.

The shadows of the shirt should be pronounced along the wrinkle lines.

The sleeve on the left side of the shirt is pulled so draw the wrinkles towards the direction it's being pulled.

4

Final touches

Draw a wrinkle in the left hand where the man grabs the shirt. The light shines on his upper body so add a large shadow over his legs.

Since the tanktop is tucked in, draw some wrinkles around the waistline.

By adding a shadow to the legs, you can get a clearer sense of the upper body being exposed to the light.

Pose

39

Low angle
Diagonal view

Direction of light

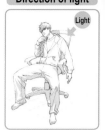

Light

Sitting on a Chair + Resting Chin on Hand ②

For this pose, the main focus is on how the upper body is drawn. Add narrative detail by giving him an intimidating pose.

Pay close attention to the position of the neck and the hand. If the neck sticks out too much, it'll look unnatural.

1

Sketching

Draw the character sitting forward on the chair. Think about the body's position on the chair.

When you're sitting forward on a chair, there's a space between the waist and the back. Draw the character's back in a diagonal line rather than along the backrest of the chair.

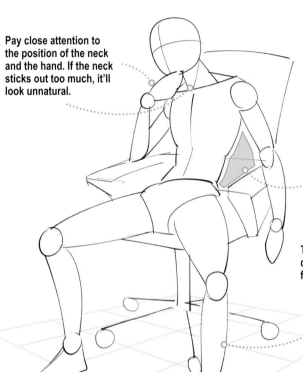

The left foot is extended, so draw it longer than the right foot, which is farther away.

Make his arms and legs muscular to add bulk and depth.

Since the character is leaning back, the line from the chest to the abdomen is curved.

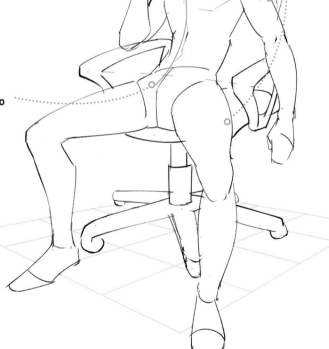

2

Fleshing out

To make the character intimidating, make his body solid and muscular.

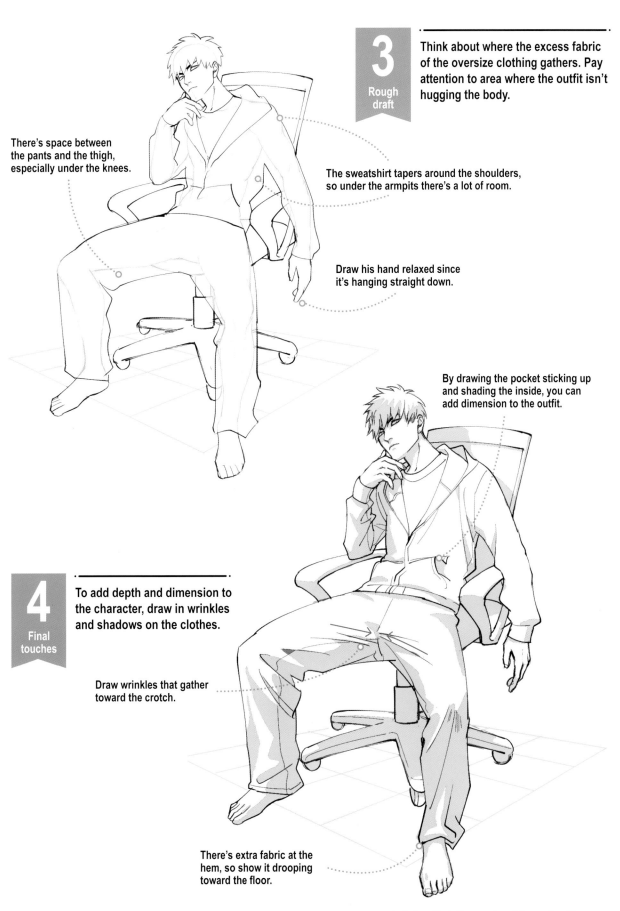

3
Rough draft

Think about where the excess fabric of the oversize clothing gathers. Pay attention to area where the outfit isn't hugging the body.

There's space between the pants and the thigh, especially under the knees.

The sweatshirt tapers around the shoulders, so under the armpits there's a lot of room.

Draw his hand relaxed since it's hanging straight down.

By drawing the pocket sticking up and shading the inside, you can add dimension to the outfit.

4
Final touches

To add depth and dimension to the character, draw in wrinkles and shadows on the clothes.

Draw wrinkles that gather toward the crotch.

There's extra fabric at the hem, so show it drooping toward the floor.

Pose

40

High angle
Diagonal view

Sitting on the Floor + Looking Up

Direction of light

Light

A young woman sits on the floor with her knees up. When seen from above, there are many parts of the body that aren't visible. Pay close attention to the perspective when sketching.

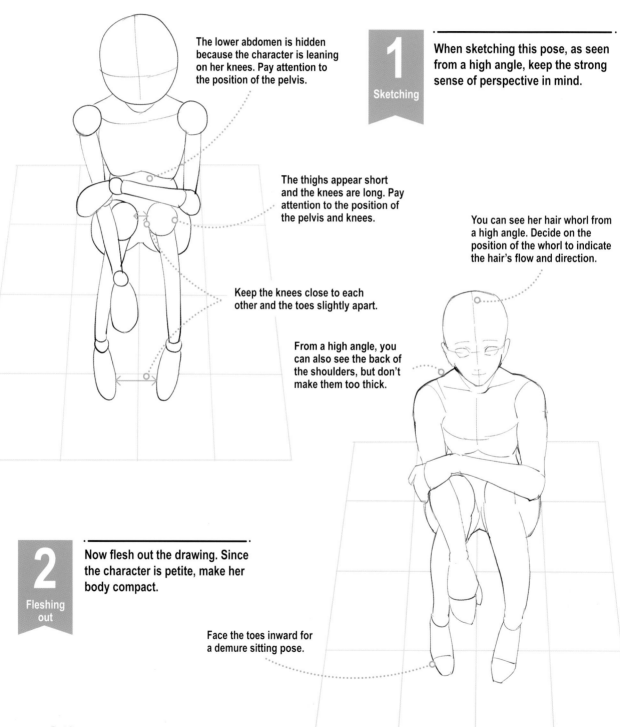

The lower abdomen is hidden because the character is leaning on her knees. Pay attention to the position of the pelvis.

1

Sketching

When sketching this pose, as seen from a high angle, keep the strong sense of perspective in mind.

The thighs appear short and the knees are long. Pay attention to the position of the pelvis and knees.

You can see her hair whorl from a high angle. Decide on the position of the whorl to indicate the hair's flow and direction.

Keep the knees close to each other and the toes slightly apart.

From a high angle, you can also see the back of the shoulders, but don't make them too thick.

2

Fleshing out

Now flesh out the drawing. Since the character is petite, make her body compact.

Face the toes inward for a demure sitting pose.

3

Rough draft

Add details to her face, arms, legs and also to her oversized outfit.

Since her outfit is baggy, it barely shows her body outline.

Put her hands over her arms, not her clothes.

Pull the sleeve down so it covers the back of the hand a little.

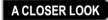

Draw attention to the eyes by adding volume to the lashes and add light to the pupils

Since the upper lashes are emphasized when seen from the high angle, focus on the eyes. You can also add volume to her lashes or plenty of light to the pupils to make them sparkle.

By adding shadows under the collar, you can indicate the thickness of the fabric.

4

Final touches

Add shadows and winkles, keeping in mind the looseness of the clothing. Including a shadow under her head makes it easy to see that she's looking up.

Since she's clasping her knees, draw winkles toward the center.

Wrinkles gather toward the elbow. Bring out the folds by drawing in shadows.

Lying Down +
Looking at a Phone

A young woman lies on her stomach playing on her phone. First consider the hardest part of the pose: the character elevating her upper body a little with her elbows.

Direction of light

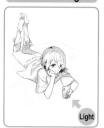

Light

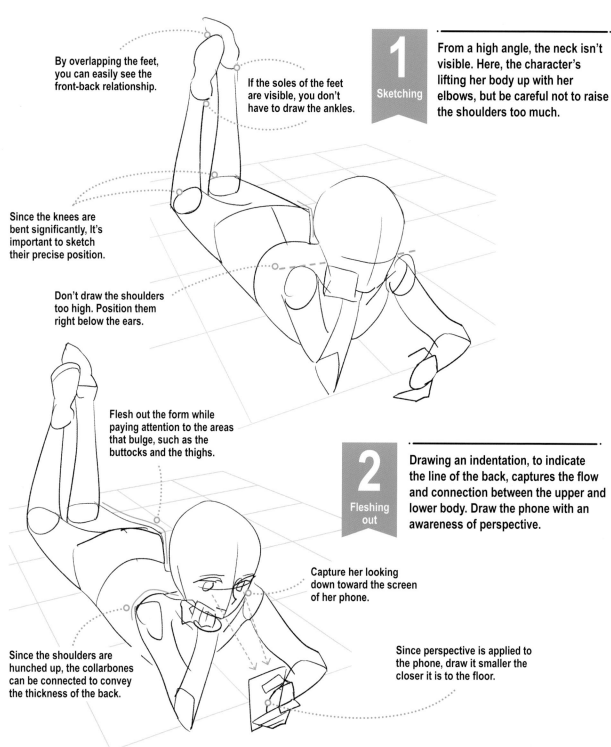

By overlapping the feet, you can easily see the front-back relationship.

If the soles of the feet are visible, you don't have to draw the ankles.

1 Sketching

From a high angle, the neck isn't visible. Here, the character's lifting her body up with her elbows, but be careful not to raise the shoulders too much.

Since the knees are bent significantly, It's important to sketch their precise position.

Don't draw the shoulders too high. Position them right below the ears.

Flesh out the form while paying attention to the areas that bulge, such as the buttocks and the thighs.

2 Fleshing out

Drawing an indentation, to indicate the line of the back, captures the flow and connection between the upper and lower body. Draw the phone with an awareness of perspective.

Capture her looking down toward the screen of her phone.

Since the shoulders are hunched up, the collarbones can be connected to convey the thickness of the back.

Since perspective is applied to the phone, draw it smaller the closer it is to the floor.

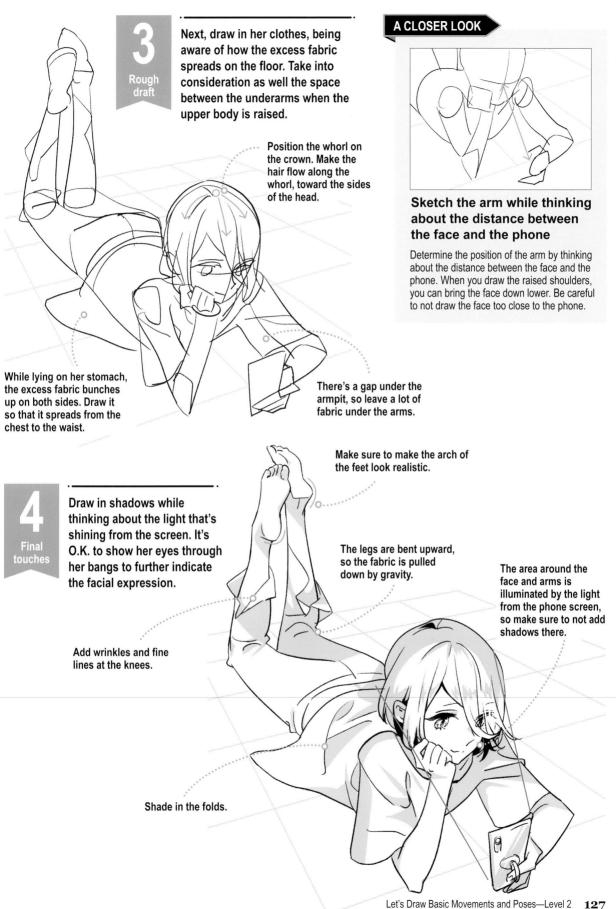

3 Rough draft

Next, draw in her clothes, being aware of how the excess fabric spreads on the floor. Take into consideration as well the space between the underarms when the upper body is raised.

Position the whorl on the crown. Make the hair flow along the whorl, toward the sides of the head.

While lying on her stomach, the excess fabric bunches up on both sides. Draw it so that it spreads from the chest to the waist.

There's a gap under the armpit, so leave a lot of fabric under the arms.

A CLOSER LOOK

Sketch the arm while thinking about the distance between the face and the phone

Determine the position of the arm by thinking about the distance between the face and the phone. When you draw the raised shoulders, you can bring the face down lower. Be careful to not draw the face too close to the phone.

4 Final touches

Draw in shadows while thinking about the light that's shining from the screen. It's O.K. to show her eyes through her bangs to further indicate the facial expression.

Make sure to make the arch of the feet look realistic.

The legs are bent upward, so the fabric is pulled down by gravity.

The area around the face and arms is illuminated by the light from the phone screen, so make sure to not add shadows there.

Add wrinkles and fine lines at the knees.

Shade in the folds.

Lying Down + Crossing Legs

A young man lies on his back, with his hand behind his head and crossing his legs. Pay attention to how the arms look and how his leg rests on his knee.

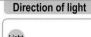

Direction of light

Light

1 Sketching

Since the leg over the knee is raised forward, the back of the foot isn't visible.

Draw a clear line for the chin so it's easy to see the separation of the head and the neck.

The bottom of the left calf is in the back, so make it shorter.

The forearm can be seen in front of the head.

Draw the bottom of the buttocks in a diagonal. Think about the connection between the back and the left leg.

2 Fleshing out

Since the arms are placed around the back of the head, the chest is lifted a little. Pay close attention to how to draw the facial features from this angle.

Point the toes up for a natural pose.

The tip of the nose points up, so make it sharply defined.

Draw the center line from the neck down toward the chest.

When the face is seen from a high angle, the eyebrows and eyes are positioned higher on the face.

Draw the heel to toe in a diagonal plane. Keep the angle of the body in mind.

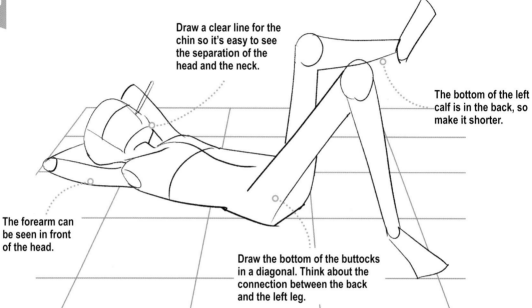

3

Rough draft

Lying on the back causes the excess fabric of the clothes to lay flat on the ground. For the upper arm and ankle, draw a tubular shape to add dimension.

There's room around the ankle, so draw the hem of the pants in a tubular shape.

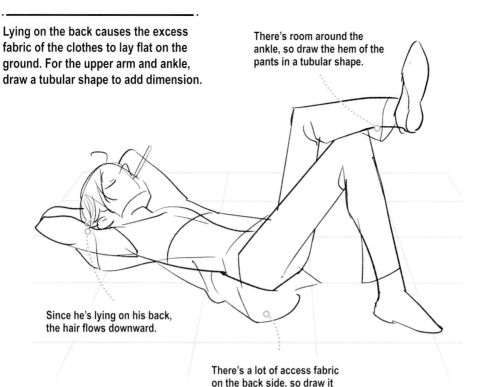

Since he's lying on his back, the hair flows downward.

There's a lot of access fabric on the back side, so draw it under the buttocks.

4

Final touches

Add a shadow to the right knee, back and other areas that aren't exposed to light. Draw shadows to express the uneven areas such as the dent in the abdomen.

Draw a shadow where the leg overlaps. Since his leg is coming over from the back, draw the shadow in a diagonal line.

Draw a shadow on left arm in the back.

Add small details like a popsicle stick in his mouth.

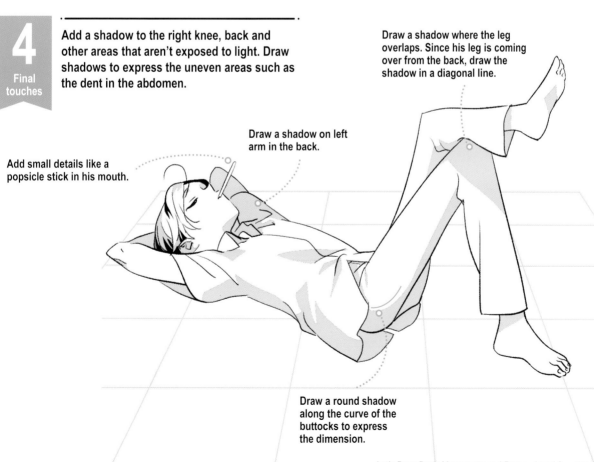

Draw a round shadow along the curve of the buttocks to express the dimension.

Izumi

Izumi is an Illustrator in charge of drawing Tsurumaru Kuninaga and Sadamune Monoyoshi for the game "Touken Ranbu." She is also the illustrator for the light novel series "Marihana Kanriden" by Rinne Ishida.

Interview

What was your weakness when you started drawing illustrations?

When I first started drawing . . . I wasn't very good at it (laughs). I received an award in an illustration contest and started drawing illustrations as a job from there, but I faced the reality that drawing only by intuition would not work very well.

So what did you do to improve your illustrations?

It's important to "observe." How do movies, manga and anime express such a high degree of realism? It became a habit to observe and analyze. . . . I don't think I'm the only one in a similar profession who has formed a habit of

observing. It's a good idea to observe real humans until you can draw a manga character so that it looks natural.

When do you find it fun to draw illustrations?

When a design comes together after repeated trial and error. Then the pressure's off and the character's personality comes into focus (laughs).

What do you keep in mind when drawing manga characters?

I try to draw realistic facial expressions and poses for each character. In particular, I try to draw the hand gestures carefully. I think the hand is the most important part in expressing the character's emotions.

Let's Draw Dynamic Movements and Poses

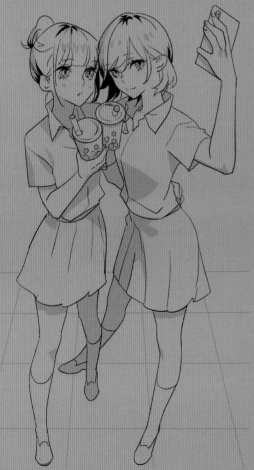

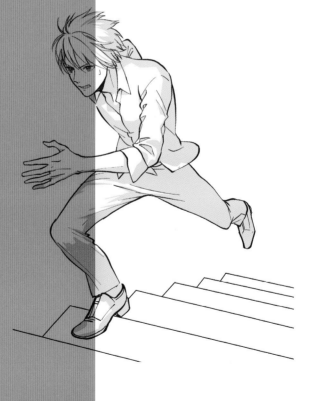

Climbing up stairs, jumping, stretching and even two-character poses. It's time to show off and stretch the skills you've learned so far.

Direction of light

Light

Pose

43

High angle
Diagonal view

Running Upstairs

Now it's time to draw a guy dashing upstairs. If you sketch the character learning forward according to the perspective of the stairs, you can show your determined hero bounding up the staircase with all his might.

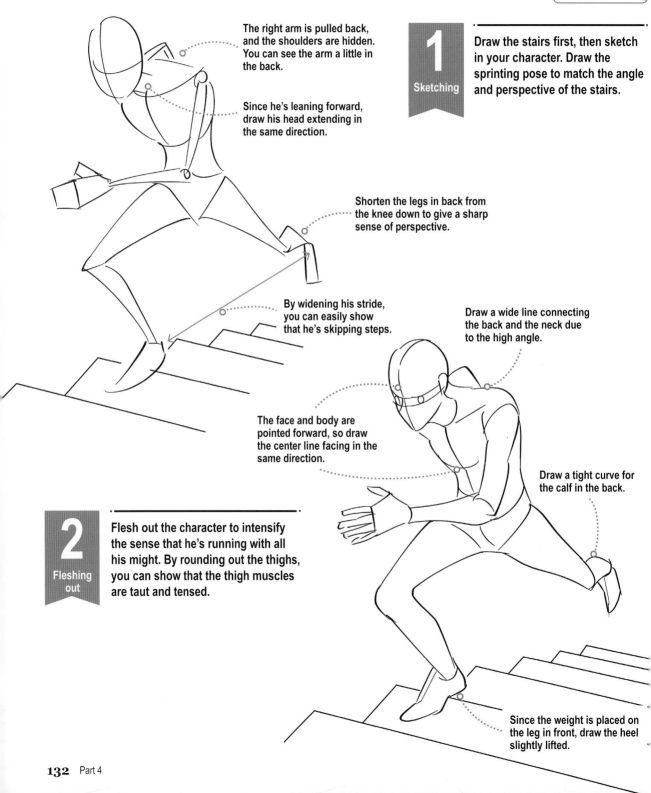

The right arm is pulled back, and the shoulders are hidden. You can see the arm a little in the back.

Since he's leaning forward, draw his head extending in the same direction.

1
Sketching

Draw the stairs first, then sketch in your character. Draw the sprinting pose to match the angle and perspective of the stairs.

Shorten the legs in back from the knee down to give a sharp sense of perspective.

By widening his stride, you can easily show that he's skipping steps.

Draw a wide line connecting the back and the neck due to the high angle.

The face and body are pointed forward, so draw the center line facing in the same direction.

Draw a tight curve for the calf in the back.

2
Fleshing out

Flesh out the character to intensify the sense that he's running with all his might. By rounding out the thighs, you can show that the thigh muscles are taut and tensed.

Since the weight is placed on the leg in front, draw the heel slightly lifted.

3

Rough draft

Let his hair and shirt flutter backward to further suggest he's sprinting upstairs.

The hair that's being blown by the wind should be flowing backward.

Draw the eyebrows close to the eyes to capture the sense he's looking straight up the stairs.

Draw the back flap of the shirt also flowing backward.

A CLOSER LOOK

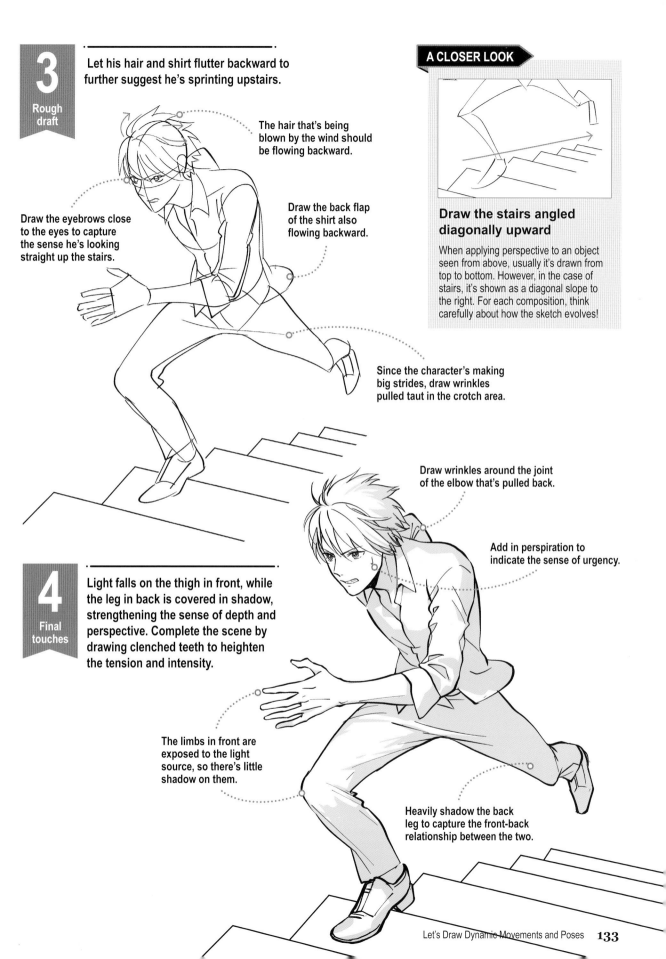

Draw the stairs angled diagonally upward

When applying perspective to an object seen from above, usually it's drawn from top to bottom. However, in the case of stairs, it's shown as a diagonal slope to the right. For each composition, think carefully about how the sketch evolves!

Since the character's making big strides, draw wrinkles pulled taut in the crotch area.

Draw wrinkles around the joint of the elbow that's pulled back.

Add in perspiration to indicate the sense of urgency.

4

Final touches

Light falls on the thigh in front, while the leg in back is covered in shadow, strengthening the sense of depth and perspective. Complete the scene by drawing clenched teeth to heighten the tension and intensity.

The limbs in front are exposed to the light source, so there's little shadow on them.

Heavily shadow the back leg to capture the front-back relationship between the two.

Let's Draw Dynamic Movements and Poses **133**

Pose

44

Low angle
Straight angle

Going Downstairs

At some point, your character will need to go downstairs. Although expressing the sense of speed and motion is essential, keep the pose graceful.

Light

Raise the shoulders to show her carefully going down the stairs.

Draw a diamond to indicate the general shape of the fists.

By drawing the arms bending up at different angles, you can better express the body's movement.

1 Sketching

First sketch the stairs, then the figure. Be aware that the bottom half of the body appears longer than the upper half because of the low angle.

By holding her hands with the palm side facing forward, this will give her a girly gesture.

Make the leg in the back shorter.

For the leg that's landing on the steps, add a slight bend to make it look more natural.

Balance the upper body so it doesn't look like she's falling forward. Draw the chest stretched out straight.

Since she's looking down in the direction she's moving, cast her line of sight downward.

2 Fleshing out

Draw in the eyes while thinking about the direction she's looking. Add curves to the delicate body shape.

Draw a line for the kneecap to show the bending of the knee.

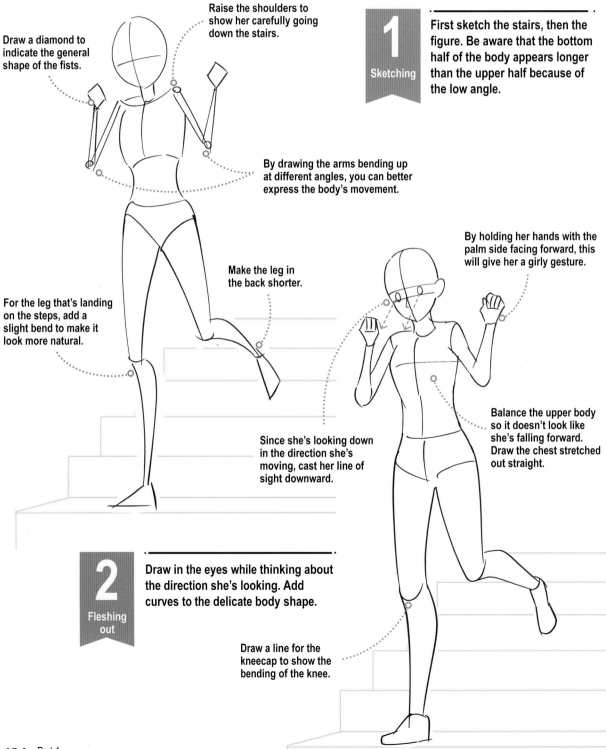

Draw the hair fluttering backward.

Make her look like she's in a rush by drawing her mouth open wide and angle the eyebrows.

3

Rough draft

The key point of this step is to draw her hair and skirt fluttering backward to express the direction she's traveling in. Let's make her look like she's in a rush.

Draw the hemline according to the direction of the body's movement.

Add a shadow to the palms since it's being covered by the fingers.

Because the light is shining from the front, the hem of the skirt and the leg in the back are shaded.

Wrinkles bunch up in waist area, so add them in.

Think about the position of the heel and sketch in the general shape of the shoe.

4

Final touches

Refine the folds in the skirt and wrinkles on the shirt. By shading the leg in the back, you can capture the front-back relationship between the legs.

You can add dimension to the leg in front by drawing a line and a shadow along the kneecap.

Pose
45
Low angle
Diagonal view

Two People Looking at Each Other

For this composition, two young woman are conversing. What are they talking about and what's going on? With this exchange of ideas, keep the low angle in mind.

The figure on the left is holding her hands to her chest. Draw the position of her elbows at the same height.

The shoulders in the back are almost invisible because they're facing each other at a diagonal view.

1 Sketching

Keeping the two characters in the same perspective, draw a horizontal line to align the legs.

Have the left hand of this figure rest on her hips.

While being aware of the difference in height between the two, draw the eyes so that the lines of sight intersect.

If you round her shoulders, you can capture her timid expression.

Lengthen the calves to match the low angle. The point is to keep both characters' knees at the same level.

Due to the delicate body shape, the chest should be small and compact.

Express the bulge of the chest and the curved hip.

2 Fleshing out

Capture the difference between the two girl by drawing the one on the right with a fuller body than the one on the left. Consider the angle of the character's face and make sure their eyes are meeting.

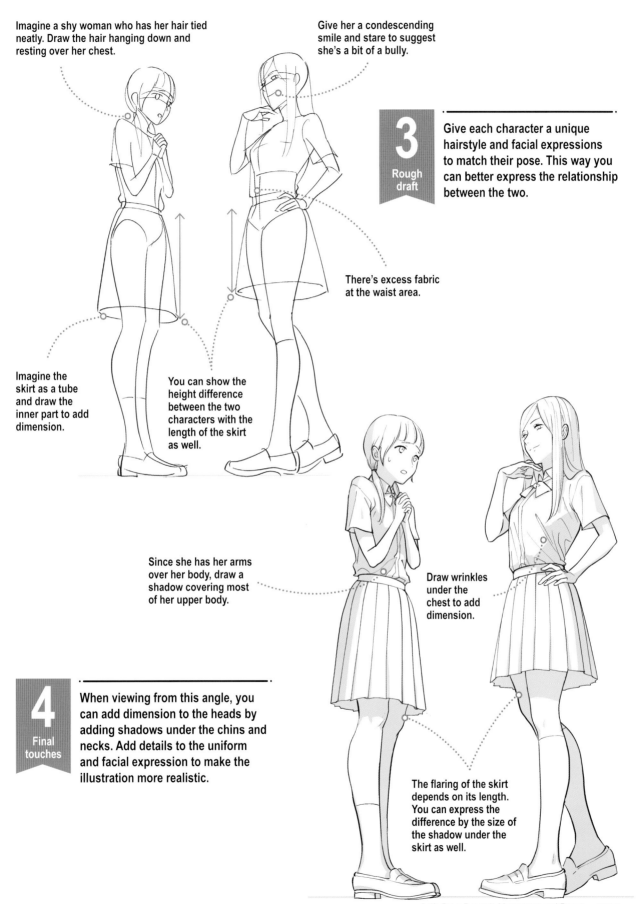

Imagine a shy woman who has her hair tied neatly. Draw the hair hanging down and resting over her chest.

Give her a condescending smile and stare to suggest she's a bit of a bully.

3
Rough draft

Give each character a unique hairstyle and facial expressions to match their pose. This way you can better express the relationship between the two.

There's excess fabric at the waist area.

Imagine the skirt as a tube and draw the inner part to add dimension.

You can show the height difference between the two characters with the length of the skirt as well.

Since she has her arms over her body, draw a shadow covering most of her upper body.

Draw wrinkles under the chest to add dimension.

4
Final touches

When viewing from this angle, you can add dimension to the heads by adding shadows under the chins and necks. Add details to the uniform and facial expression to make the illustration more realistic.

The flaring of the skirt depends on its length. You can express the difference by the size of the shadow under the skirt as well.

PART 4

Pose

46

High angle
Diagonal view

Reaching Out + Looking Back

A young man calls out to his friend, who looks back in response. For these poses, think about the context and draw this composition from a high angle.

Direction of light

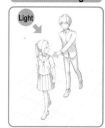

Light

1 Sketching

Based on the line of perspective, position each character, making sure that they're in arms reach of each other.

Draw the upper body leaning forward.

His left arm is reaching toward her left shoulder. Keep in mind that he's not able to reach her shoulder from this position.

Since the right leg is stepping forward, let's draw it longer than the other leg to give a sense of perspective.

Draw his shoulders wider than hers to show difference between the two.

Even if she's turning her head around, her face isn't completely turned back. Draw the profile of her face and the back of her head.

By turning to the left, the left shoulder is lightly pulled back and the upper body twists a little.

Spread the fingers out a little to show him trying to grab her shoulder.

Position the eye and the nose at the perfect profile view.

2 Fleshing out

Keep in mind the difference between their two bodies, especially in the waistlines and chests. Draw their eyes and make sure their gazes meet.

Add a curved or cinched waist.

3

Rough draft

Express the difference in their body shapes at this step. His uniform is fit to his body, while there's looseness in her sleeve and neck area.

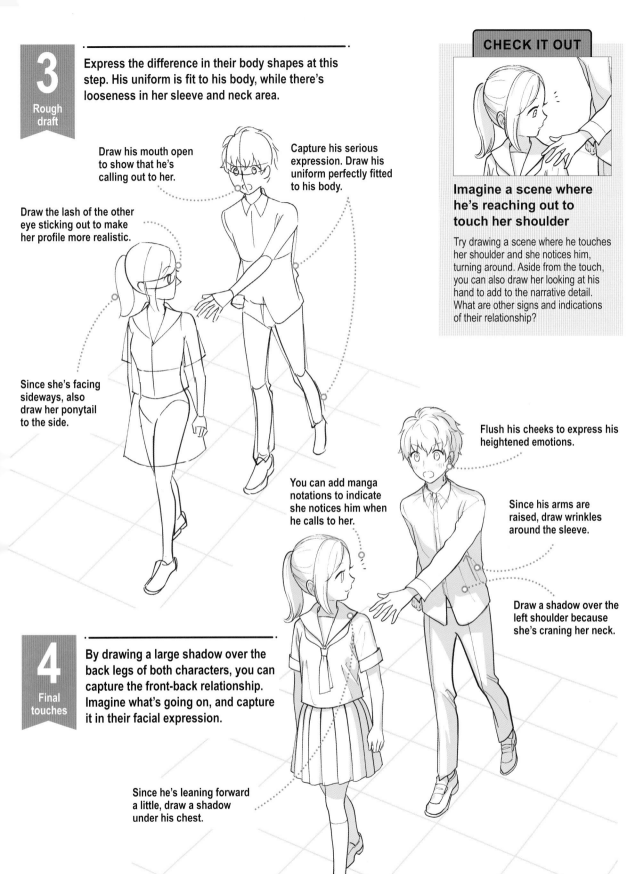

Draw his mouth open to show that he's calling out to her.

Capture his serious expression. Draw his uniform perfectly fitted to his body.

Imagine a scene where he's reaching out to touch her shoulder

Try drawing a scene where he touches her shoulder and she notices him, turning around. Aside from the touch, you can also draw her looking at his hand to add to the narrative detail. What are other signs and indications of their relationship?

Draw the lash of the other eye sticking out to make her profile more realistic.

Since she's facing sideways, also draw her ponytail to the side.

Flush his cheeks to express his heightened emotions.

Since his arms are raised, draw wrinkles around the sleeve.

You can add manga notations to indicate she notices him when he calls to her.

Draw a shadow over the left shoulder because she's craning her neck.

4

Final touches

By drawing a large shadow over the back legs of both characters, you can capture the front-back relationship. Imagine what's going on, and capture it in their facial expression.

Since he's leaning forward a little, draw a shadow under his chest.

Pose
47
Slighty high angle
Diagonal view

Crawling on All Fours

Here a young woman is crawling on the ground as if she's looking for something. Since she's raising her head, the back curves to connect the upper body and the hips.

Light

1 Sketching

When sketching, take the distance between the hands and feet into consideration. Draw carefully so that the upper and lower body connects naturally.

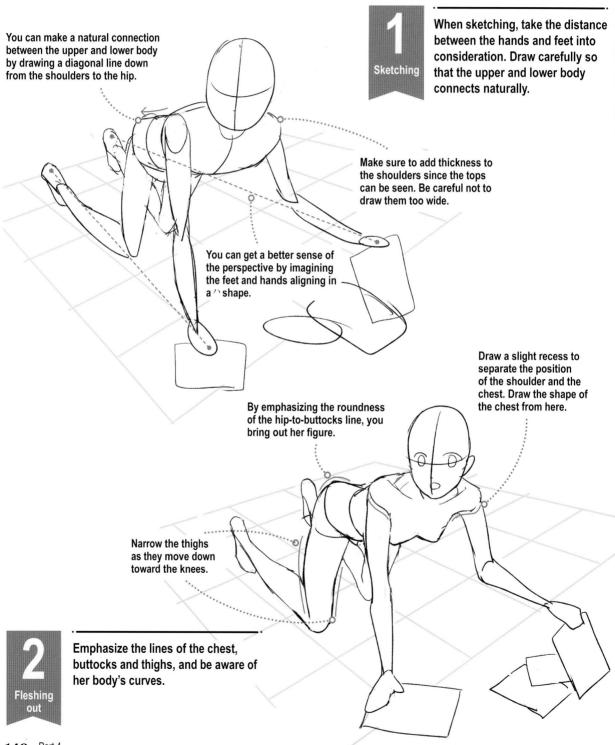

You can make a natural connection between the upper and lower body by drawing a diagonal line down from the shoulders to the hip.

Make sure to add thickness to the shoulders since the tops can be seen. Be careful not to draw them too wide.

You can get a better sense of the perspective by imagining the feet and hands aligning in a ∧∧ shape.

Draw a slight recess to separate the position of the shoulder and the chest. Draw the shape of the chest from here.

By emphasizing the roundness of the hip-to-buttocks line, you bring out her figure.

Narrow the thighs as they move down toward the knees.

2 Fleshing out

Emphasize the lines of the chest, buttocks and thighs, and be aware of her body's curves.

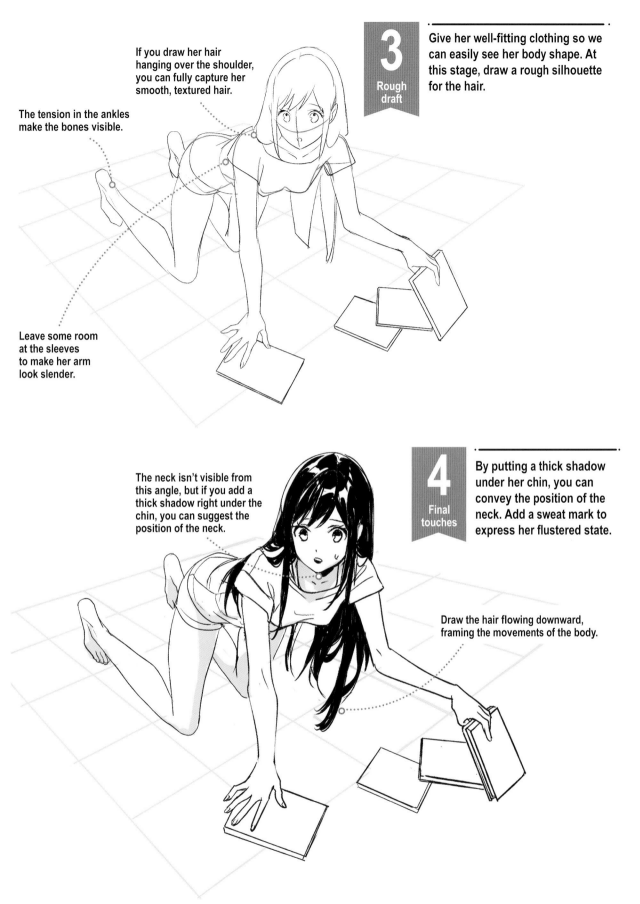

If you draw her hair hanging over the shoulder, you can fully capture her smooth, textured hair.

The tension in the ankles make the bones visible.

Leave some room at the sleeves to make her arm look slender.

3 **Rough draft**

Give her well-fitting clothing so we can easily see her body shape. At this stage, draw a rough silhouette for the hair.

The neck isn't visible from this angle, but if you add a thick shadow right under the chin, you can suggest the position of the neck.

4 **Final touches**

By putting a thick shadow under her chin, you can convey the position of the neck. Add a sweat mark to express her flustered state.

Draw the hair flowing downward, framing the movements of the body.

Pose

48

Low angle
Diagonal view

Walking While Listening to Music

Here a young woma is walking while listening to music through her earphones. Consider the length of the lower body when it's viewed from low angle.

Direction of light

Light

Since you can't see the right shoulder, draw the upper body while paying attention to the curve of the chest.

1

Sketching

Align the shoulders, waist and hips in a diagonal line for the upper body. The leg in the back is positioned a little lower than the one in front.

Draw the waistline parallel to the shoulder line.

You can add dimension to the composition by drawing both shoulders popping upward. This makes it easier to tell that we're viewing the character from a low angle.

Draw a rough sketch for the hand over the hips.

Draw the leg under the right knee short, then draw the back toe to be at the same height as the front heel.

Since it will affect the movement of the clothes, flesh out the muscles of the thigh.

Don't forget to draw the bulge at the knees. Note that the angles are not straight from the base of the thighs.

2

Fleshing out

Keep in mind the curves of the shoulders when viewed from a low angle. Also flesh out the soles of the feet.

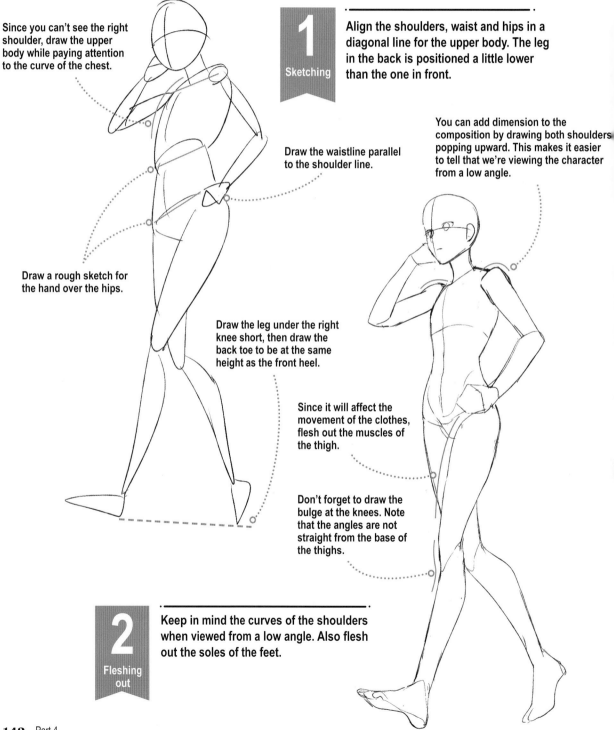

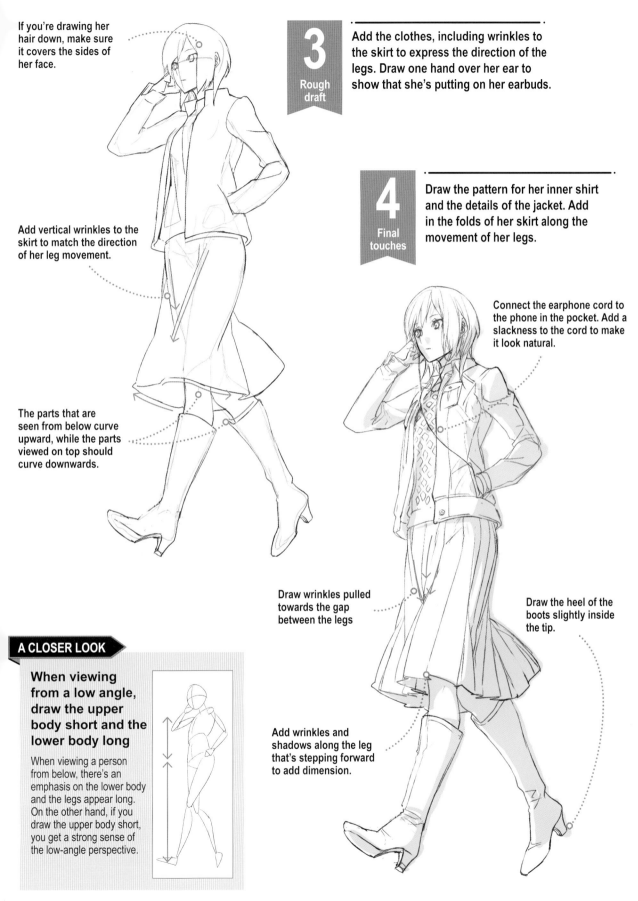

If you're drawing her hair down, make sure it covers the sides of her face.

3 Rough draft

Add the clothes, including wrinkles to the skirt to express the direction of the legs. Draw one hand over her ear to show that she's putting on her earbuds.

Add vertical wrinkles to the skirt to match the direction of her leg movement.

4 Final touches

Draw the pattern for her inner shirt and the details of the jacket. Add in the folds of her skirt along the movement of her legs.

Connect the earphone cord to the phone in the pocket. Add a slackness to the cord to make it look natural.

The parts that are seen from below curve upward, while the parts viewed on top should curve downwards.

Draw wrinkles pulled towards the gap between the legs

Draw the heel of the boots slightly inside the tip.

A CLOSER LOOK

When viewing from a low angle, draw the upper body short and the lower body long

When viewing a person from below, there's an emphasis on the lower body and the legs appear long. On the other hand, if you draw the upper body short, you get a strong sense of the low-angle perspective.

Add wrinkles and shadows along the leg that's stepping forward to add dimension.

Pose

49

Eye level

Straight view

Jumping for Joy

For this pose, a young cheerleader jumping with her arms and pompoms extended. Think about the angle of her arms and legs, adding movement to her hair and clothes.

Direction of light

Light

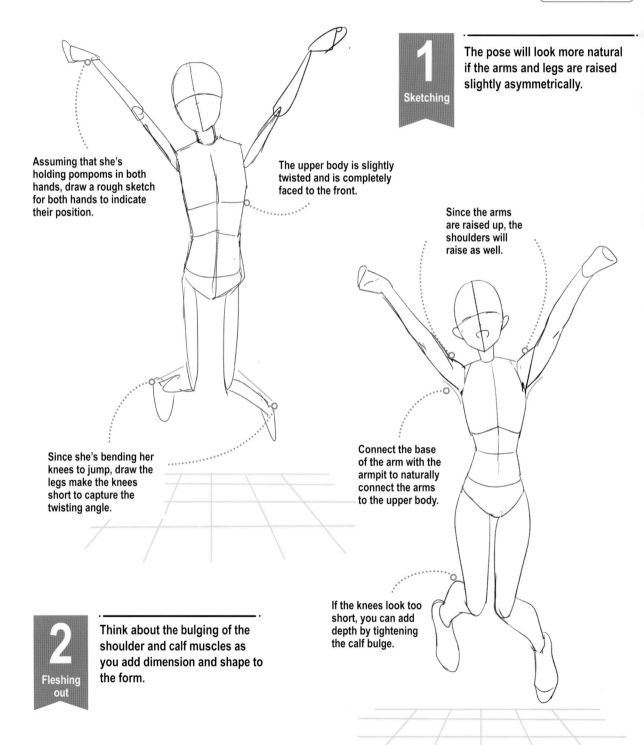

Assuming that she's holding pompoms in both hands, draw a rough sketch for both hands to indicate their position.

The upper body is slightly twisted and is completely faced to the front.

1 Sketching

The pose will look more natural if the arms and legs are raised slightly asymmetrically.

Since the arms are raised up, the shoulders will raise as well.

Since she's bending her knees to jump, draw the legs make the knees short to capture the twisting angle.

Connect the base of the arm with the armpit to naturally connect the arms to the upper body.

2 Fleshing out

Think about the bulging of the shoulder and calf muscles as you add dimension and shape to the form.

If the knees look too short, you can add depth by tightening the calf bulge.

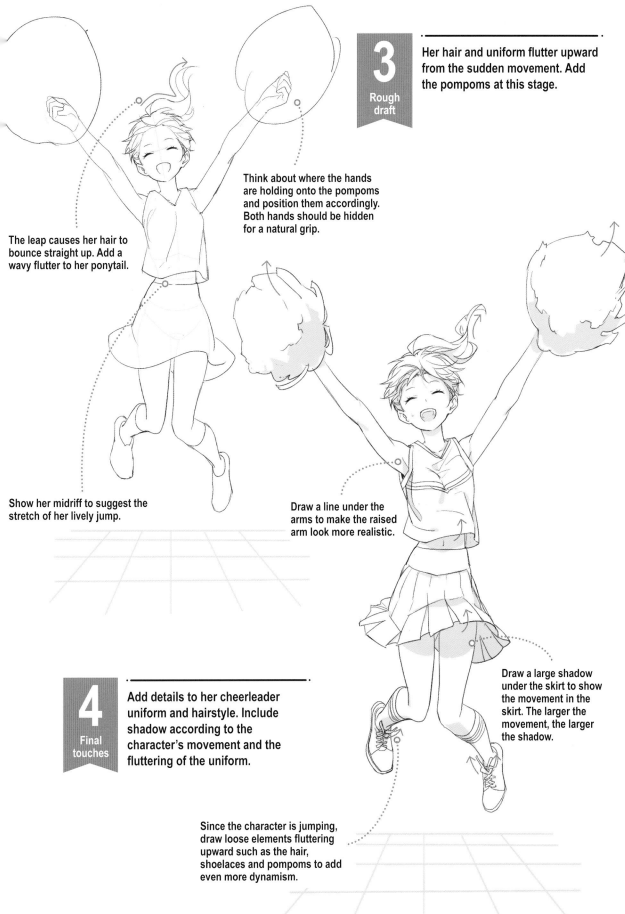

3

Rough draft

Her hair and uniform flutter upward from the sudden movement. Add the pompoms at this stage.

Think about where the hands are holding onto the pompoms and position them accordingly. Both hands should be hidden for a natural grip.

The leap causes her hair to bounce straight up. Add a wavy flutter to her ponytail.

Show her midriff to suggest the stretch of her lively jump.

Draw a line under the arms to make the raised arm look more realistic.

4

Final touches

Add details to her cheerleader uniform and hairstyle. Include shadow according to the character's movement and the fluttering of the uniform.

Draw a large shadow under the skirt to show the movement in the skirt. The larger the movement, the larger the shadow.

Since the character is jumping, draw loose elements fluttering upward such as the hair, shoelaces and pompoms to add even more dynamism.

Pose

50

High angle
Diagonal view

Lying Down with One Hand Up

Here the character's lying on her back, looking at something through her hand. Think about the how the high-angled perspective affects the view of the body from head to toe.

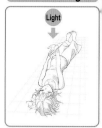

Light

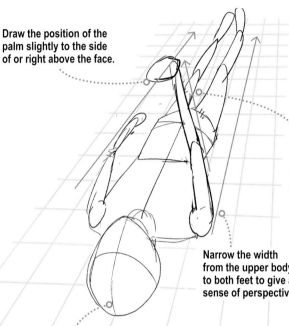

Draw the position of the palm slightly to the side of or right above the face.

1 Sketching

Sketch the head in front and the feet in back. When sketching the full body, it gets narrower as the parts are farther away.

Draw the perspective of the whole body, then the arms sticking upward. This is the key point of the composition.

Narrow the width from the upper body to both feet to give a sense of perspective.

Draw curves and bulges for the muscles of the thigh to the knee, then the knee to the ankle.

Since the top of the head is in front, make the upper part of the head wide.

The wrist isn't visible, so draw the entire palm.

2 Fleshing out

Emphasize the curves of the body to make the difference between the upper and lower body more visible. At this stage, roughly determine the orientation of the palm.

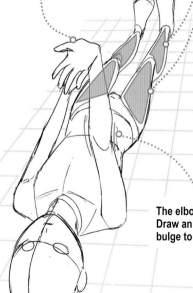

The elbow sticks out a little. Draw an indentation and a bulge to suggest this.

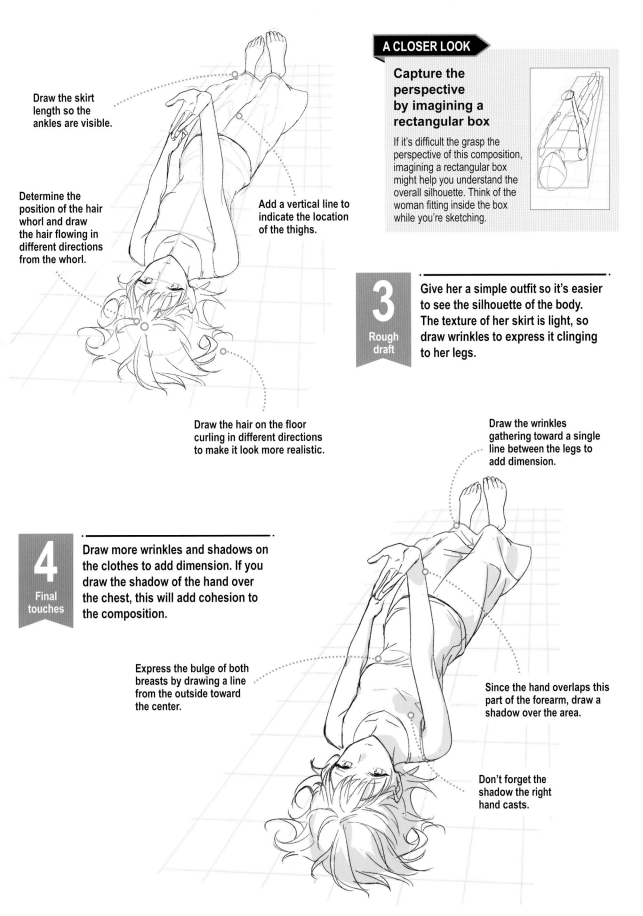

Draw the skirt length so the ankles are visible.

Determine the position of the hair whorl and draw the hair flowing in different directions from the whorl.

Add a vertical line to indicate the location of the thighs.

Draw the hair on the floor curling in different directions to make it look more realistic.

A CLOSER LOOK

Capture the perspective by imagining a rectangular box

If it's difficult the grasp the perspective of this composition, imagining a rectangular box might help you understand the overall silhouette. Think of the woman fitting inside the box while you're sketching.

3

Rough draft

Give her a simple outfit so it's easier to see the silhouette of the body. The texture of her skirt is light, so draw wrinkles to express it clinging to her legs.

Draw the wrinkles gathering toward a single line between the legs to add dimension.

4

Final touches

Draw more wrinkles and shadows on the clothes to add dimension. If you draw the shadow of the hand over the chest, this will add cohesion to the composition.

Express the bulge of both breasts by drawing a line from the outside toward the center.

Since the hand overlaps this part of the forearm, draw a shadow over the area.

Don't forget the shadow the right hand casts.

How to Draw Gestures with Accessories

By giving your characters specific gestures, you can bring out their unique and distinguishable qualities. Are they cute, cool, complex or a beguiling blend? While including accessories to match with the scene, you can add even more to the character's mark of originality.

Matching pose and accessories.

We'll be looking at gestures and expressions for a range of teenaged girls and adults. Express their quirky gestures while paying attention to the characters' age range.

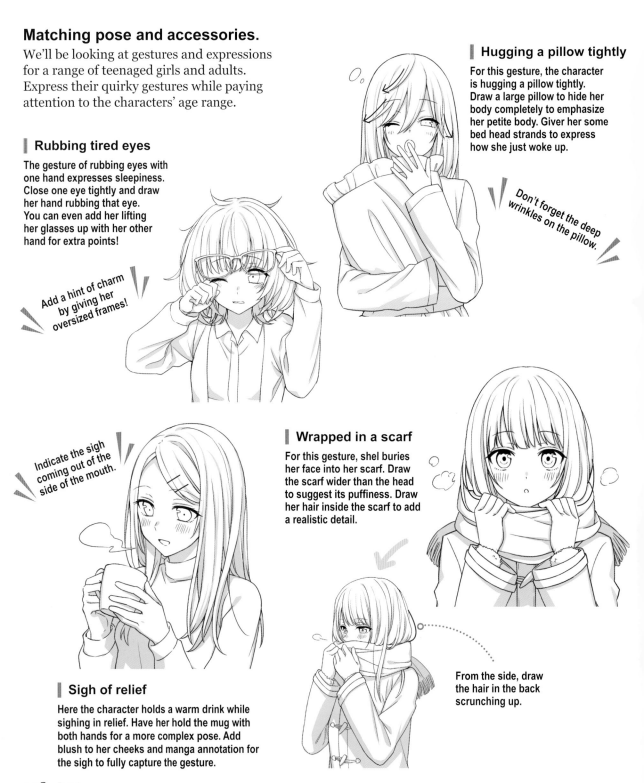

Rubbing tired eyes

The gesture of rubbing eyes with one hand expresses sleepiness. Close one eye tightly and draw her hand rubbing that eye. You can even add her lifting her glasses up with her other hand for extra points!

Add a hint of charm by giving her oversized frames!

Hugging a pillow tightly

For this gesture, the character is hugging a pillow tightly. Draw a large pillow to hide her body completely to emphasize her petite body. Giver her some bed head strands to express how she just woke up.

Don't forget the deep wrinkles on the pillow.

Indicate the sigh coming out of the side of the mouth.

Wrapped in a scarf

For this gesture, shel buries her face into her scarf. Draw the scarf wider than the head to suggest its puffiness. Draw her hair inside the scarf to add a realistic detail.

From the side, draw the hair in the back scrunching up.

Sigh of relief

Here the character holds a warm drink while sighing in relief. Have her hold the mug with both hands for a more complex pose. Add blush to her cheeks and manga annotation for the sigh to fully capture the gesture.

Since she's holding the pen upright, you can see the fingers of her right hand and the bottom of the pen.

Fixing makeup

In this pose, the character's applying lipstick while using a compact's mirror. Draw the mouth small and purse the lips a little. Draw her holding the lipstick delicately by spreading the index finger out, and make the back of the hand visible.

Her gaze is pointed toward the compact!

Taking notes intensely

For this gesture the character's intensely taking notes. Draw the arms tight against the body to express the stiffness of the pose. Add to her intense concentration by giving her sharply drawn eyebrows.

Draw her eyebrows pointing downward to show she's stuffing her face.

Arch the joint to make the stretching look more natural.

Stretching

For this gesture, the character is raising her arms to stretch. The body is extended upward, so puff her chest up and out. Give her a relaxed, contented facial expression.

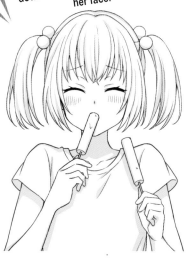

Eating ice cream

For this gesture, draw the character's eyes shut tightly to capture her joyfulness. If you draw her enjoying ice cream on both hands, you can further add to her sense of enjoyment.

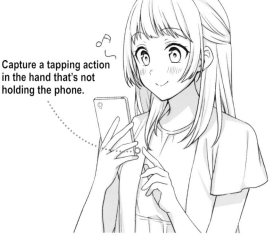

Capture a tapping action in the hand that's not holding the phone.

Holding a hat down

The character's holding her hat down as it's about to be blown away. Draw her hair fluttering and a curve in the hat to capture the wind. For an extra touch, draw one eye closed, as the wind is blowing into her face.

Smiling at one's phone

Here the character's eagerly awaiting an answer to a text. Draw her eyes wide while her smiling mouth is closed. This way you can express her amused anticipation.

When you draw the hat's rim curving and bending, you can suggest the wind's movement.

A gallery of gestures

While paying attention to the physique, practice this range of gestures. Men sometimes have simpler accessories, but not always.

Untying a necktie

The character is untying his necktie with one hand while using his index finger to pull it down. If he's untying with his left hand, draw the tie being pulled to the left and vice versa for the right hand.

Add a slight bulge to the muscles to capture the motion.

ZOOM

Checking the time

For this gesture, put the right hand over the left forearm to show that the sleeves are being pulled back. The ruggedness of the hands will increase the appeal.

Face the dial of the watch toward the character's line of sight.

Wiping sweat

For this gesture, the character is wiping dripping sweat out of his face. Use the right hand to have him dab his chin. Align the sweat drops with the position of the hand that's wiping the sweat.

Draw lines under his eyes to suggest his heightened mood.

When removing with the right hand, draw the glasses moving to the left, and vice versa when using the other hand.

Draw vertical lines on the lens to show the reflecting sunlight.

Pulling sunglasses upward

Here the character is pulling his sunglasses up to rest on his forehead. Draw the bows of the glasses emerging from behind the ears.

Removing glasses

Now the character is removing his glasses with one hand. For a natural pose when taking glasses off with one hand, draw them moving in the opposite direction of the hand.

Pairing gestures

Express the relationship between two figures and the gestures that add clarity and specificity to the scene. Pay attention to the differences between the characters' bodies and physiques.

Add to the moment by having her gaze at the ring being placed on her finger.

Putting a ring on her finger

For this gesture, the man is supporting the woman's hand while putting a ring on her finger. Since the fingertips of the two characters is the focal point, pay close attention to conveying the difference in finger size between the two.

Since the back of the hand is hidden, just show the fingertips.

Pat on the head

Here the young woman is receiving a pat on the head. Draw his hand connecting with her head to show that he's giving her a gentle pat. Add diagonal lines across the her face to show that she's blushing.

Poking cheeks

Now the woman is getting her cheek poked from behind. As she's looking backward, draw a line to express the cheek being touched. You can draw this gesture in two scenes, the moment he calls out to her and then the moment she turns around and gets her cheek poked.

Give his finger a little bit of a bend to make it look more natural.

Pose

51

Low angle
Diagonal view

Falling Forward

Look out! Your character's on the verge of falling over! For this action pose, consider how the upper body and the back side, as well as the legs, are positioned.

Direction of light

Light

The face should be tilted upward as the chin points up also.

Capture the curve of the back and buttocks while distinguishing each.

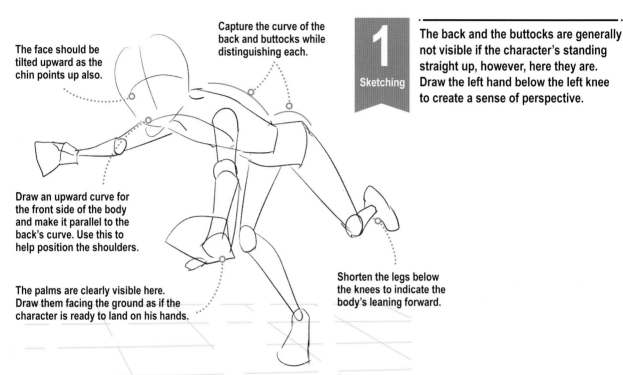

1
Sketching

The back and the buttocks are generally not visible if the character's standing straight up, however, here they are. Draw the left hand below the left knee to create a sense of perspective.

Draw an upward curve for the front side of the body and make it parallel to the back's curve. Use this to help position the shoulders.

The palms are clearly visible here. Draw them facing the ground as if the character is ready to land on his hands.

Shorten the legs below the knees to indicate the body's leaning forward.

2
Fleshing out

The right foot supports the entire body weight, so add emphasis to the calf muscle. Think about his facial expression as he tumbles forward.

Since the face is leaning forward over the body, make the facial features, such as the eyes and mouth, larger.

Add the collarbone lines toward the center of the body.

Since the hands are fully open, draw the fingers fanning out.

Since the entire body weight is placed on the right foot, add a significant bulge to the calves.

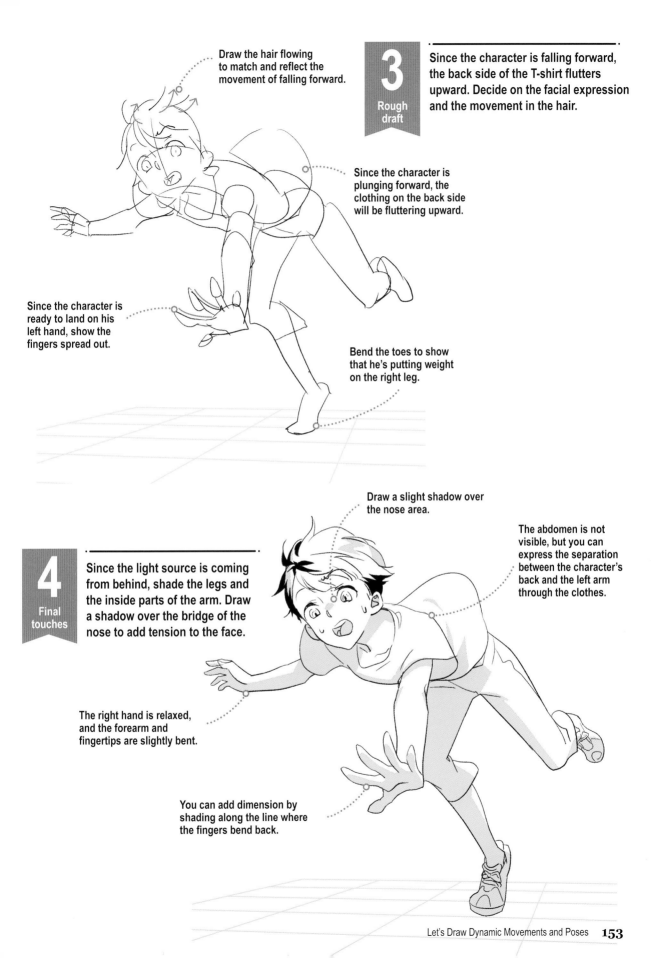

Draw the hair flowing to match and reflect the movement of falling forward.

3 Rough draft

Since the character is falling forward, the back side of the T-shirt flutters upward. Decide on the facial expression and the movement in the hair.

Since the character is plunging forward, the clothing on the back side will be fluttering upward.

Since the character is ready to land on his left hand, show the fingers spread out.

Bend the toes to show that he's putting weight on the right leg.

Draw a slight shadow over the nose area.

The abdomen is not visible, but you can express the separation between the character's back and the left arm through the clothes.

4 Final touches

Since the light source is coming from behind, shade the legs and the inside parts of the arm. Draw a shadow over the bridge of the nose to add tension to the face.

The right hand is relaxed, and the forearm and fingertips are slightly bent.

You can add dimension by shading along the line where the fingers bend back.

Pose

52

Eye level
Slightly diagonal view

Stretching

Here the character is spreading his legs while stretching or leaning forward. For this pose, think about how to express the depth of the legs and upper body bending forward.

Light

The line of the upper body is greatly curved toward the waist.

Since the character is leaning forward, the back of the head appears wider than usual. Pay attention to the eye's position.

1 Sketching

Sketch the leg spreading in a triangle shape connecting the pelvis and the legs. To balance the upper body with the legs, the head should be aligned with the tip of the triangle.

From this perspective, only the shoulder and hand can be seen.

For the left foot, draw the heel like a cylinder, then sketch the tip of the foot from there.

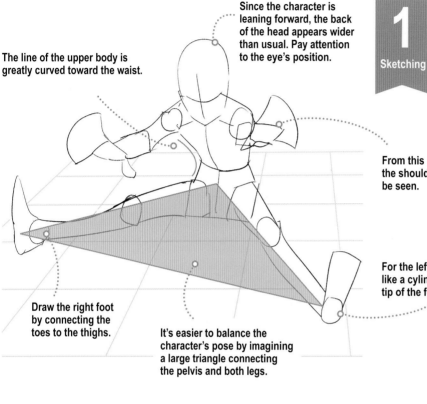

Draw the right foot by connecting the toes to the thighs.

It's easier to balance the character's pose by imagining a large triangle connecting the pelvis and both legs.

When you're stretching forward, your fingers are splayed. Use them to accentuate the sense of reach and to add depth.

Locate his gaze a little above the floor.

2 Fleshing out

The upper body is leaning forward, so the face is angled downward. The fingers are spread apart and the arms are lifted forward..

Using the belly button's position as a guide, add a horizontal wrinkle to the abdomen to underscore the lean.

Don't forget the flat crotch line as the character is sitting on the floor.

3

Rough draft

Give the character a loose shirt and shorts to draw attention to the lithe figure's flexibility.

Draw a line for the shirt and some horizontal wrinkles along the belly. area.

While bending forward, the character's whorls are visible. Use them as a reference point for the hair's direction.

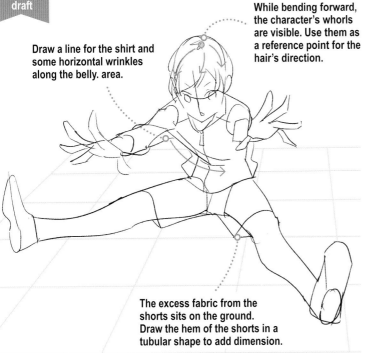

The excess fabric from the shorts sits on the ground. Draw the hem of the shorts in a tubular shape to add dimension.

CHECK IT OUT

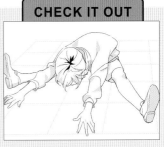

Try posing the character completely stretched out on the floor

You can further challenge yourself by drawing the character completely stretched out on the floor. In this case, you can see the back of the head and the hair whorl. Rounding the back and hips, you can express the thickness of the upper body. Draw the arms pulled slightly more forward than the feet.

4

Final touches

The abdomen is not exposed to light, so add in a large shadow. Since the character's leaning forward, you can even draw in shadows around the thighs.

The zipper should dangle slightly.

By drawing excess fabric on the sleeves, you can get a sense of perspective from the shoulders.

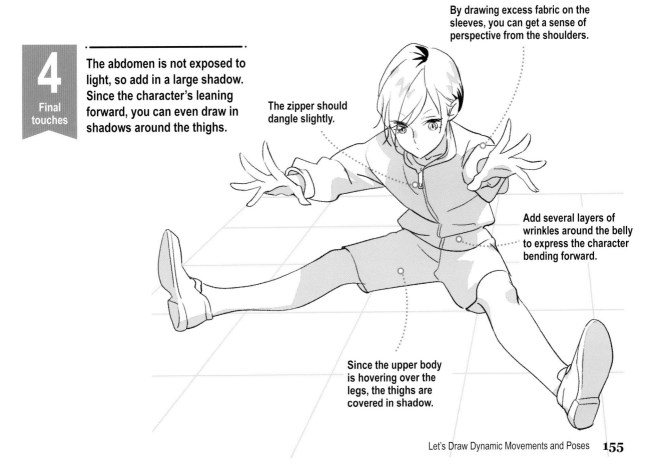

Add several layers of wrinkles around the belly to express the character bending forward.

Since the upper body is hovering over the legs, the thighs are covered in shadow.

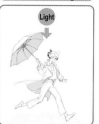

Light

Pose

53

Eye level

Side view

Holding an Umbrella

A woman leaps forward while holding an umbrella. There's a dual lesson here, mastering an umbrella grip as well as showing a character jumping forward.

1

Sketching

Since the chest is sticking out, bend the back at the waistline. Bend the knees lightly for a natural jumping posture.

Note that if you draw the armpit connecting with the shoulder, it'll look unnatural.

Since you can see the inside of the umbrella, draw it in a trapezoid along the curve of the frame.

Since the forearm is in the foreground, draw it a little thicker than the upper arm.

The fingers on the right hand are mostly hidden by the back of the hand.

By bending the upper body, it gives the impression of a light leap.

2

Fleshing out

Pay attention to the shoulders sticking out, the curved lines of the chest. At this stage, it's a good idea to determine her line of sight.

The chest and hips are connected in a gentle S shape, emphasizing the curve of the back.

Draw a bend at the knees and the bulge at the calf for a natural stepping pose.

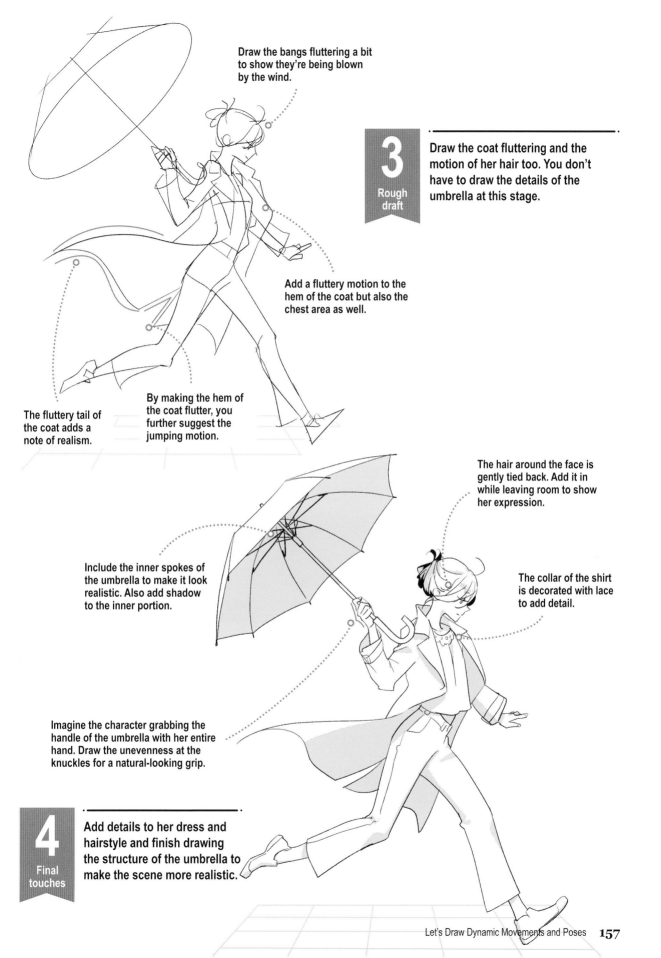

Draw the bangs fluttering a bit to show they're being blown by the wind.

3 Rough draft

Draw the coat fluttering and the motion of her hair too. You don't have to draw the details of the umbrella at this stage.

Add a fluttery motion to the hem of the coat but also the chest area as well.

By making the hem of the coat flutter, you further suggest the jumping motion.

The fluttery tail of the coat adds a note of realism.

The hair around the face is gently tied back. Add it in while leaving room to show her expression.

Include the inner spokes of the umbrella to make it look realistic. Also add shadow to the inner portion.

The collar of the shirt is decorated with lace to add detail.

Imagine the character grabbing the handle of the umbrella with her entire hand. Draw the unevenness at the knuckles for a natural-looking grip.

4 Final touches

Add details to her dress and hairstyle and finish drawing the structure of the umbrella to make the scene more realistic.

Pose
54
Slightly high angle
Straight view

Two People Running
Hand in Hand

A determined young woman is on the run, pulling a friend along with her. For this interaction, think about the specific body parts that are being tugged and yanked forward.

Direction of light

Light

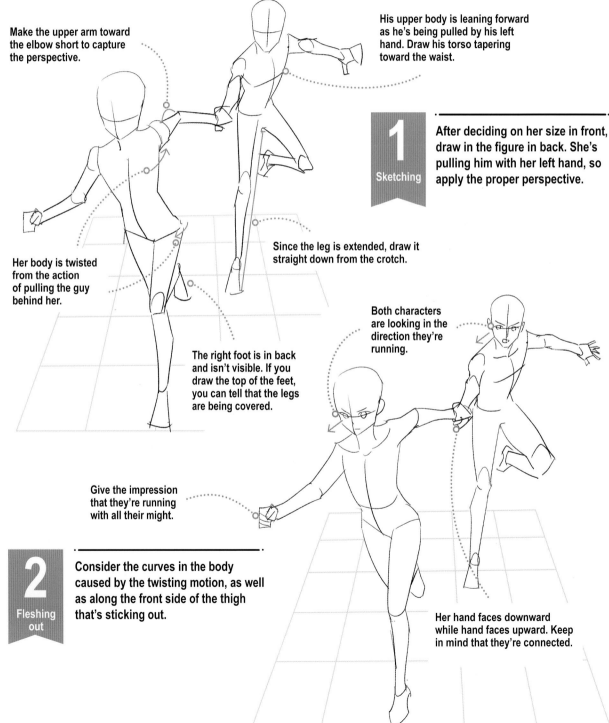

Make the upper arm toward the elbow short to capture the perspective.

His upper body is leaning forward as he's being pulled by his left hand. Draw his torso tapering toward the waist.

1
Sketching

After deciding on her size in front, draw in the figure in back. She's pulling him with her left hand, so apply the proper perspective.

Since the leg is extended, draw it straight down from the crotch.

Her body is twisted from the action of pulling the guy behind her.

The right foot is in back and isn't visible. If you draw the top of the feet, you can tell that the legs are being covered.

Both characters are looking in the direction they're running.

Give the impression that they're running with all their might.

2
Fleshing out

Consider the curves in the body caused by the twisting motion, as well as along the front side of the thigh that's sticking out.

Her hand faces downward while hand faces upward. Keep in mind that they're connected.

3

Rough draft

The hair moves in the direction of the wind. Give them light clothing to emphasize the motion, energy and dynamism of the scene.

A CLOSER LOOK

Direction of motion

Line of sight

Extended arm

Extended leg

The main point is to suggest speed

All the elements such as the front-back relationship between the two people, the line of sight, the direction of the arms and the movement of the legs are directed forward. This is the secret to creating a sense of speed. You can add more energy by expressing it in the movement of the hair and clothes.

When the wind is blowing form the front, the hair flows backward. Draw the movement of the tips while thinking about the direction of the wind.

Draw the movement in the clothing to match the body movements.

Since the arm is pulled far back, draw a large gap in the clothing.

For short hair, there's movement not only in the tips, but along the hairline as well.

One of the ways to express wrinkles on the sleeves is to put a thin shadow on them.

4

Final touches

A piercing gaze conveys the tension and intensity. Draw in shadows for parts such as the knees, the back of the legs and the neck.

Add shadow to the back of the legs to heighten the sense of perspective.

Since the thighs are sticking out in front of the body, add shadows under the knees.

Let's Draw Dynamic Movements and Poses **159**

Two People Taking a Selfie

Two women are taking a selfie from a high angle. Determine the positional relationship between the phone and the two figures to strike the right balance.

Direction of light

Light

Sketch the hand holding the phone in the palm while supporting it with the fingers.

1
Sketching

Move the arm holding the phone away from the face to create a sense of perspective. With the high-angle view, make the lower bodies narrower as you move down.

The figure on the right is holding the phone toward the foreground, so make it larger than the other elements.

Considering what wil fit on the screen of the phone, put the faces and drinks within the camera's frame.

Notice the difference in the angles of the two faces. The crosshairs on the face should be upward on the left and downward on the right.

Since the body is bent, it emphasizes the waistline and roundness of the buttocks.

Draw the girl on the right's right leg behind the girl on the left side to express the front-back relationship.

Draw it turning inward to refine the pose.

Since they're standing straight, the roundness of the waist is fine here.

2
Fleshing out

Pay special attention to the curves at the waist. Draw the eyes and nose while thinking about the angle of the two faces pointed toward the phone.

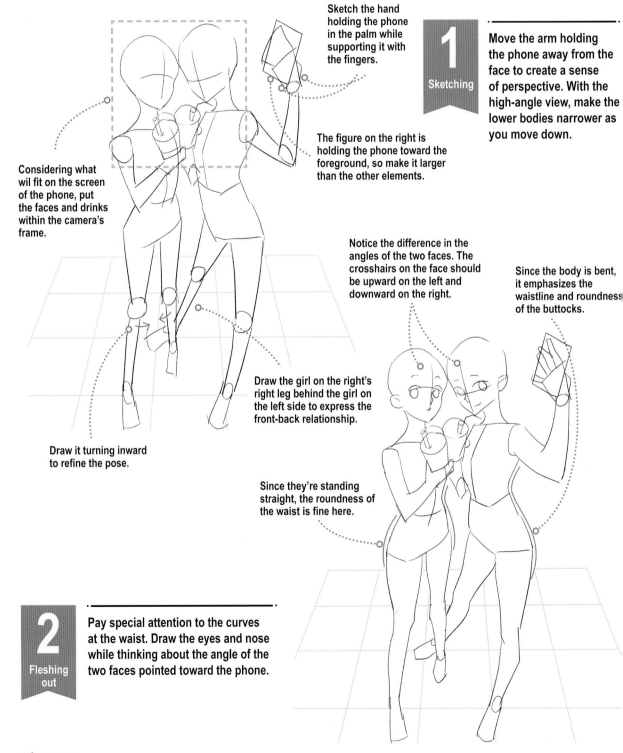

3

Rough draft

Give the characters their own hairstyles and facial expressions, differentiating the closely positioned figures.

When including a bun, draw a large lump of hair on the back of the head, then add in pieces flowing towards it.

When viewing from a high angle, it is recommended to draw the skirt hem and socks curving downward.

Draw the shirt tucked into the skirt. If you draw some folds around the tucked-in area, it'll look more natural.

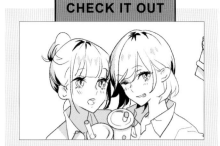

Different poses for selfies

Explore the range of ways you can show the two having fun posing for a selfie. Eyes, mouth and eyebrows are the key parts. Try drawing a wink or an open mouth.

You don't have to draw the thumb because it's pressing the button on the camera phone.

4

Final touches

It's good to add details that are often overlooked such as the content of the drinks. Also give them expressions suitable to taking a selfie.

The bulge of the arm and chest casts a shadow on the abdomen.

Draw folds and creases at the hips.

Pose

56

Eye level

Straight view

Two People Playing Games

Here two young men are playing a game. Capture the exact moment of victory for one and defeat for the other. Try adding variations not only to their facial expressions, but also to their posture and gestures.

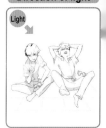

Light

1 Sketching

When the upper body leans forward, the back of the head is more visible. It's not visible when leaning back, but the positions of the two are almost the same.

Although one leans forward and the other leans back, the height of their heads still remains at the same level.

The neck isn't visible when leaning forward.

His neck is exposed because he's leaning back.

The two are sitting in the same position, so the buttocks are parallel.

If you draw a curved line along the chest and back, it bends backward.

The biceps flex because of the pressure placed on the fist. Since the line of the body is compact, you can add in a bulge.

Connect the waist and the upper arm with a gentle curve.

2 Fleshing out

The back and shoulders are rounded when you slouch forward. The arms and back are curved when you bend backward. Pay attention to these details when fleshing out.

The sole of the foot is facing the front, so don't draw the ankle.

If you angle the eyebrows and lift the mouth, you can impart a mischievous look.

To give the impression that he's frustrated from losing the game, draw the eyes shut tightly and the mouth open wide.

3 Rough draft

Add their clothes. These two are dressed the same because they're playing video games after school.

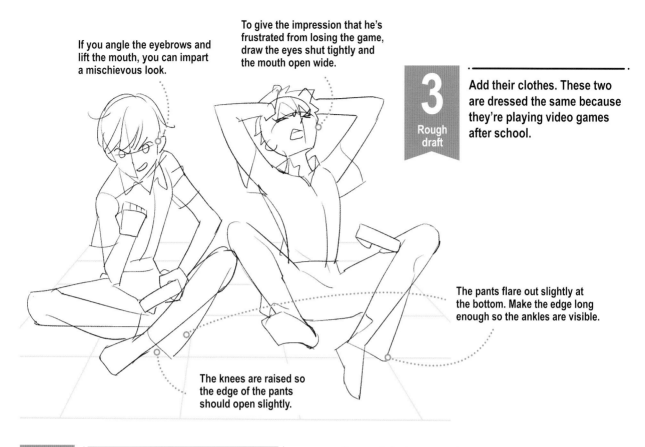

The pants flare out slightly at the bottom. Make the edge long enough so the ankles are visible.

The knees are raised so the edge of the pants should open slightly.

4 Final touches

Draw in shadows according to the angle of each character's upper body. Also use shadows to intensify their emotions and expressions.

If you put shadows around the eyes, you can capture a sense of disappointment.

Draw the opening of the sleeves to add dimension. You can also emphasize the thinness of his arm.

To show the fist, draw a vertical line from the index finger down toward the pinky.

Draw a jagged line on the shirt seams to indicate the bent upper body.

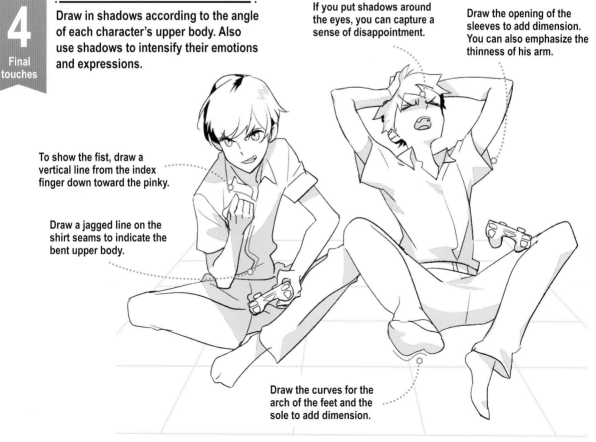

Draw the curves for the arch of the feet and the sole to add dimension.

Direction of light

Light

Pose

57

Eye level

Diagonal view

Sitting on Chair + Tying Hair

Here a younger sister sits while her older sibling is tying her hair up from behind. Pay attention to the balance between the seated figure and the one standing at a diagonal angle.

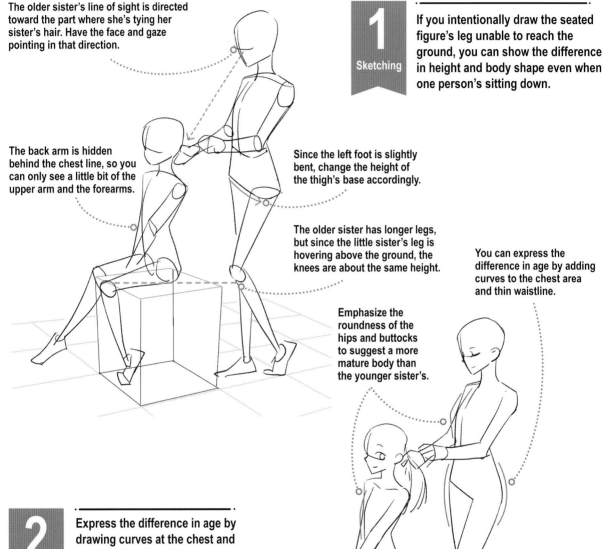

The older sister's line of sight is directed toward the part where she's tying her sister's hair. Have the face and gaze pointing in that direction.

The back arm is hidden behind the chest line, so you can only see a little bit of the upper arm and the forearms.

1 Sketching

If you intentionally draw the seated figure's leg unable to reach the ground, you can show the difference in height and body shape even when one person's sitting down.

Since the left foot is slightly bent, change the height of the thigh's base accordingly.

The older sister has longer legs, but since the little sister's leg is hovering above the ground, the knees are about the same height.

You can express the difference in age by adding curves to the chest area and thin waistline.

Emphasize the roundness of the hips and buttocks to suggest a more mature body than the younger sister's.

2 Fleshing out

Express the difference in age by drawing curves at the chest and waist of the older sister.

Draw a straight line on the back of the thigh to align with the top of the seat.

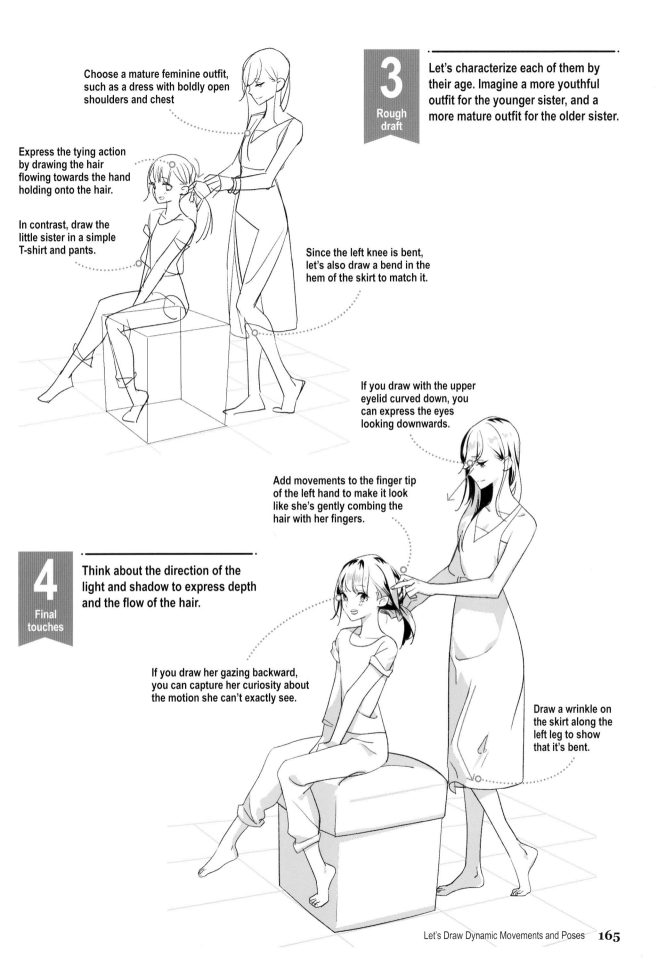

Choose a mature feminine outfit, such as a dress with boldly open shoulders and chest

Express the tying action by drawing the hair flowing towards the hand holding onto the hair.

In contrast, draw the little sister in a simple T-shirt and pants.

3

Rough draft

Let's characterize each of them by their age. Imagine a more youthful outfit for the younger sister, and a more mature outfit for the older sister.

Since the left knee is bent, let's also draw a bend in the hem of the skirt to match it.

If you draw with the upper eyelid curved down, you can express the eyes looking downwards.

Add movements to the finger tip of the left hand to make it look like she's gently combing the hair with her fingers.

4

Final touches

Think about the direction of the light and shadow to express depth and the flow of the hair.

If you draw her gazing backward, you can capture her curiosity about the motion she can't exactly see.

Draw a wrinkle on the skirt along the left leg to show that it's bent.

Pose
58
Slightly high angle
Diagonal view

Seated + Standing

Here a woman sits crosslegged, looking up at a man peering down at her from behind. Be aware of their position and make sure their gazes meet.

Light

Locate his face directly above hers.

When looking down, emphasize the chin line. It's a good idea to draw a sharp chin at this stage.

1
Sketching

After deciding on the location of her face, position his accordingly. Think about how each character looks from a diagonal view and sketch accordingly.

When looking up, the chin and neck seem wider. Connect the chin and neck in a gentle line.

As he's looking down, draw his upper body slightly bent. She's looking up, so have her bending backward.

His fingers are hidden in his pockets, so you don't have to draw them. Add in vertical lines to indicate the pockets.

To sketch a crossed leg pose, imagine a triangle connecting the crotch and the knees.

The right half of the face is hidden by the nose, so draw only the eyebrows and eyes in the front.

Draw the right collarbone connecting with the neck. Draw the left collarbone the same height as the right side.

Make the thighs to the knees straight. Then add a little curve from below the knees to the ankles for a natural silhouette.

2
Fleshing out

Make sure the characters are peering into each other's eyes. Also draw in the lines for the limbs.

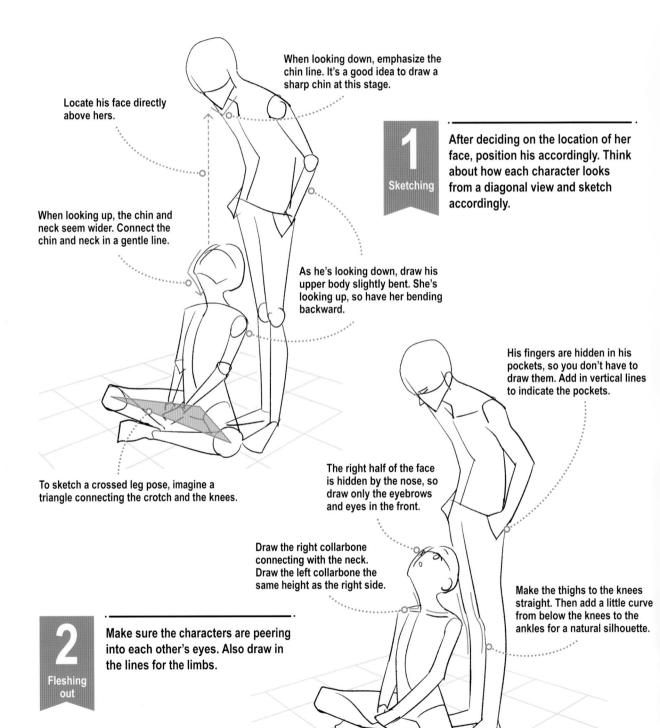

3

Draw the hair movement according to the angle of the face to make the pose more natural looking. Give them loungewear so you can suggest the intimate relationship between the two characters.

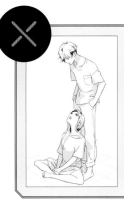

When your characters are close, but not too close

Her head tilts back, her face leaning upward. Be sure you properly render the arch in her neck and his downward-directed gaze, almost to his feet.

When you draw the bangs hanging down, you indicate that he's looking down.

Since she's looking straight up, draw pieces of hair flowing backward.

At the navel, draw a horizontal wrinkle on his shirt to show that he's bending forward.

If you can see only the profile, aligning the nose to the mouth is fine. Since you can see the other side of her cheeks, the nose and mouth don't align in this situation.

4

Once you finish drawing the characters' faces, their noses should be aligned with each other. The right half of his body and the area below her chest are mostly shaded.

Since the chest is sticking out, draw a shadow over the abdomen and thighs.

You can subtly indicate the eye in the back by drawing the curved lashes.

Draw a bulge for the heel behind the ankle to give the foot dimension.

Ojyou

Twitter ▶ @ojyou100

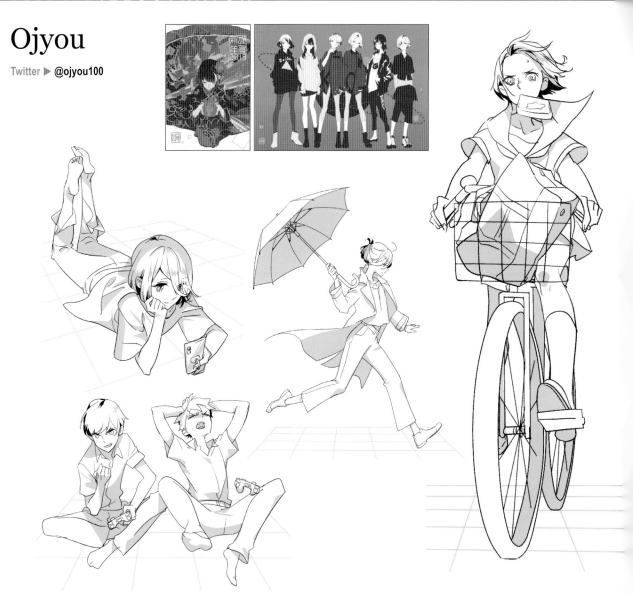

Interview

Please tell us the reason why you started working as an illustrator.

I've loved manga since I was in elementary school. I'd draw pictures of my favorite manga characters and monsters. I couldn't draw it well, but wanted to continue. So I thought, "I could be an illustrator."

How did you practice to improve?

I bought a pose collection and sketched the entire book with a pen on blank looseleaf paper. After I started doing digital art, I used to watch croquis videos on YouTube, and practice croquis digitally.

In this book there are a lot of attractive compositions drawn in various angles and poses. How did you improve?

I'd draw while thinking of the entire picture. It's actually still a challenge for me. I'd spend time looking at a lot of good illustrations and think to myself "who's it for" or "how is it done." I think I improved a lot more when I started analyzing illustrations that way.

When you're working on an illustration, what are some moments that make you think "this is fun"?

It's fun when I'm just sketching roughly while imagining the world I'm conjuring. It's so much fun, just like riding a roller coaster!

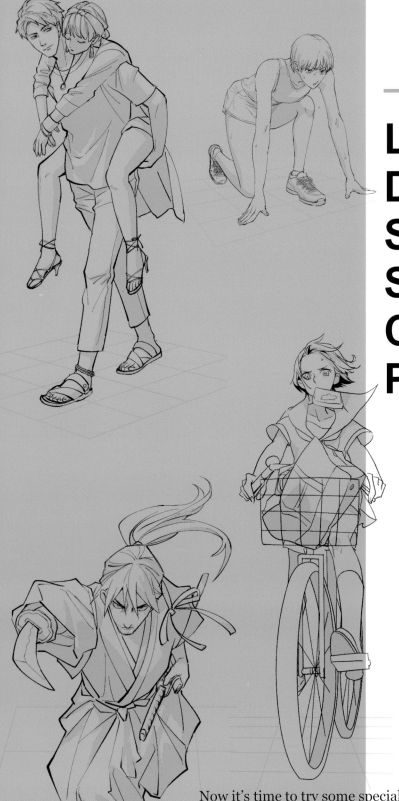

PART 5

Let's Try Drawing Special Scenes and Challenging Poses

Now it's time to try some special poses: riding a bike, swimming, kicking, swinging a bat. We'll also try some scenes and poses where characters are fighting with guns and swords. Give them facial expressions that match their intensity and determination.

Scary Face

Now it's time for something a little more sinister. This pose is a great study in light and perspective, and it's fun to practice too!

Direction of light

Light

The neck isn't visible because the face is sticking forward.

Draw a flashlight right on the median line.

1
Sketching

Place focus on the face and draw the body narrower as you move toward the lower body. Pay attention to how limbs are bending.

For the left hand, roughly sketch the fingertips ing downward.

Make her eyes asymmetrical to accentuate the scary face.

Imagine the character wobbling from the knees like a spirit instead of standing up straight.

Flesh out the fingers on the left hand. At this stage, you don't have to draw the details for each finger yet.

2
Fleshing out

When the character is leaning forward from a high angle, the width of the shoulders is emphasized. If you draw the legs shorter below the knee, you can convey a sense of the perspective of the composition.

Draw inward lines at the kneecaps to help show the direction of the shin versus the calves.

Because this composition is from a high angle, draw the curve of the calves tightly.

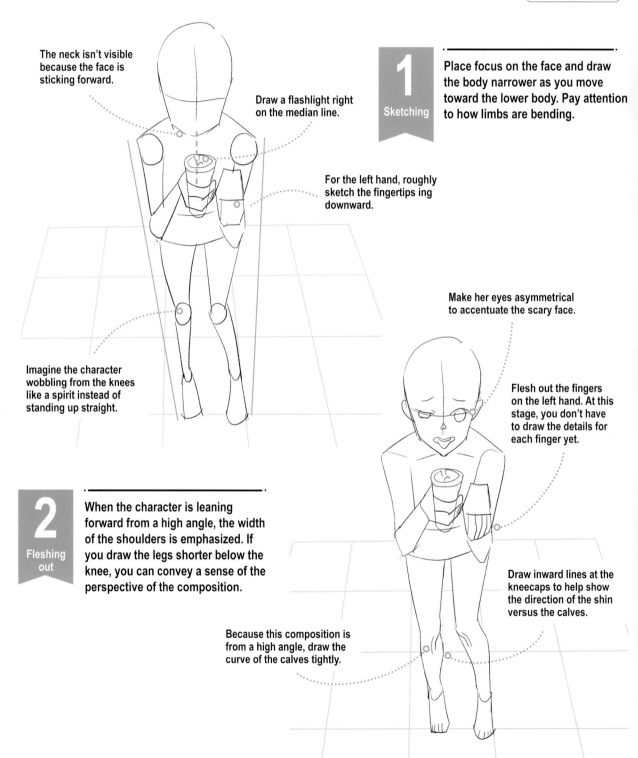

3

Rough draft

Give the character unique outfits such as a triangle headband and a white costume to match the creepy scene.

The shadows from the flashlight add eeriness

By putting shadows below the eyes, you can create an eerie atmosphere. You can also shade in the bridge of the nose since the light shines from below.

If you draw the hair in a ハ shape, you'll give it a sense of volume.

The triangle headband holds the hair down.

The hem of the white costume is tight, so draw it so that it fits on both legs.

There's excess fabric around the arm so draw it hanging down.

Draw shadows while considering the range of the flashlight. The light doesn't reach the back of the head or behind the ears.

4

Final touches

Think about where the flashlight shines and where shadows are cast. In this composition, the facial expression is the focal point so lay down the shadows appropriately.

When you relax your wrists, your fingers also weaken. Be careful not to draw them too stiff.

Although the lower body is not exposed to light, don't shade it completely so as to show off the costume.

By slightly shifting the hem that overlaps at the knees, you can create a natural fit that matches the movement of the legs.

Pose

60

Low angle
Slightly diagonal

Riding a Bike

It's like riding a bike! Here's a great pose to master, a cyclist in midpedal. She speeds along on her bike. Think about how her body is positioned as she goes.

Direction of light

Light

Draw the left shoulder pulled forward and twist the upper body slightly.

Consider the width of the shoulders and align them with the handlebars. Draw both arms spread at an angle in an H shape.

1
Sketching

Draw the figure after sketching the bicycle. Give a sense of perspective while considering the front and rear wheels and her leg movement.

The left foot is pedaling so you can see the bottom of the knee and the sole of her foot.

Incorporate details such as her breakfast clenched in her teeth to show that she's rushing to school.

To show perspective, draw the front wheels large and the rear wheels smaller.

The right leg is pulled back so you can see more of the thigh.

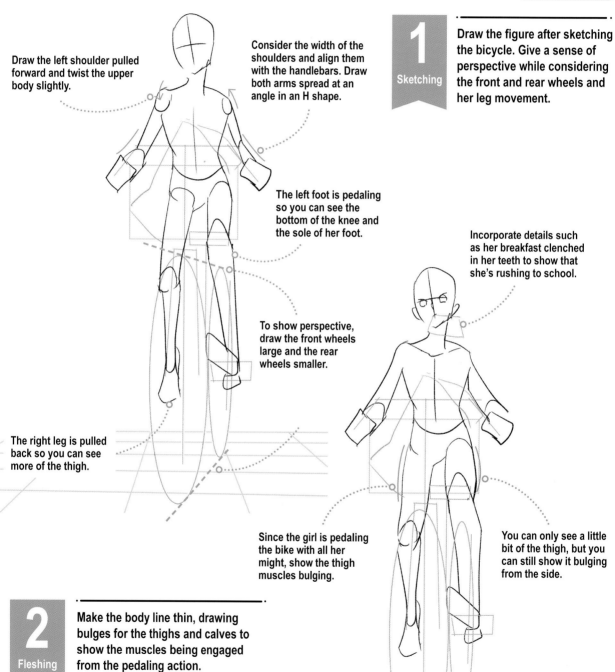

Since the girl is pedaling the bike with all her might, show the thigh muscles bulging.

You can only see a little bit of the thigh, but you can still show it bulging from the side.

2
Fleshing out

Make the body line thin, drawing bulges for the thighs and calves to show the muscles being engaged from the pedaling action.

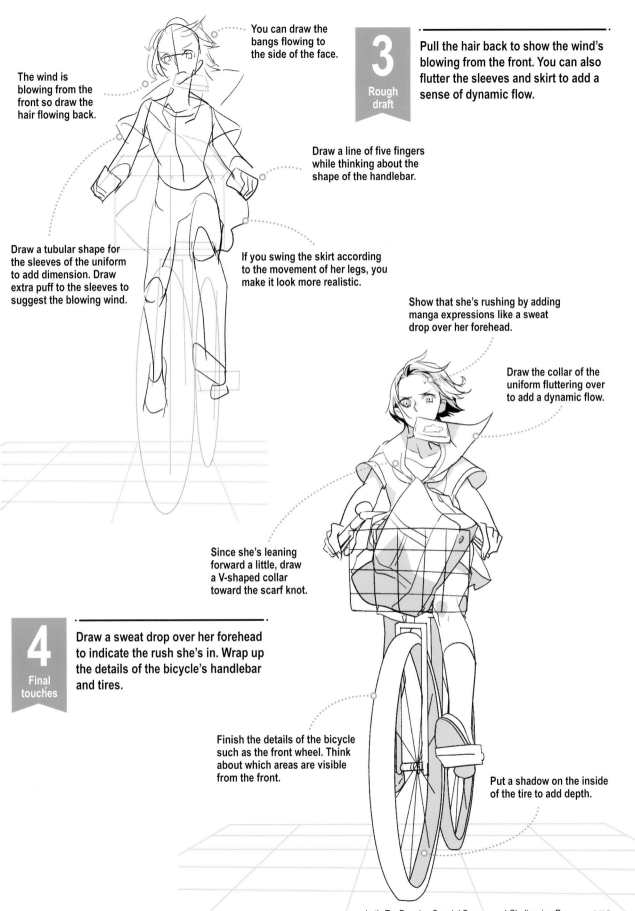

You can draw the bangs flowing to the side of the face.

3 Rough draft

Pull the hair back to show the wind's blowing from the front. You can also flutter the sleeves and skirt to add a sense of dynamic flow.

The wind is blowing from the front so draw the hair flowing back.

Draw a line of five fingers while thinking about the shape of the handlebar.

Draw a tubular shape for the sleeves of the uniform to add dimension. Draw extra puff to the sleeves to suggest the blowing wind.

If you swing the skirt according to the movement of her legs, you make it look more realistic.

Show that she's rushing by adding manga expressions like a sweat drop over her forehead.

Draw the collar of the uniform fluttering over to add a dynamic flow.

Since she's leaning forward a little, draw a V-shaped collar toward the scarf knot.

4 Final touches

Draw a sweat drop over her forehead to indicate the rush she's in. Wrap up the details of the bicycle's handlebar and tires.

Finish the details of the bicycle such as the front wheel. Think about which areas are visible from the front.

Put a shadow on the inside of the tire to add depth.

Pose
61
High angle
Diagonal view

Swinging a Bat

Batter up! A young man stands at the play, eye on the pitcher. A swing and a miss or a homerun? Consider the twist of the upper body and the appearance of both arms holding the bat.

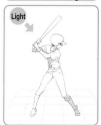
Light

Both hands are holding onto the bat's handle. Be careful not to show the hands overlapping.

Since the character is facing sideways, it's a good idea to draw the face flat.

The arm on top is shortened since it's facing forward.

As the upper body twists, the median line is also curved. Since the waist is the twisting point, draw an indentation at the waist.

The center of gravity is on the leg in the back. Since the character is leaning forward a little, the plane for the shoulders, hips and knees is diagonal.

1
Sketching

Since the bat's held behind the body, the upper body twists significantly. Imagine the direction in which he's looking and draw the face accordingly.

You can show the thickness of the back by not connecting the armpit to the shoulder line.

Don't worry too much about the roundness of the buttocks. Make the thigh muscles firm.

2
Fleshing out

The body is slim and lithe. Notice how it aligns with and counterbalances the extended bat.

Since the entire weight is placed on the right foot, include well-defined calf muscles.

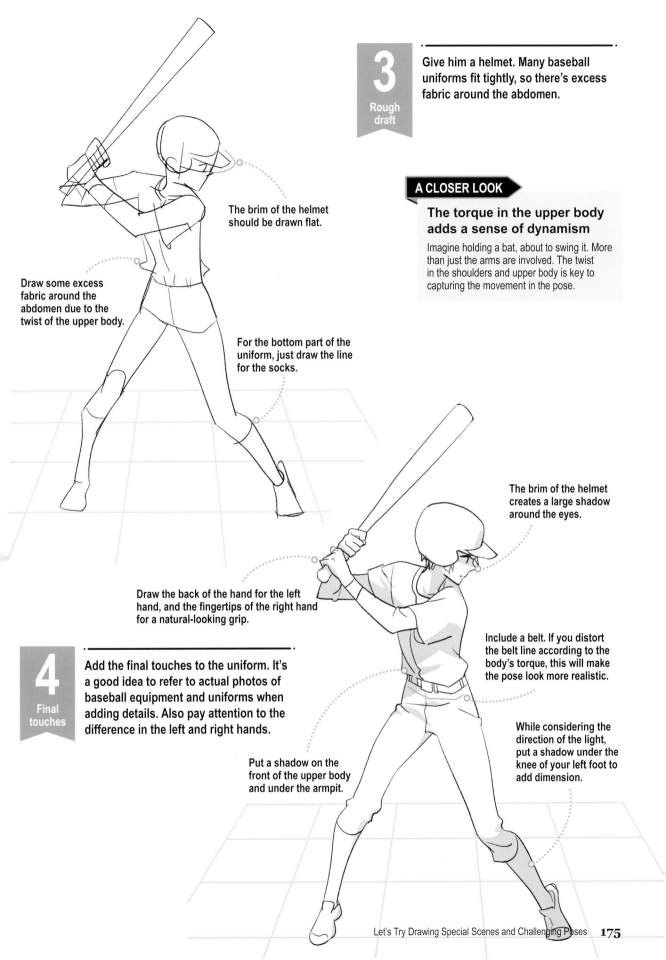

3
Rough draft

Give him a helmet. Many baseball uniforms fit tightly, so there's excess fabric around the abdomen.

The brim of the helmet should be drawn flat.

Draw some excess fabric around the abdomen due to the twist of the upper body.

For the bottom part of the uniform, just draw the line for the socks.

A CLOSER LOOK

The torque in the upper body adds a sense of dynamism

Imagine holding a bat, about to swing it. More than just the arms are involved. The twist in the shoulders and upper body is key to capturing the movement in the pose.

The brim of the helmet creates a large shadow around the eyes.

Draw the back of the hand for the left hand, and the fingertips of the right hand for a natural-looking grip.

4
Final touches

Add the final touches to the uniform. It's a good idea to refer to actual photos of baseball equipment and uniforms when adding details. Also pay attention to the difference in the left and right hands.

Include a belt. If you distort the belt line according to the body's torque, this will make the pose look more realistic.

While considering the direction of the light, put a shadow under the knee of your left foot to add dimension.

Put a shadow on the front of the upper body and under the armpit.

Pose

62

Eye level
Diagonal view

Talking on the Phone While Doing Nails

For this pose, a young woman does her nails while talking on the phone. Pay attention to the sense of depth here and the placement of her hands and legs.

Light

The phone is sandwiched between her ears and shoulders, so place the shoulders just below the ears.

While raising the right shoulder, the left arm comes out in front of the right arm.

1

Sketching

Since both arms are extended forward, the character's crouching forward as well. The front shoulder is raised to pinch the phone so the left and right shoulders are not at the same height. Draw a gentle curve to express this.

Determine the position and angle of the toes, considering that the line of sight is directed to the toes.

The body is slightly couched forward, so draw the back a little hunched.

If you draw the right foot diagonally from the hips to the toes, you'll bring out the character's depth.

Draw a dent in the armpit and leave a space between the back and shoulder for a natural connection.

Keep the kneecap flat.

2

Fleshing out

Thinking about the curves and angular parts of the body such as the kneecaps and elbows.

Draw a slight indentation to express the boundary between the back and buttocks to add dimension.

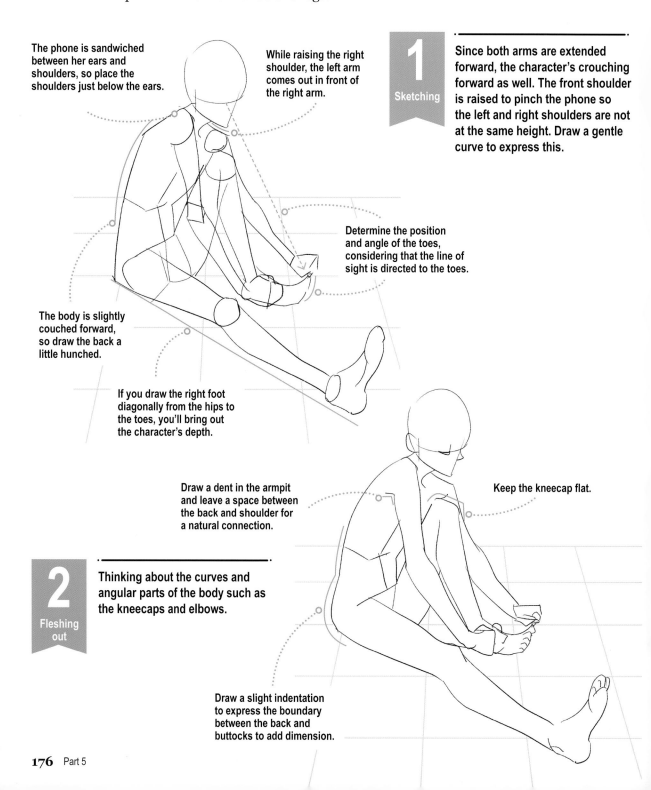

3
Rough draft

Draw the movement of the hair according to the angle of the face. Give her some loose clothing like loungewear.

In the case of a tanktop, the line under the armpit is curved up from the chest to the back to make it look more natural.

For the hairstyle that exposes the forehead, the hair flows to the side. Pay attention to the position of the hairline and the bangs.

Draw parts that are in contact with the skin as well as the excess fabric on the floor to add dimension.

A CLOSER LOOK

Keep in mind the distance between the stomach and thighs

Unless the character is intentionally pressing her thighs against her stomach, there's naturally a gap that's created. Make sure to draw it between the stomach, thigh and waist, since this section is thinner than the chest and hips.

4
Final touches

Since one knee is sticking up, draw a large shadow on the front side of the upper body. It's a good idea to use real photos for reference when drawing the pedicure and phone.

Add the finishing touches, giving the phone a realistic proportion. Don't forget to consider the distance between the phone, ear and mouth.

Shade in the upper-body and thigh sections that are being covered.

Draw the left hand holding the pedicure brush. If you curve the tip of the brush, you can show that the polish is being applied.

You can also draw the right hand holding the polish bottle.

Light

Pose

63

High angle
Straight view

Punching

Fist of fury, now it's time to learn how to land a punch. Her roundhouse right extends forward, straight at the viewer. Pay attention to the twist of her body and the sense of perspective created when the fist flies forward.

Since the right arm is pulled forward and the left arm is pulled back, draw the shoulder accordingly.

1 Sketching

Shorten the area from the shoulder to the wrist. In this pose, the character's standing shoulder width apart, and the upper body is twisted.

You can get a sense of perspective by shortening the distance between the shoulders and elbows as well as the distance between the elbow and wrist.

Since the upper body is twisted, the waistline and the base of the foot are drawn diagonally.

The position of the fist should be in line with the face to give power to the punch.

Draw without connecting the neck and back to show the thickness of the back.

Draw the line of the forearm and the upper arm without connecting them to add depth to the left arm.

In this composition, the character is punching straight forward so draw the arms curving inward.

Don't draw the wrist in order to make the fist's position realistic.

2 Fleshing out

Don't forget the sloping shoulder, the thinness in the arm as well as the rounded waist curve.

If you draw the toes straight from the ankles, the feet are facing forward.

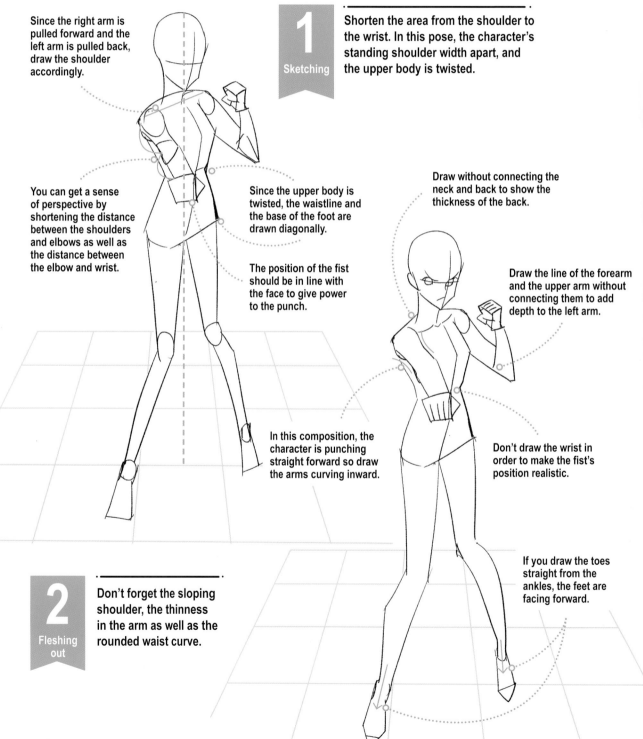

3

Rough draft

Give movement to her hair and jacket to express the explosive power of the punch. Match the expression to the pose and give her a fierce face.

Understanding the twist of the upper body due to the arm movement

If you look at a punching pose from the side, you can see that the upper body is twisted from the right arm pulling forward and the left arm backward. It's also important that you understand that the right leg is also slightly bent to support this movement.

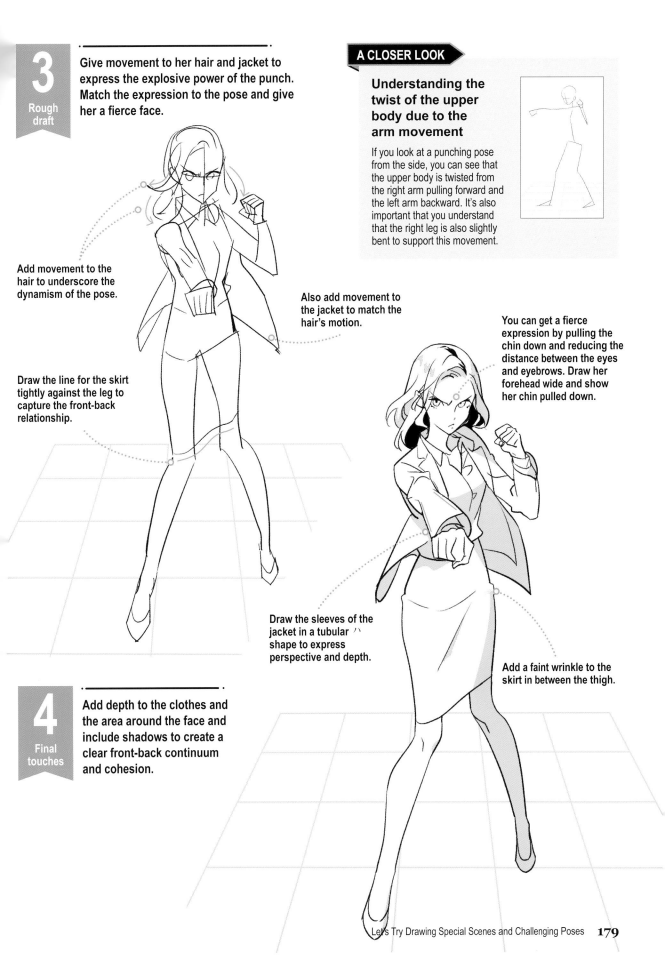

Add movement to the hair to underscore the dynamism of the pose.

Also add movement to the jacket to match the hair's motion.

Draw the line for the skirt tightly against the leg to capture the front-back relationship.

You can get a fierce expression by pulling the chin down and reducing the distance between the eyes and eyebrows. Draw her forehead wide and show her chin pulled down.

Draw the sleeves of the jacket in a tubular shape to express perspective and depth.

Add a faint wrinkle to the skirt in between the thigh.

4

Final touches

Add depth to the clothes and the area around the face and include shadows to create a clear front-back continuum and cohesion.

64

Eye level
Straight angle

Kicking

The upper body leans diagonally in order to unleash the straight kick. Fill out the body while paying attention to the position of the leg and how the perspective affects the face.

Direction of light

Light

1
Sketching

Be aware of the perspective and the twist of the body. Since the left leg is raised to waist level, the upper body is tilted diagonally.

Since the upper body is tilted backward diagonally, it's a good idea to draw the face tilting downward to the side.

If you draw the upper body shorter than the lower body, you can get a sense of perspective.

Both knees and toes are facing outward.

The toes are facing forward for the leg that's kicking.

For the kicking leg, draw a short line between the thigh and knee then a longer one from the knee to the ankle to show the perspective.

On the upper arm, chest and abdomen, show the muscles bulging.

Since you can see the side of the body, increase the thickness of the back and chest muscles.

Be aware of the depth of the leg when drawing the leg muscles. Draw indentations to show the separation between the hips, thighs and knees.

2
Fleshing out

Give the body solidity and firmness by making the back and hips thicker. Draw the core and arm muscles with a similar sense of strength.

Since the entire weight is supported by the right foot, draw the calf muscles with significant bulges.

3

Sketch in the clothing while thinking about which body parts show through the tight-fitting shirt. Think about the character's personality and give him a haircut to match it.

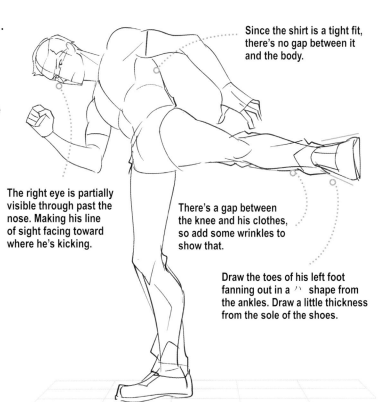

Since the shirt is a tight fit, there's no gap between it and the body.

The right eye is partially visible through past the nose. Making his line of sight facing toward where he's kicking.

There's a gap between the knee and his clothes, so add some wrinkles to show that.

Draw the toes of his left foot fanning out in a ⌒ shape from the ankles. Draw a little thickness from the sole of the shoes.

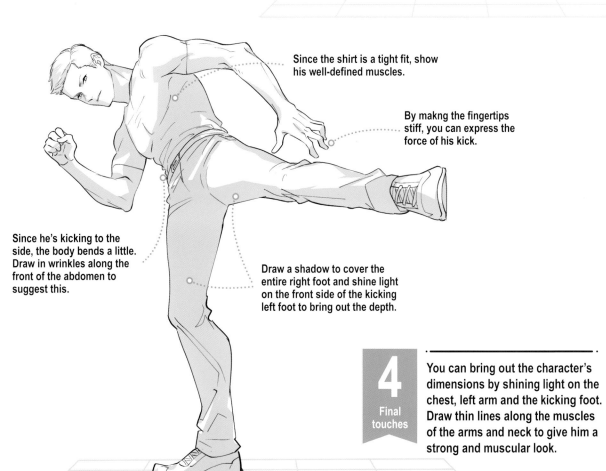

Since the shirt is a tight fit, show his well-defined muscles.

By makng the fingertips stiff, you can express the force of his kick.

Since he's kicking to the side, the body bends a little. Draw in wrinkles along the front of the abdomen to suggest this.

Draw a shadow to cover the entire right foot and shine light on the front side of the kicking left foot to bring out the depth.

4

You can bring out the character's dimensions by shining light on the chest, left arm and the kicking foot. Draw thin lines along the muscles of the arms and neck to give him a strong and muscular look.

Pose

65

Eye level
Side view

Climbing

Now it's time for the dangling, acrobatic pose of a freestyle rock climber. The key point is to show the taut muscles and give him an intense expression to match the scene.

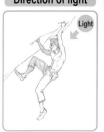
Light

Pay attention to the direction the joints are facing.

Draw a large curve to express the bulge of the back muscles.

1

Sketching

First, let's decide on the shape of the rock, then draw in the body. When sketching, pay attention to the distance between the arms and how it'll be support the entire body weight.

The abdominal muscles are tensed, so draw an indentation to express this.

The back muscles are lifted along with the raised arm.

The right foot's about to find a toehold on the rockface, so the knees and toes are facing the wall.

The arms that are supporting the body weight are engaged, so add in bulging muscles.

Along the chest, add a line from the armpits toward the center line.

The right foot making contact with the rockface, so add bulges to the calf muscles.

Make the back of the thighs thick to suggest the muscular leg.

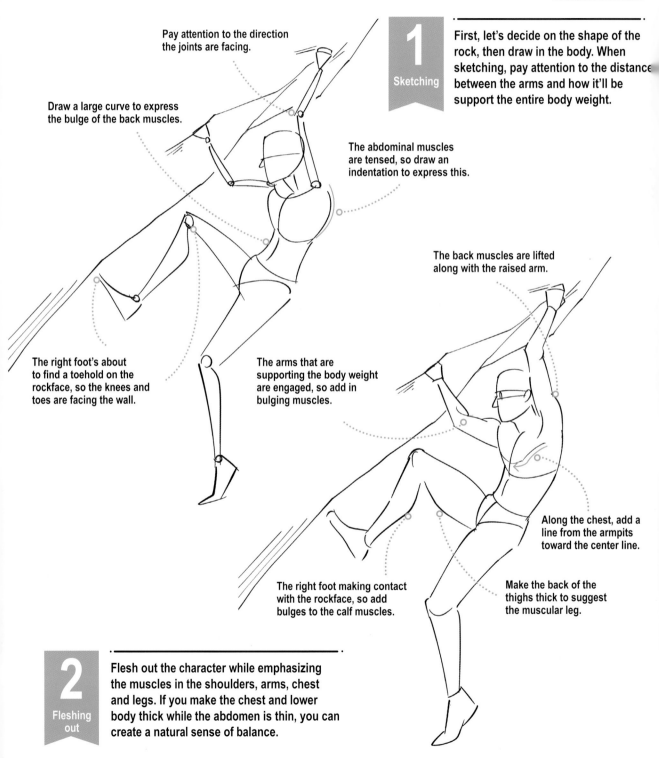

2

Fleshing out

Flesh out the character while emphasizing the muscles in the shoulders, arms, chest and legs. If you make the chest and lower body thick while the abdomen is thin, you can create a natural sense of balance.

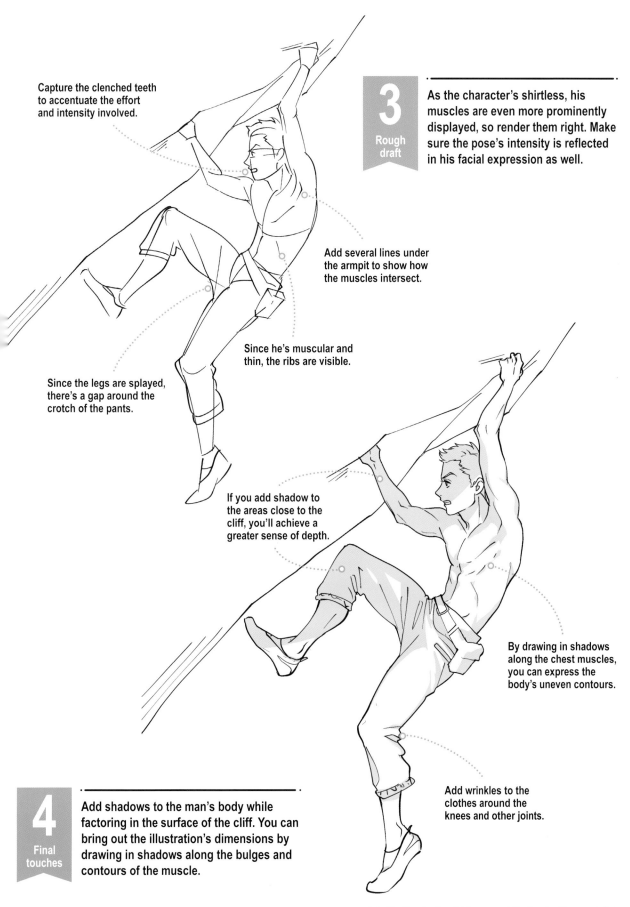

Capture the clenched teeth to accentuate the effort and intensity involved.

3 Rough draft

As the character's shirtless, his muscles are even more prominently displayed, so render them right. Make sure the pose's intensity is reflected in his facial expression as well.

Add several lines under the armpit to show how the muscles intersect.

Since he's muscular and thin, the ribs are visible.

Since the legs are splayed, there's a gap around the crotch of the pants.

If you add shadow to the areas close to the cliff, you'll achieve a greater sense of depth.

By drawing in shadows along the chest muscles, you can express the body's uneven contours.

4 Final touches

Add shadows to the man's body while factoring in the surface of the cliff. You can bring out the illustration's dimensions by drawing in shadows along the bulges and contours of the muscle.

Add wrinkles to the clothes around the knees and other joints.

Pose 66

Eye level

Diagonal view

Cheering Someone On

You can do it! A young woman cheers someone on. Draw her hunching forward a little, as she's trying to project her voice.

Light

Align the right foot with the crosshairs on the face.

Originally this pose creates a space under the armpits, but because of the perspective we're viewing from, the left arm overlaps with the upper body.

Imagine a straight line from the face down to the right foot. Since the character is leaning forward, position the shoulders extending from the line.

1 Sketching

Since she's leaning forward a little, draw her face almost straight on. Be careful not to draw her head extending beyond her right foot, it'll look unnatural.

However on the left arm, there's a space under the armpit, so draw the arms extending away from the body.

Starting from the right shoulder, connect the contours and curves of the chest, abdomen, waist and hip.

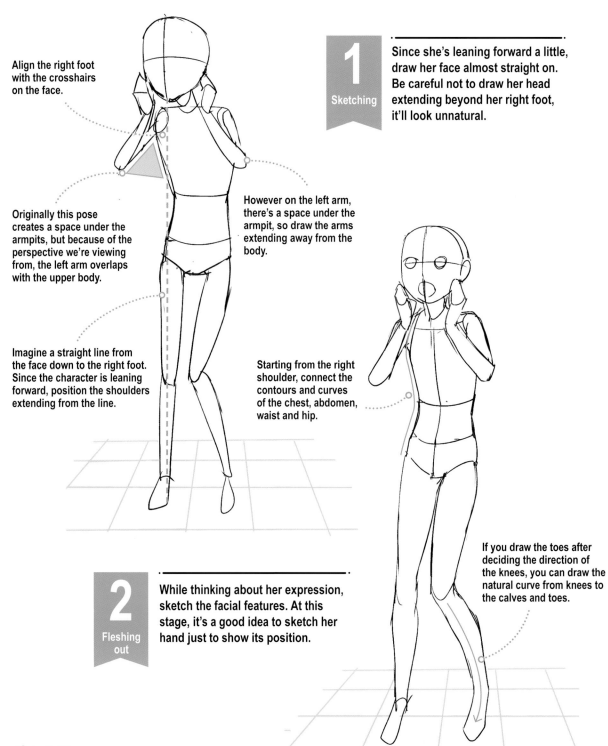

2 Fleshing out

While thinking about her expression, sketch the facial features. At this stage, it's a good idea to sketch her hand just to show its position.

If you draw the toes after deciding the direction of the knees, you can draw the natural curve from knees to the calves and toes.

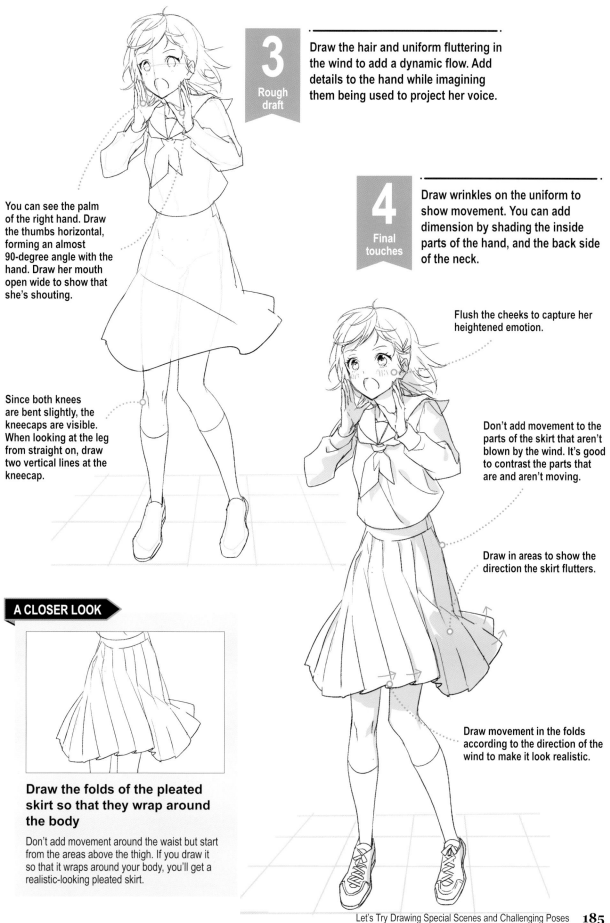

3 Rough draft

Draw the hair and uniform fluttering in the wind to add a dynamic flow. Add details to the hand while imagining them being used to project her voice.

You can see the palm of the right hand. Draw the thumbs horizontal, forming an almost 90-degree angle with the hand. Draw her mouth open wide to show that she's shouting.

Since both knees are bent slightly, the kneecaps are visible. When looking at the leg from straight on, draw two vertical lines at the kneecap.

4 Final touches

Draw wrinkles on the uniform to show movement. You can add dimension by shading the inside parts of the hand, and the back side of the neck.

Flush the cheeks to capture her heightened emotion.

Don't add movement to the parts of the skirt that aren't blown by the wind. It's good to contrast the parts that are and aren't moving.

Draw in areas to show the direction the skirt flutters.

Draw movement in the folds according to the direction of the wind to make it look realistic.

A CLOSER LOOK

Draw the folds of the pleated skirt so that they wrap around the body

Don't add movement around the waist but start from the areas above the thigh. If you draw it so that it wraps around your body, you'll get a realistic-looking pleated skirt.

Pose

67

Eye level

Diagonal view

Head in a Lap

Here a man uses his partner's lap as a pillow. Think about the position of his head and make sure it aligns with her legs.

Light

1

Sketching

Here the triangle is key. The positions of the two bodies overlap and interconnect.

Since she's leaning forward in this pose, draw the waistline curved in a ‹ shape.

When drawing her legs, imagine a triangle that connects the pelvis and the knees.

He is stretching his legs slowly. Draw them longer than his upper body to bring out the perspective.

It's easier to position his head by placing it over her right leg.

2

Fleshing out

Keep in mind the difference between the two bodies. Give her more rounded features and him a more linear definition.

While thinking about the position of her mouth, flesh out the finger and palm section.

Keep in mind that the arm is on the back side of his body, and the forearm is only slightly visible connecting with the wrist.

Draw an indentation to separate the back hip and thigh. Add a gentle curve for the knee and calf.

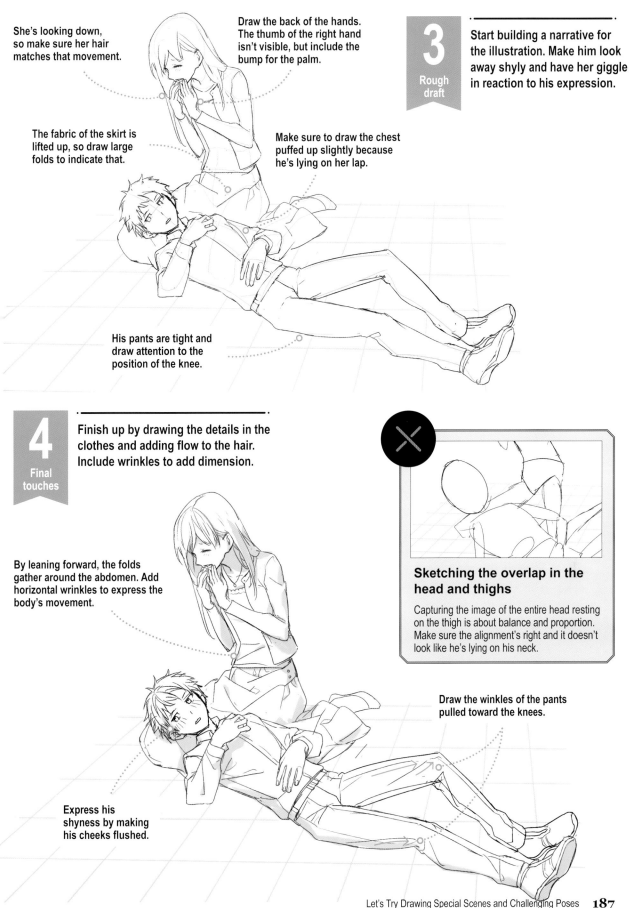

She's looking down, so make sure her hair matches that movement.

Draw the back of the hands. The thumb of the right hand isn't visible, but include the bump for the palm.

3
Rough draft

Start building a narrative for the illustration. Make him look away shyly and have her giggle in reaction to his expression.

The fabric of the skirt is lifted up, so draw large folds to indicate that.

Make sure to draw the chest puffed up slightly because he's lying on her lap.

His pants are tight and draw attention to the position of the knee.

4
Final touches

Finish up by drawing the details in the clothes and adding flow to the hair. Include wrinkles to add dimension.

By leaning forward, the folds gather around the abdomen. Add horizontal wrinkles to express the body's movement.

Sketching the overlap in the head and thighs

Capturing the image of the entire head resting on the thigh is about balance and proportion. Make sure the alignment's right and it doesn't look like he's lying on his neck.

Draw the winkles of the pants pulled toward the knees.

Express his shyness by making his cheeks flushed.

Light

Pose

68

Low angle
Diagonal view

Two People Sitting + Leaning

For this pairing, one guy's reading a book, while the other snoozes on his shoulder. Be aware of the context and the dimension of the two characters.

1 Sketching

Sketch the guy reading the book first, then the one leaning. He's positioned slightly behind the guy reading the book.

After sketching the guy reading the book, you can determine position of the other character's head. Align the leaner's eyes to the shoulder of the reader to achieve a good balance.

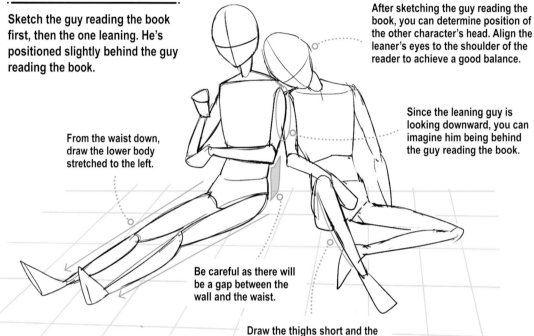

From the waist down, draw the lower body stretched to the left.

Since the leaning guy is looking downward, you can imagine him being behind the guy reading the book.

Be careful as there will be a gap between the wall and the waist.

Draw the thighs short and the section below the knees long to show the perspective.

2 Fleshing out

Think about how the legs are affected by perspective. Draw the shoulders wide and the neck thick.

Make their necks as wide as their heads.

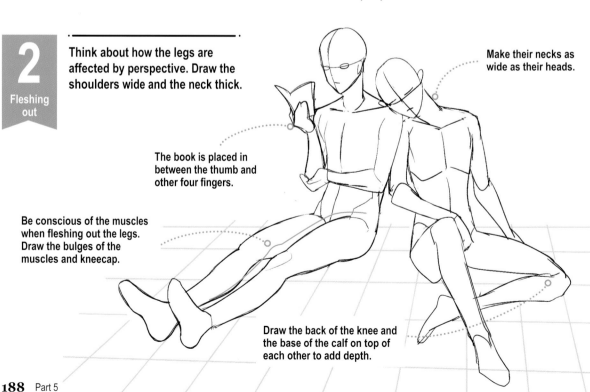

The book is placed in between the thumb and other four fingers.

Be conscious of the muscles when fleshing out the legs. Draw the bulges of the muscles and kneecap.

Draw the back of the knee and the base of the calf on top of each other to add depth.

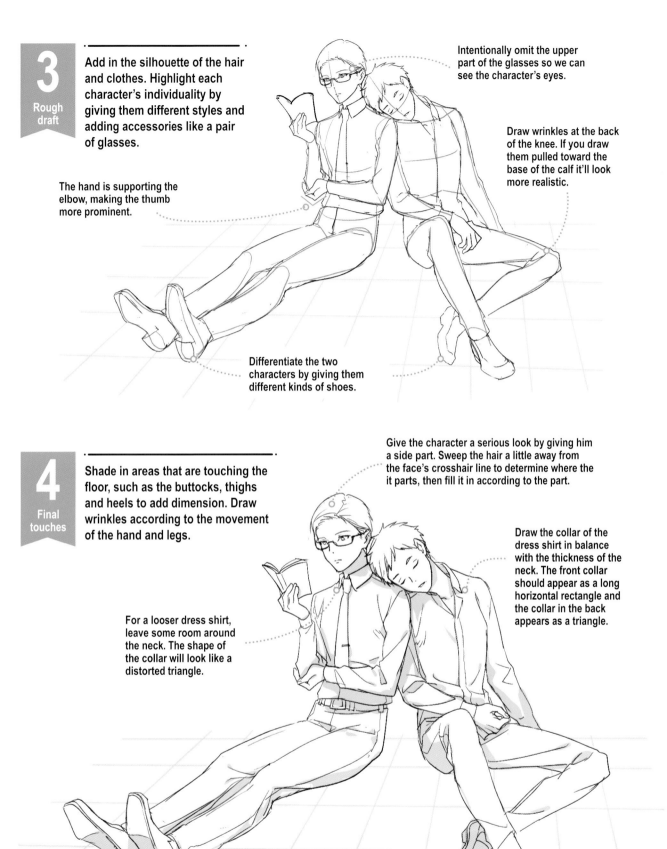

3
Rough draft

Add in the silhouette of the hair and clothes. Highlight each character's individuality by giving them different styles and adding accessories like a pair of glasses.

Intentionally omit the upper part of the glasses so we can see the character's eyes.

Draw wrinkles at the back of the knee. If you draw them pulled toward the base of the calf it'll look more realistic.

The hand is supporting the elbow, making the thumb more prominent.

Differentiate the two characters by giving them different kinds of shoes.

4
Final touches

Shade in areas that are touching the floor, such as the buttocks, thighs and heels to add dimension. Draw wrinkles according to the movement of the hand and legs.

Give the character a serious look by giving him a side part. Sweep the hair a little away from the face's crosshair line to determine where the it parts, then fill it in according to the part.

Draw the collar of the dress shirt in balance with the thickness of the neck. The front collar should appear as a long horizontal rectangle and the collar in the back appears as a triangle.

For a looser dress shirt, leave some room around the neck. The shape of the collar will look like a distorted triangle.

Shade in the arch of the shoe to add dimension.

Playing the Violin

In this pose, a virtuoso violinist gives a performance. Pay attention to the spatial relationship between the man and his instrument.

Direction of light

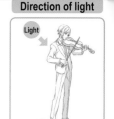

Let's sketch while thinking about the space where the violin is located in between the shoulder and chin.

At this stage, if you also draw a rough sketch of the violin, the pose will be easier to complete.

1
Sketching

Although it's a simple standing pose, it's important to pay attention to the stretch of the chest and tilt of the neck while sketching.

Draw the elbows bent showing proper form when playing the violin.

Make him turn toward his left hand.

Because of the diagonal composition, draw his right leg longer than the left one.

At this stage, be sure to draw the thickness of the violin.

By drawing his arms and legs narrower toward the joints, you can indicate his slender figure.

The center of gravity is placed on the left leg, and the waist sticks out slightly.

2
Fleshing out

Since he's a slender character, flesh out the illustration while thinking about places to tighten his form.

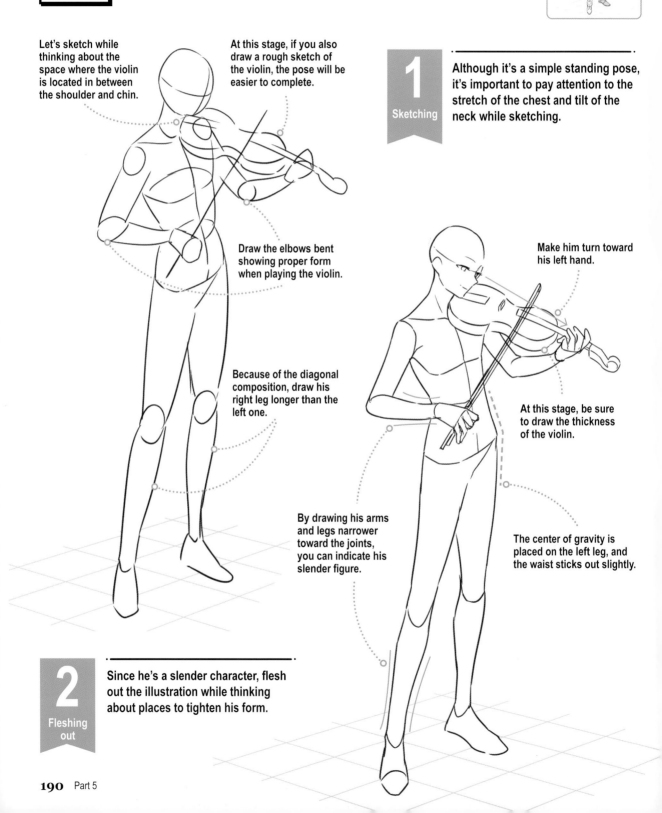

3

Rough draft

The fit of the clothes is important for formal wear. Be careful to keep the whole body in balance.

A CLOSER LOOK

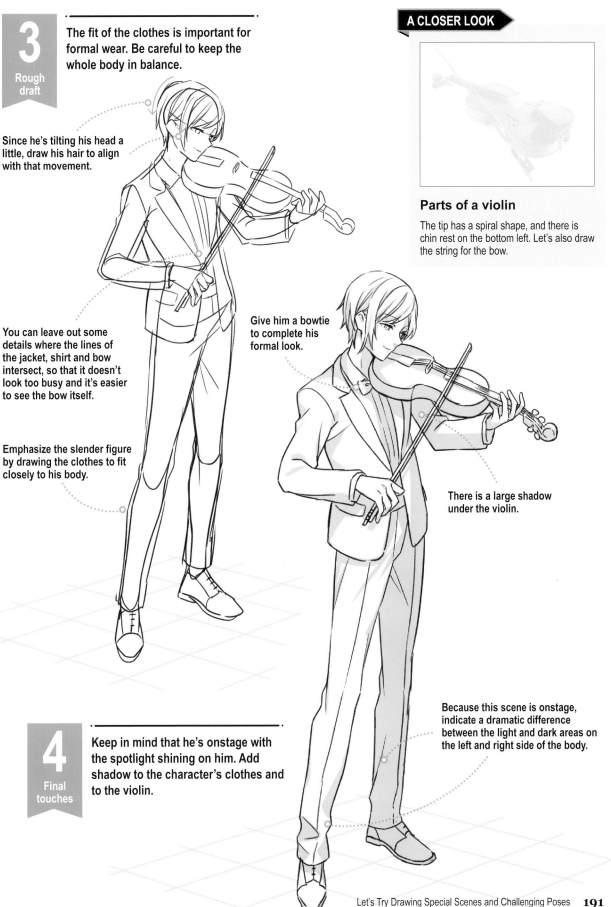

Since he's tilting his head a little, draw his hair to align with that movement.

Parts of a violin

The tip has a spiral shape, and there is chin rest on the bottom left. Let's also draw the string for the bow.

You can leave out some details where the lines of the jacket, shirt and bow intersect, so that it doesn't look too busy and it's easier to see the bow itself.

Give him a bowtie to complete his formal look.

Emphasize the slender figure by drawing the clothes to fit closely to his body.

There is a large shadow under the violin.

4

Final touches

Keep in mind that he's onstage with the spotlight shining on him. Add shadow to the character's clothes and to the violin.

Because this scene is onstage, indicate a dramatic difference between the light and dark areas on the left and right side of the body.

Pose

70

Eye level
Straight view

Light

Throwing a Ball While Jumping

A man leaps into the air, about to throw a ball. Practice the complex areas, such as the arm holding the ball and indicating the direction of the character's aim.

1

Sketching

With this pose, the character's body is facing diagonally and the upper part is bent back. Decide on the basic composition at this stage.

The hand holding the ball is pulled far back, so draw a short upper arm to express the depth.

The palm of the left hand is in front of the body, so make it larger.

By arching the torso, you can show the character bending back.

You can create a greater sense of immediacy by having him aim straight at the viewer.

In this pose, connect the head with the leg using a 〈 shape.

Raise the shoulders a little to show their strength.

Draw the hand extending in the direction he's aiming the ball.

2

Fleshing out

Draw strong muscles around the shoulders. Pay close attention to the direction of the fingers.

Flesh out the thigh muscle on the leg that's supporting the jump.

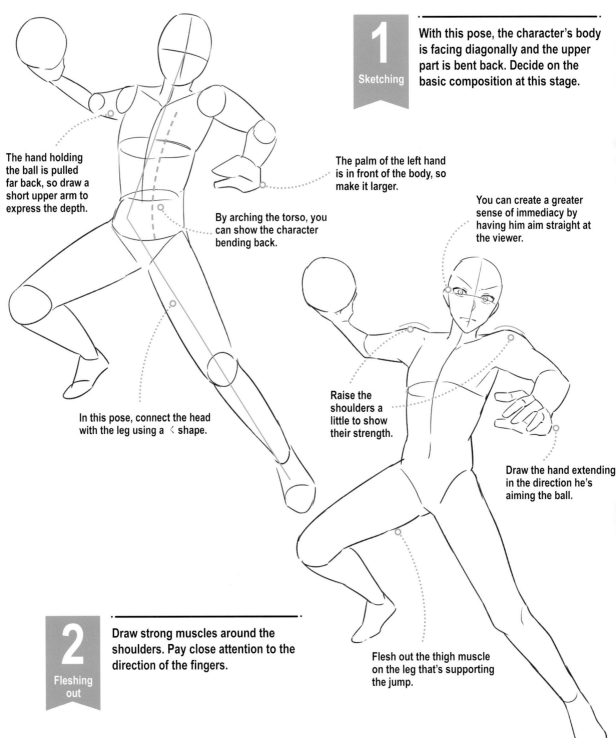

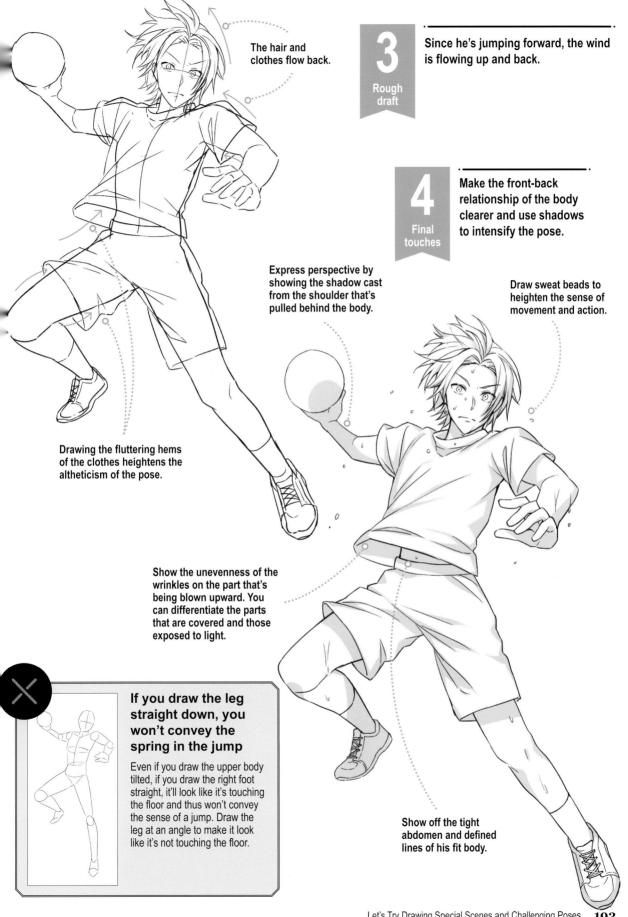

The hair and clothes flow back.

3 Rough draft

Since he's jumping forward, the wind is flowing up and back.

4 Final touches

Make the front-back relationship of the body clearer and use shadows to intensify the pose.

Express perspective by showing the shadow cast from the shoulder that's pulled behind the body.

Draw sweat beads to heighten the sense of movement and action.

Drawing the fluttering hems of the clothes heightens the altheticism of the pose.

Show the unevenness of the wrinkles on the part that's being blown upward. You can differentiate the parts that are covered and those exposed to light.

If you draw the leg straight down, you won't convey the spring in the jump

Even if you draw the upper body tilted, if you draw the right foot straight, it'll look like it's touching the floor and thus won't convey the sense of a jump. Draw the leg at an angle to make it look like it's not touching the floor.

Show off the tight abdomen and defined lines of his fit body.

Outfits for Different Character Types

Design and refine different outfits according to your character's personality, style, facial features, whatever inspires you! Pay close attention to details such as hats, accessories and shoes, and match them to the scene and season.

Women's spring and summer outfits

Light summer clothes such as a sleeveless dress or shorts help define a form. Think about how fabric and texture affect movement.

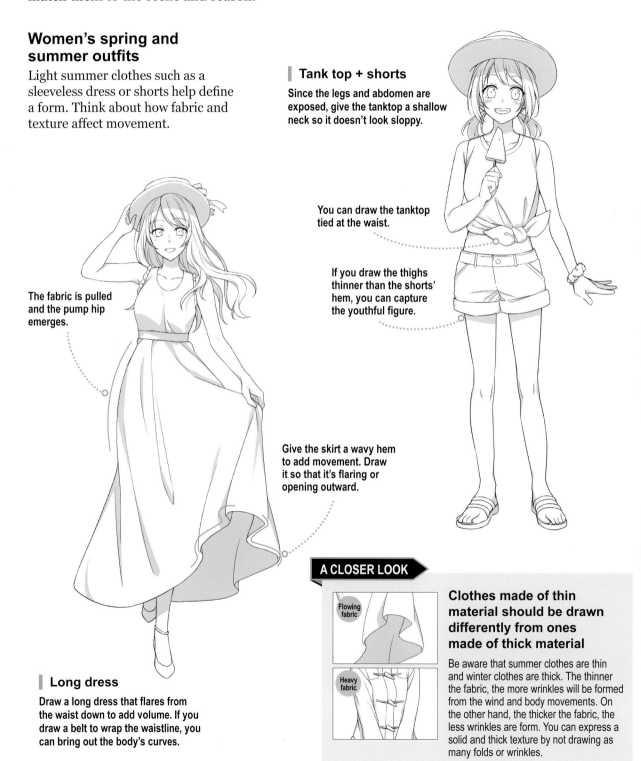

Tank top + shorts

Since the legs and abdomen are exposed, give the tanktop a shallow neck so it doesn't look sloppy.

You can draw the tanktop tied at the waist.

If you draw the thighs thinner than the shorts' hem, you can capture the youthful figure.

The fabric is pulled and the pump hip emerges.

Give the skirt a wavy hem to add movement. Draw it so that it's flaring or opening outward.

Long dress

Draw a long dress that flares from the waist down to add volume. If you draw a belt to wrap the waistline, you can bring out the body's curves.

A CLOSER LOOK

Flowing fabric

Heavy fabric

Clothes made of thin material should be drawn differently from ones made of thick material

Be aware that summer clothes are thin and winter clothes are thick. The thinner the fabric, the more wrinkles will be formed from the wind and body movements. On the other hand, the thicker the fabric, the less wrinkles are form. You can express a solid and thick texture by not drawing as many folds or wrinkles.

Women's autumn and winter outfits

With the assumption that outfits are being layered, draw outerwear with more flow and margins. You can still show off curves and sleek forms.

Winter coat + skirt

Since the coat is thick, the lines of the arms are straight. Draw the length of the skirt to cover the hips and make it peek out a little under the coat.

The fur on the collar looks flat from the front, so curve it along the chest and the back of the neck.

Draw the long boots starting right below the knees. Add in the calf bulge and thin ankles.

Add some elegant accessories such as a clutch and a necklace.

Off the shoulder top + skinny jeans

The curly hair, off-the-shoulder top and skinny jeans give a stylish impression. This outfit suggests a cool urban type.

Fit the top around the shoulders and give some room around the arms for an attractive silhouette.

Draw the jeans to hug her legs for a tight fit. Add some wrinkles to the knees and ankles.

When draping the coat over the shoulders, emphasize the parts that are sticking out from underneath, such as the shoulders and elbows.

Dress + coat

Emphasize the curves and the chest, waist and hips. Draw the coat loosely draped over the shoulders to give her a fashionable vibe.

Spring/summer outfits for men

T-shirts and light cardigans are thinner than winter clothes, so add lots of wrinkles. Think about the combination of clothes and match it to your character's personality.

Cardigan + chinos

A long, loose cardigan gives him a mature look. Draw short sleeves to show the muscular forearms.

Since he's wearing a V-neck, show the collarbones popping out.

T-shirt + shorts

T-shirt and shorts make for a perfect casual outfit. Loosen the arm and leg areas for a street-wear fit. Draw the lines from the torso and feet straight.

For the chinos, draw some horizontal wrinkles at the crotch.

Since the right arm is raised up, draw wrinkles on the T-shirt sleeves.

Draw wrinkles toward the crotch to suggest the soft texture.

A CLOSER LOOK

Add accessories to increase the appeal

Men's clothing tends to be simpler than women's. You can add accessories such as watches and necklaces to make the ensembles more fashionable.

Autumn/winter outfits for men

Think about the texture of the fabric of outerwear fabric to help determine how the clothes wrinkle. Practice drawing different textures such as leather, nylon and knits.

Turtleneck + slim pants

A turtleneck tends to bring out the body line. Sketch the outfit while thinking about the character's physique. Pairing the turtleneck with slim pants yields a neat and fashionable atmosphere.

Extend the neck up to the chin to hide the face a little.

Lift the hem of the turtleneck slightly to the hips.

Heavy jacket

Draw the shoulders and torso as a straight line to suggest the jacket's thick leather material. Draw in details like the collar and studs, while you design the jacket.

By adding a sharp angle for the shoulders, you can convey the jacket's thick texture.

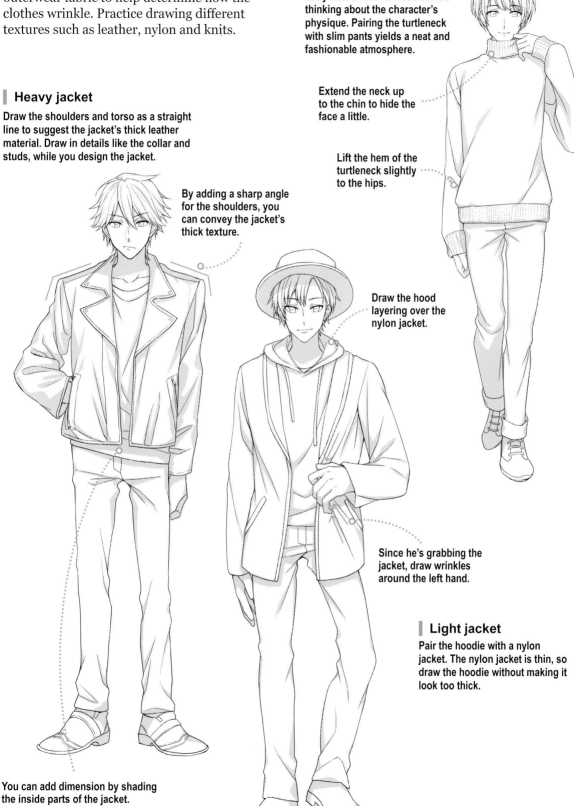

Draw the hood layering over the nylon jacket.

Since he's grabbing the jacket, draw wrinkles around the left hand.

Light jacket

Pair the hoodie with a nylon jacket. The nylon jacket is thin, so draw the hoodie without making it look too thick.

You can add dimension by shading the inside parts of the jacket.

Outfits reflecting scene & character

Customize your clothing and costumes to fit the scene. The outfits help to tell the story, as much as the expressions and poses do.

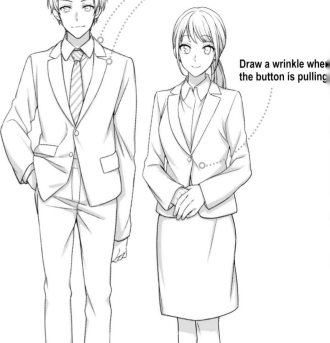

The suit's collar is divided into a short part and a long part. You can add dimension by drawing a curve around the neck.

Draw a wrinkle where the button is pulling

▌ Suit

Include fewer wrinkles to express the stiffer texture of the suits. Draw an indented waistline for both men and women.

Draw the sleeves short to show the wrist.

Draw a large flower decoration on her hair to enhance the outfit.

Shade in the area where the kimono's ohashori is overlapping.

▌ Yukata

A man's obi is drawn thin and wrapped around the waist, while a woman's is thick and wrapped right below the chest. For women, draw the overlap of the sash from the bottom of the obi.

A CLOSER LOOK

Half-collar

Collar

Primary obi

Secondary obi

Sleeve

Differences between a yukata and a kimono

Keep in mind that yukata and kimono look similar, but they're worn differently. The main difference between the two is that for kimonos, there is an obi sash beneath the obi, as well as a kimono sash tied over the obi. Also, beneath the kimono's collar known as the eri, there's a han-eri (half-collar). When drawing kimonos, it's a good idea to look at a range of photos first.

Idol

Give them fashionable costumes with a lot of decorations. You can incorporate stars, ribbons and hearts to the design. Decide on a pose while picturing them singing and dancing.

Draw big and round eyes that pop.

Add a glitter effect to create an idol-like sparkle.

Add designs to the necktie and jacket.

The eyepatch is an essential accessory for Yami-kei.

Draw the eyes dull for an emotionless appearance.

Draw a soft textured skirt that puffs up from underneath.

Draw in long bangs and a mask to add to the mysterious vibe.

Draw his legs thin to add to the overall impression.

Yami-Kei

Yami-kei is a style of Japanese subculture fashion that accessorizes with items often used by those who are sick or injured. Create a dark and hard-to-approach atmosphere to complete the look. For women, you can add gothic elements such as ribbon and laces. For men, you can emphasize the slender bodies by giving them an oversize hoodie.

Pose 71

Eye level
Diagonal view

Floating Underwater

When you dive into the water, your body sinks but other parts like your hair and clothes billow upward. Pay extra attention to the postion of the limbs with this supsended-in-water pose.

Direction of light

Light

1 Sketching

There's no part touching the ground when you're underwater. Draw her floating limbs and don't worry too much about the center of gravity.

The limbs are lighter than the body, so draw it spreading out and up to make it look like it's floating.

Show the character sinking at the chest and hips while paying attention to the center of gravity.

By spreading the fingers, you can express buoyancy.

Since the center of gravity is placed on the chest and hips, the left and right legs can lift up. By drawing the left and right legs in different positions, you can make it look like she's floating.

2 Fleshing out

Capture the flowing curves of the buoyant body freely suspended in the water, while being careful not to draw any tensed or taut muscles.

Flesh out the thin waist and rounded hips.

To make sure the toes don't look unnatural, position them according to the direction of the knees.

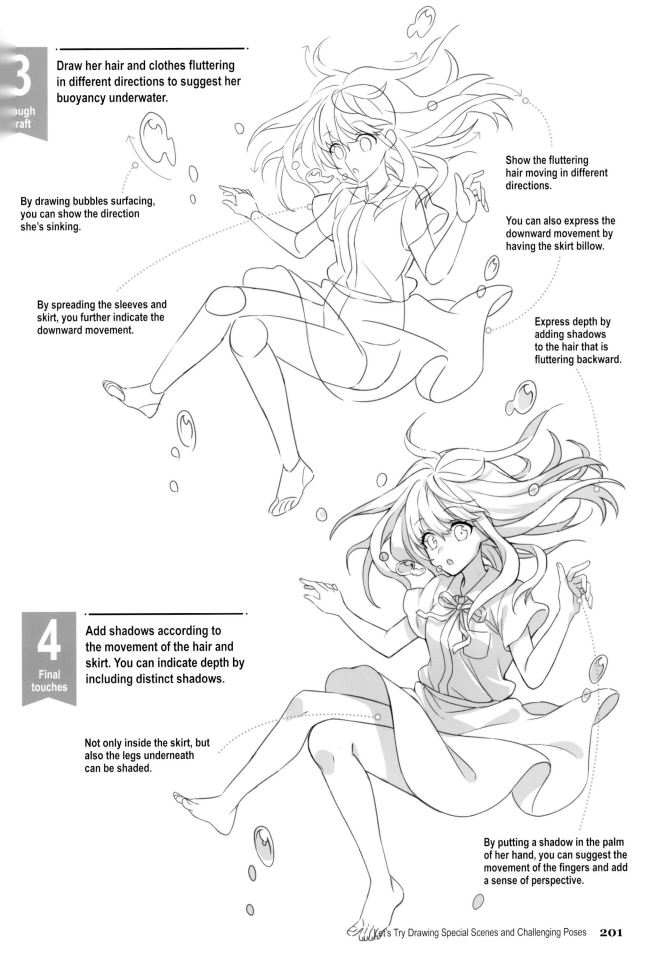

3

Rough Draft

Draw her hair and clothes fluttering in different directions to suggest her buoyancy underwater.

By drawing bubbles surfacing, you can show the direction she's sinking.

By spreading the sleeves and skirt, you further indicate the downward movement.

Show the fluttering hair moving in different directions.

You can also express the downward movement by having the skirt billow.

Express depth by adding shadows to the hair that is fluttering backward.

4

Final touches

Add shadows according to the movement of the hair and skirt. You can indicate depth by including distinct shadows.

Not only inside the skirt, but also the legs underneath can be shaded.

By putting a shadow in the palm of her hand, you can suggest the movement of the fingers and add a sense of perspective.

Light

Swimming Underwater

Pose
72
Slightly high angle
Diagonal view

A young man swims through the ocean depths. Think of a figure's buoyancy when drawing underwater scenes and suggest movement through the clothes and hair.

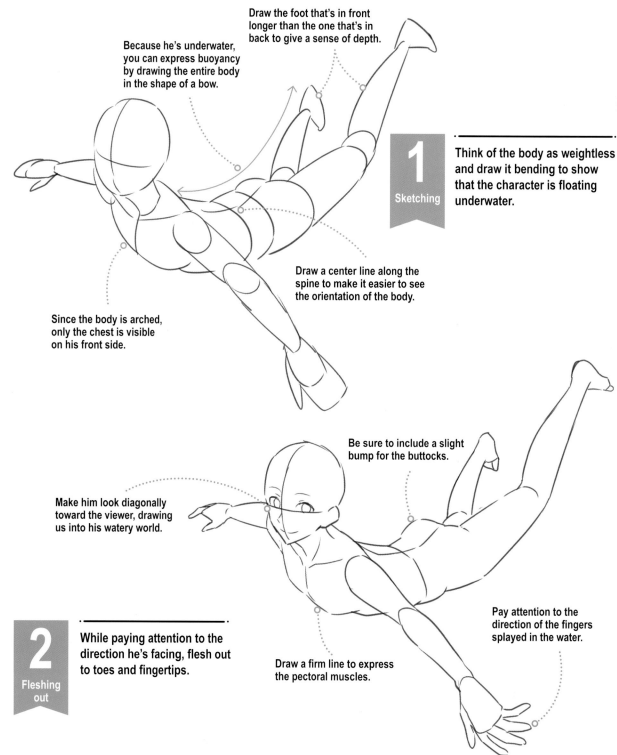

Draw the foot that's in front longer than the one that's in back to give a sense of depth.

Because he's underwater, you can express buoyancy by drawing the entire body in the shape of a bow.

1
Sketching

Think of the body as weightless and draw it bending to show that the character is floating underwater.

Draw a center line along the spine to make it easier to see the orientation of the body.

Since the body is arched, only the chest is visible on his front side.

Be sure to include a slight bump for the buttocks.

Make him look diagonally toward the viewer, drawing us into his watery world.

Pay attention to the direction of the fingers splayed in the water.

2
Fleshing out

While paying attention to the direction he's facing, flesh out to toes and fingertips.

Draw a firm line to express the pectoral muscles.

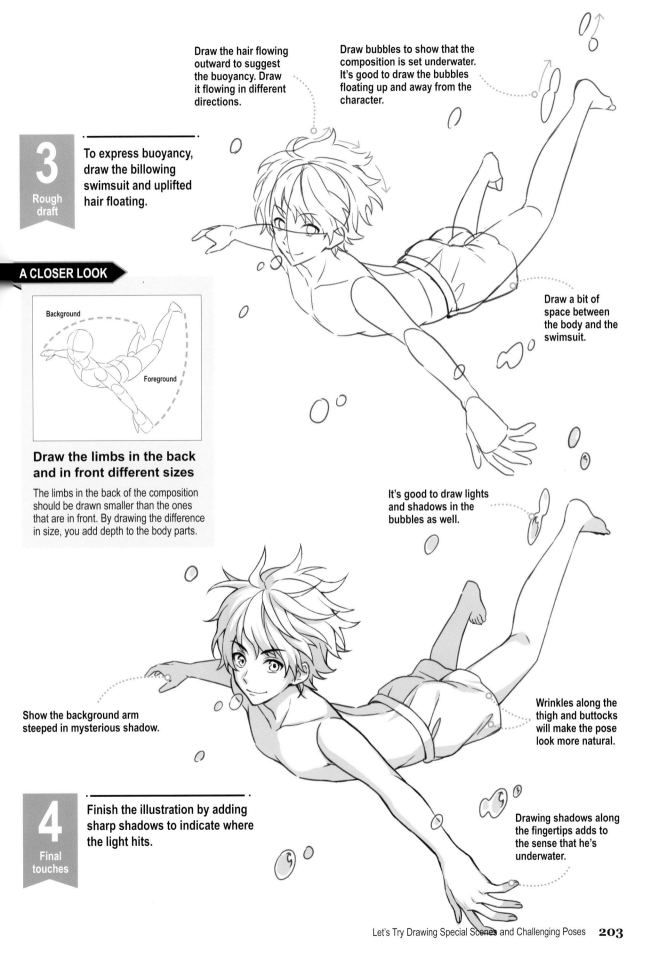

3

Rough draft

To express buoyancy, draw the billowing swimsuit and uplifted hair floating.

Draw the hair flowing outward to suggest the buoyancy. Draw it flowing in different directions.

Draw bubbles to show that the composition is set underwater. It's good to draw the bubbles floating up and away from the character.

Draw a bit of space between the body and the swimsuit.

A CLOSER LOOK

Background

Foreground

Draw the limbs in the back and in front different sizes

The limbs in the back of the composition should be drawn smaller than the ones that are in front. By drawing the difference in size, you add depth to the body parts.

It's good to draw lights and shadows in the bubbles as well.

Wrinkles along the thigh and buttocks will make the pose look more natural.

Show the background arm steeped in mysterious shadow.

4

Final touches

Finish the illustration by adding sharp shadows to indicate where the light hits.

Drawing shadows along the fingertips adds to the sense that he's underwater.

Pose
73
Slightly low angle

Side view

Coming up for Air

A swimmer surfaces, rising from the water. It's time to get a breath of air. Pay attention to the to the difference between the body parts that are above- and underwater.

Light

1 Sketching

Since the character is rising straight above the water line, draw her to look like she's stretching her body. Watch out for the position of the spine and toes.

For a side-view orientation, draw a line to indicate the position of the ears.

Stretch the back and lift the chin to make it easier to tell that the body is facing upward.

To express the character catching her breath, you can draw her mouth opening wide.

Because of the slightly low angle, draw the lower body longer than the upper body.

The pose is being viewed from the side, but since the body is slightly angled, the right breast is visible.

Pay attention to the position and size of the hands.

By pointing the toes down, you help indicate the body is freely floating.

Pay attention to the waistline.

2 Fleshing out

This composition is being viewed at a slightly low angle, so pay attention to the body's orientation and position in the water.

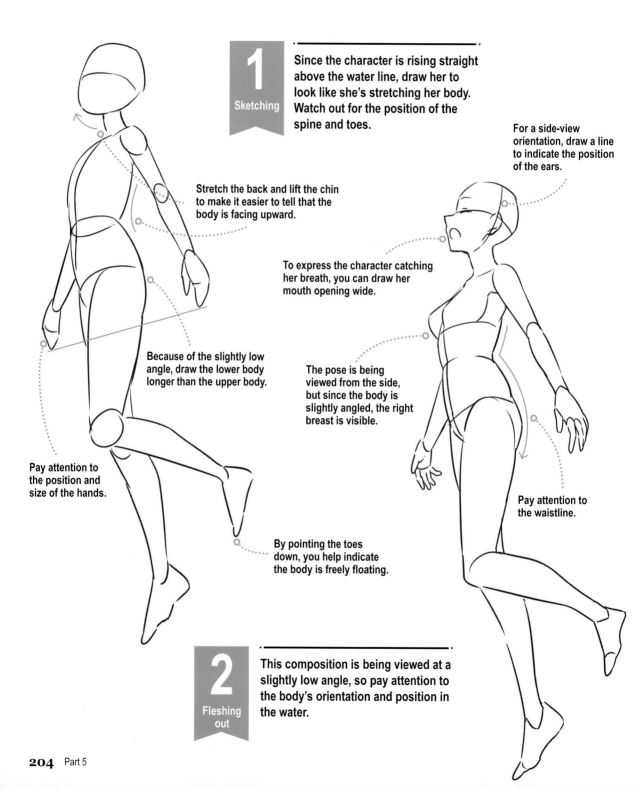

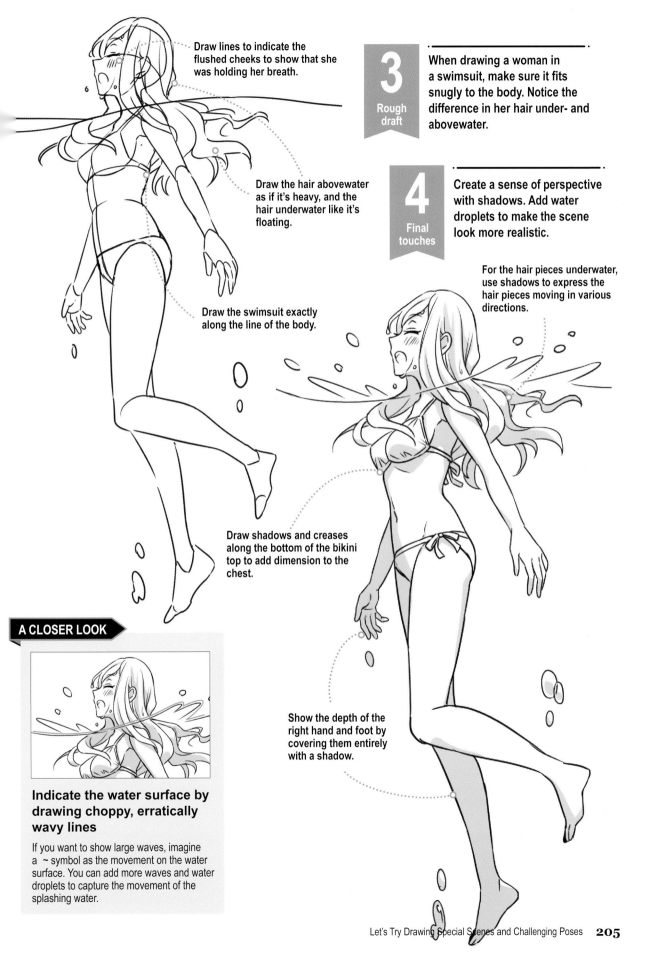

Draw lines to indicate the flushed cheeks to show that she was holding her breath.

3 Rough draft

When drawing a woman in a swimsuit, make sure it fits snugly to the body. Notice the difference in her hair under- and abovewater.

Draw the hair abovewater as if it's heavy, and the hair underwater like it's floating.

4 Final touches

Create a sense of perspective with shadows. Add water droplets to make the scene look more realistic.

Draw the swimsuit exactly along the line of the body.

For the hair pieces underwater, use shadows to express the hair pieces moving in various directions.

Draw shadows and creases along the bottom of the bikini top to add dimension to the chest.

Show the depth of the right hand and foot by covering them entirely with a shadow.

A CLOSER LOOK

Indicate the water surface by drawing choppy, erratically wavy lines

If you want to show large waves, imagine a ~ symbol as the movement on the water surface. You can add more waves and water droplets to capture the movement of the splashing water.

Pose

74

Slightly low angle

Diagonal view

Looking at a Cat

A young woman is crouched down, peering at her pet cat. Pay attention to the tilt of the character's neck and how it affects the angle of the face and eyes.

Light

1

Sketching

Since this is a crouching pose seen from a slight low angle, pay attention to the perspective while sketching.

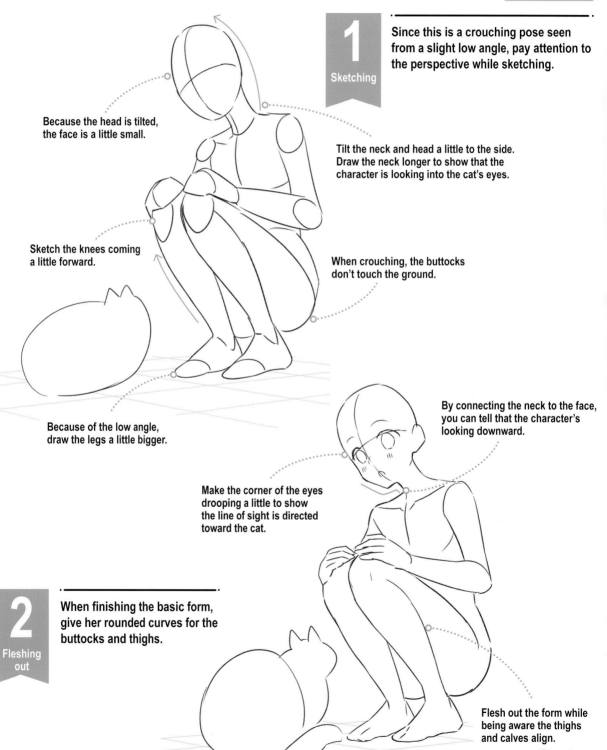

Because the head is tilted, the face is a little small.

Tilt the neck and head a little to the side. Draw the neck longer to show that the character is looking into the cat's eyes.

Sketch the knees coming a little forward.

When crouching, the buttocks don't touch the ground.

Because of the low angle, draw the legs a little bigger.

By connecting the neck to the face, you can tell that the character's looking downward.

Make the corner of the eyes drooping a little to show the line of sight is directed toward the cat.

2

Fleshing out

When finishing the basic form, give her rounded curves for the buttocks and thighs.

Flesh out the form while being aware the thighs and calves align.

3

Rough draft

Add in the clothing and accessories. Pay attention to the movement of the hair when she's looking down at the cat.

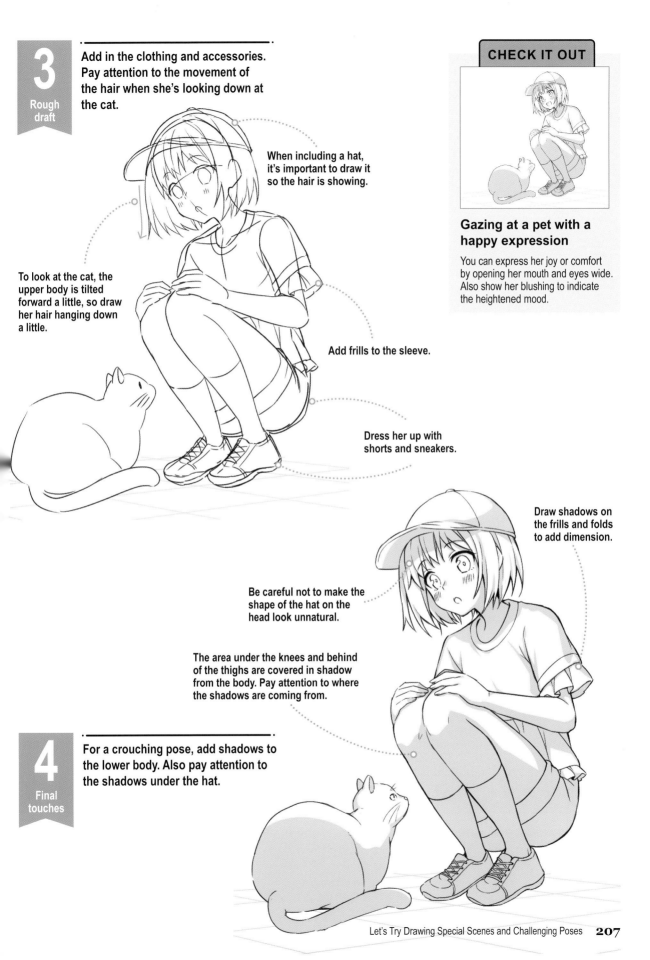

When including a hat, it's important to draw it so the hair is showing.

To look at the cat, the upper body is tilted forward a little, so draw her hair hanging down a little.

Add frills to the sleeve.

Dress her up with shorts and sneakers.

CHECK IT OUT

Gazing at a pet with a happy expression

You can express her joy or comfort by opening her mouth and eyes wide. Also show her blushing to indicate the heightened mood.

Draw shadows on the frills and folds to add dimension.

Be careful not to make the shape of the hat on the head look unnatural.

The area under the knees and behind of the thighs are covered in shadow from the body. Pay attention to where the shadows are coming from.

4

Final touches

For a crouching pose, add shadows to the lower body. Also pay attention to the shadows under the hat.

Direction of light

Light

Pose
75
High angle
Straight view

Two People Walking + Teasing Each Other

When two people are walking together, pay attention to their height differences as well as their gaze and gestures. It's also an opportunity to define or characterize their relationship.

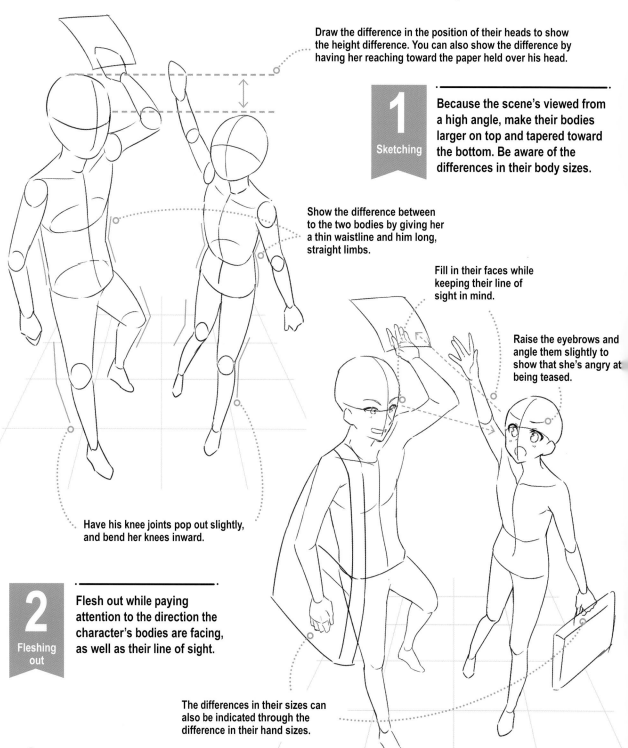

Draw the difference in the position of their heads to show the height difference. You can also show the difference by having her reaching toward the paper held over his head.

1 Sketching
Because the scene's viewed from a high angle, make their bodies larger on top and tapered toward the bottom. Be aware of the differences in their body sizes.

Show the difference between to the two bodies by giving her a thin waistline and him long, straight limbs.

Fill in their faces while keeping their line of sight in mind.

Raise the eyebrows and angle them slightly to show that she's angry at being teased.

Have his knee joints pop out slightly, and bend her knees inward.

2 Fleshing out
Flesh out while paying attention to the direction the character's bodies are facing, as well as their line of sight.

The differences in their sizes can also be indicated through the difference in their hand sizes.

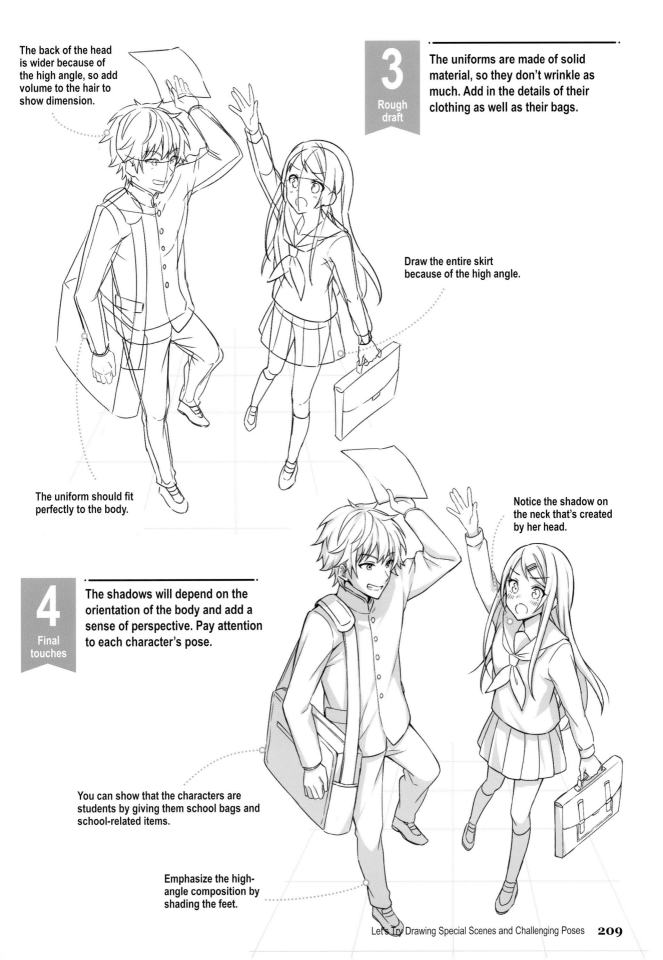

The back of the head is wider because of the high angle, so add volume to the hair to show dimension.

The uniforms are made of solid material, so they don't wrinkle as much. Add in the details of their clothing as well as their bags.

Draw the entire skirt because of the high angle.

The uniform should fit perfectly to the body.

Notice the shadow on the neck that's created by her head.

The shadows will depend on the orientation of the body and add a sense of perspective. Pay attention to each character's pose.

You can show that the characters are students by giving them school bags and school-related items.

Emphasize the high-angle composition by shading the feet.

Pose

76

Eye level
Straight view

One-Armed Handstand

This is an unusual and memorable pose to master: a one-armed handstand, a study in balance. Draw the character with widely spread and outstretched arms and legs.

Light

1
Sketching

Sketch while thinking about where the center of gravity is and how to balance the body.

The center of gravity is straight down the right leg to the left arm, so remember to draw it in a straight line.

For the limbs outside the center of gravity, bend the joints to balance the figure.

Draw the left arm as perpendicular to the ground as possible.

2
Fleshing out

Considering the angles of the arms and legs and the ways the muscles engage as he balances his weight.

The leg on the right side is falling a little forward. Draw it a little bigger than the other body parts.

The abdominal muscles are flexed and engaged.

Draw the bulging of the shoulder muscles to show strength involved.

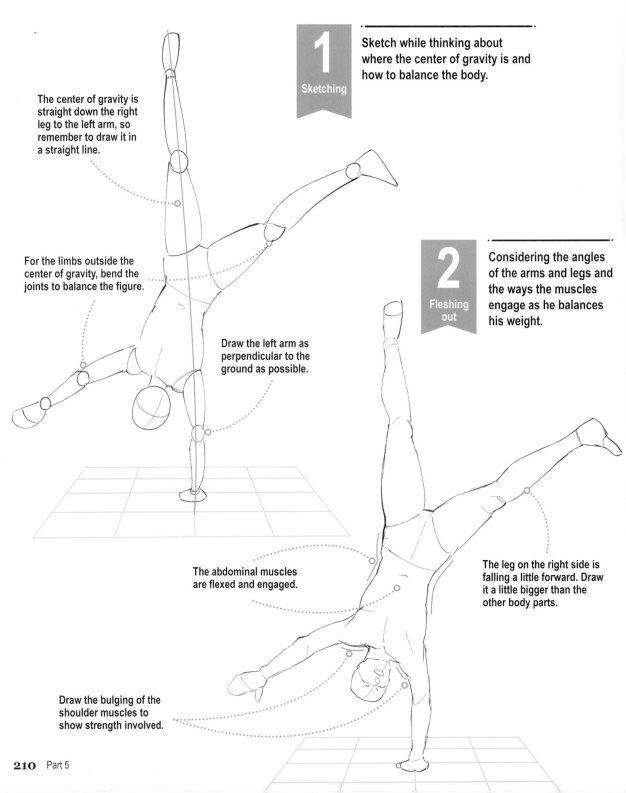

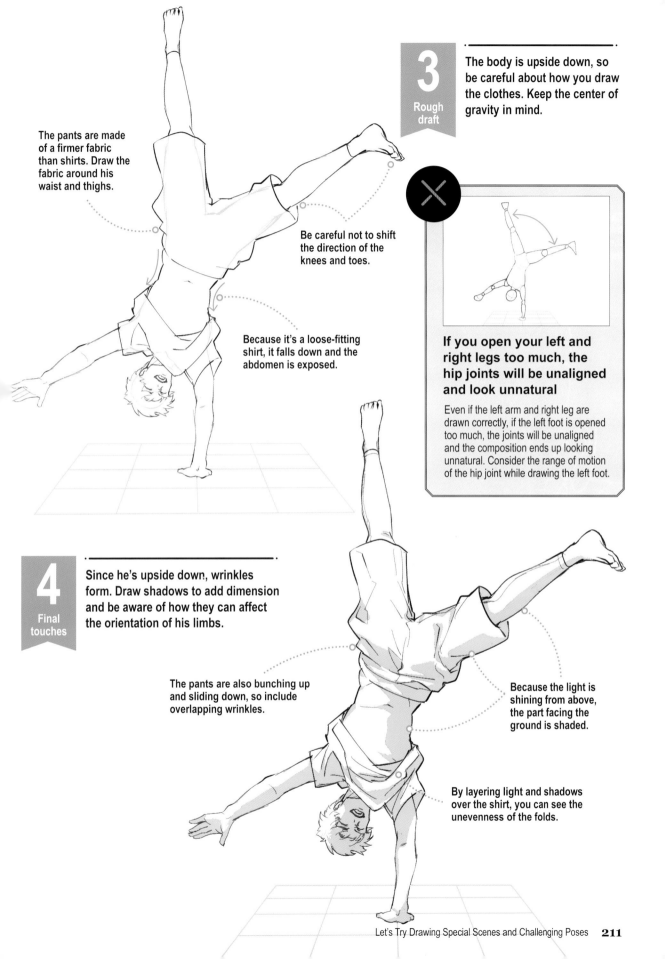

The body is upside down, so be careful about how you draw the clothes. Keep the center of gravity in mind.

The pants are made of a firmer fabric than shirts. Draw the fabric around his waist and thighs.

Be careful not to shift the direction of the knees and toes.

Because it's a loose-fitting shirt, it falls down and the abdomen is exposed.

If you open your left and right legs too much, the hip joints will be unaligned and look unnatural

Even if the left arm and right leg are drawn correctly, if the left foot is opened too much, the joints will be unaligned and the composition ends up looking unnatural. Consider the range of motion of the hip joint while drawing the left foot.

4
Final touches

Since he's upside down, wrinkles form. Draw shadows to add dimension and be aware of how they can affect the orientation of his limbs.

The pants are also bunching up and sliding down, so include overlapping wrinkles.

Because the light is shining from above, the part facing the ground is shaded.

By layering light and shadows over the shirt, you can see the unevenness of the folds.

Pose

77

Eye level
Diagonal view

At the Starting Line

On your mark, get set, go! A sprinter is posed at the starting block, ready for the race to start. Draw the character with a well-balanced posture and add a sense of tension.

Light

Since the front of the left thigh is in close contact with the upper body, draw only the back of the thigh.

1

Sketching

Since it's a pose evoking depth, pay attention to the shape of the arms and legs and how they're affected by the perspective.

Instead of bringing the left and right arms straight down, draw them so that they extend slightly outward.

2

Fleshing out

By drawing define muscles while keeping their slender frame, you can draw a cool sporty girl.

Position the hand slightly in front of the left foot.

The back isn't visible, but you can suggest it by drawing an indented curve at the waistline.

You can express the perspective of the right leg under the knee by drawing it thinner as it tapers toward the ankle.

Since both hands are placed on the ground, the upper body is leaned forward. Draw the hips sticking upward.

Draw the calf muscles bulging and tighten the ankles.

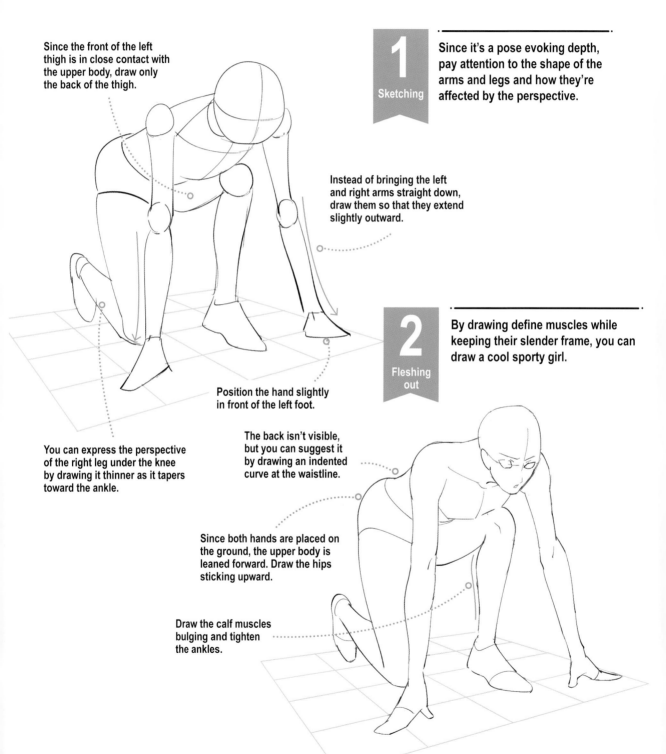

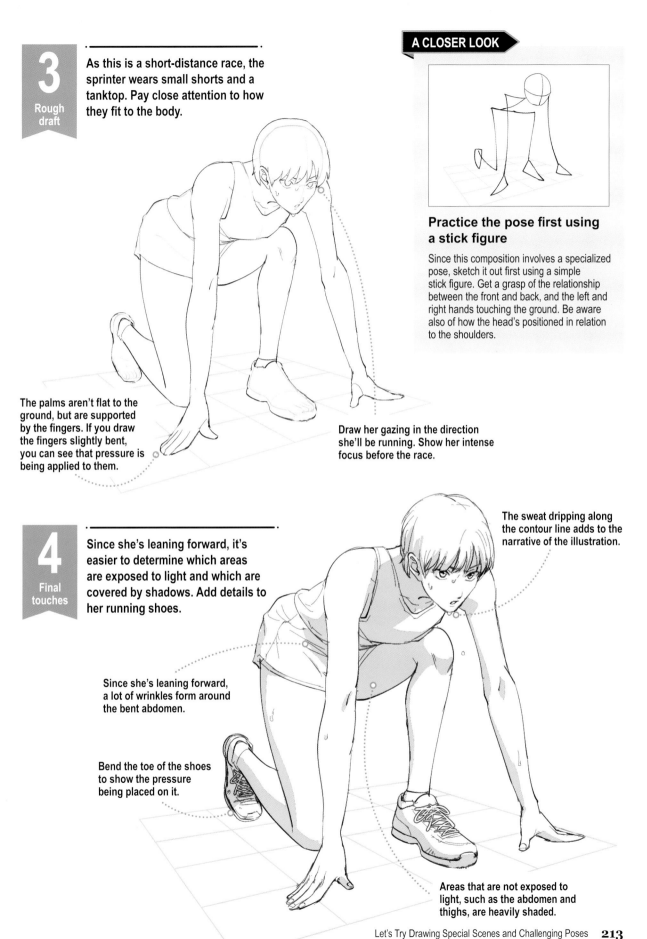

3

Rough draft

As this is a short-distance race, the sprinter wears small shorts and a tanktop. Pay close attention to how they fit to the body.

Practice the pose first using a stick figure

Since this composition involves a specialized pose, sketch it out first using a simple stick figure. Get a grasp of the relationship between the front and back, and the left and right hands touching the ground. Be aware also of how the head's positioned in relation to the shoulders.

The palms aren't flat to the ground, but are supported by the fingers. If you draw the fingers slightly bent, you can see that pressure is being applied to them.

Draw her gazing in the direction she'll be running. Show her intense focus before the race.

4

Final touches

Since she's leaning forward, it's easier to determine which areas are exposed to light and which are covered by shadows. Add details to her running shoes.

The sweat dripping along the contour line adds to the narrative of the illustration.

Since she's leaning forward, a lot of wrinkles form around the bent abdomen.

Bend the toe of the shoes to show the pressure being placed on it.

Areas that are not exposed to light, such as the abdomen and thighs, are heavily shaded.

Let's Try Drawing Special Scenes and Challenging Poses **213**

Piggyback Ride

Here, a man gives a woman a piggyback ride. Since the two bodies overlap, think carefully about which parts are visible and which aren't.

Direction of light

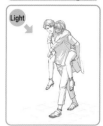

Light

With her head on his shoulder, the faces are aligned and almost parallel.

A gap is created between the man's upper body and the woman's arm.

Note that start of the girl's left leg is not visible. Let's draw based on the position where the left and right knees are parallel

1 Sketching

Draw a rough sketch of the man in the foreground, then add the second character. You can draw the entirety of her body first then erase the parts that aren't visible.

Show her left leg being supported by his left arm.

Although a portion of the neck is hidden, if you connect it to the back, you can show the slouch of the upper body.

The toes are relaxed, but be careful not to draw them facing straight down.

The thighs are being supported by his arm, so make it thicker.

2 Fleshing out

You can indicate the differences in their physiques by giving their limbs different lengths and thicknesses.

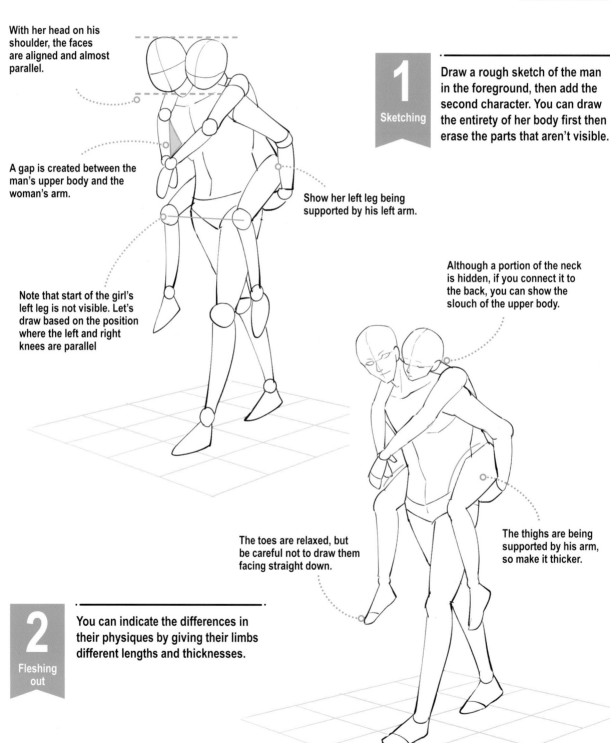

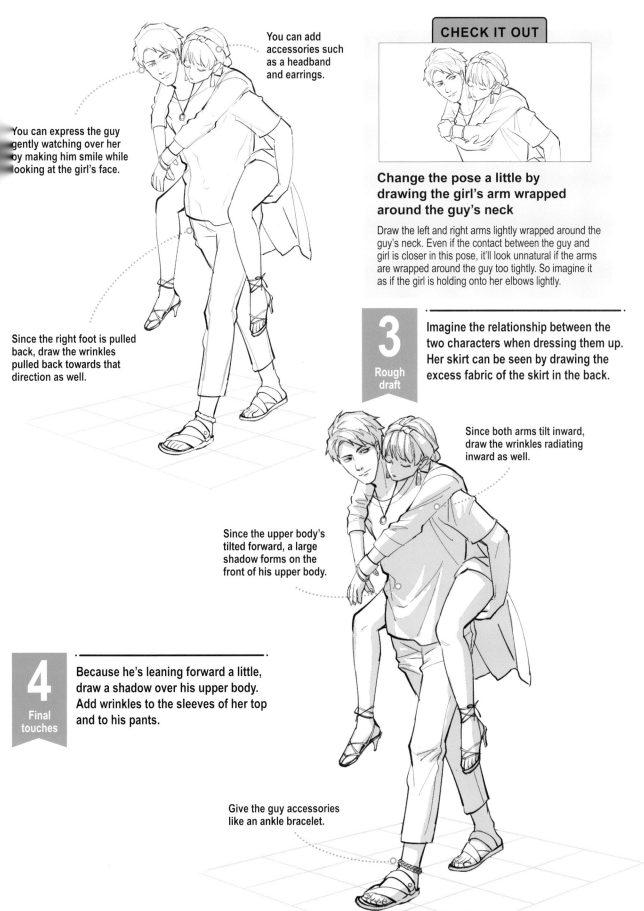

You can add accessories such as a headband and earrings.

You can express the guy gently watching over her by making him smile while looking at the girl's face.

Since the right foot is pulled back, draw the wrinkles pulled back towards that direction as well.

Change the pose a little by drawing the girl's arm wrapped around the guy's neck

Draw the left and right arms lightly wrapped around the guy's neck. Even if the contact between the guy and girl is closer in this pose, it'll look unnatural if the arms are wrapped around the guy too tightly. So imagine it as if the girl is holding onto her elbows lightly.

3
Rough draft

Imagine the relationship between the two characters when dressing them up. Her skirt can be seen by drawing the excess fabric of the skirt in the back.

Since both arms tilt inward, draw the wrinkles radiating inward as well.

Since the upper body's tilted forward, a large shadow forms on the front of his upper body.

4
Final touches

Because he's leaning forward a little, draw a shadow over his upper body. Add wrinkles to the sleeves of her top and to his pants.

Give the guy accessories like an ankle bracelet.

Pose

79

Slighty high angle
Diagonal view

Holding a Gun

A man draws his pistol, holding it firmly with both hands. Draw his legs at shoulder width for a firm stance and raise his gun to chest height.

Direction of light

Light

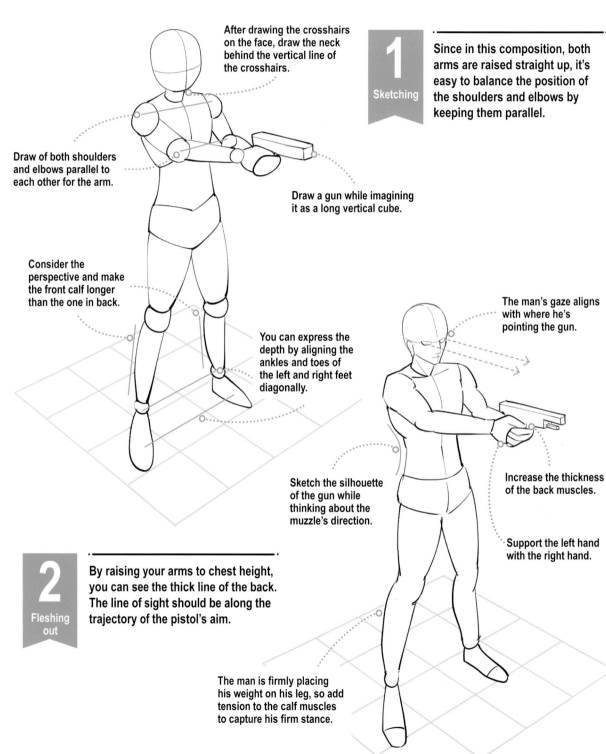

After drawing the crosshairs on the face, draw the neck behind the vertical line of the crosshairs.

1

Sketching

Since in this composition, both arms are raised straight up, it's easy to balance the position of the shoulders and elbows by keeping them parallel.

Draw of both shoulders and elbows parallel to each other for the arm.

Draw a gun while imagining it as a long vertical cube.

Consider the perspective and make the front calf longer than the one in back.

You can express the depth by aligning the ankles and toes of the left and right feet diagonally.

The man's gaze aligns with where he's pointing the gun.

Sketch the silhouette of the gun while thinking about the muzzle's direction.

Increase the thickness of the back muscles.

Support the left hand with the right hand.

2

Fleshing out

By raising your arms to chest height, you can see the thick line of the back. The line of sight should be along the trajectory of the pistol's aim.

The man is firmly placing his weight on his leg, so add tension to the calf muscles to capture his firm stance.

3

Rough draft

Give him clothes that are tight-fitting so his muscles are on view. Incorporate accessories, such as a holster, to add authenticity to his outfit.

Draw his hair slightly longer over the nape.

When drawing a shirt that's a tight fit, include small folds.

Add in the small parts of the gun.

The left hand wraps over the right hand; add dimension by drawing the knuckles.

A CLOSER LOOK

Barrel

Trigger

Grip

Holding a firearm

The grip, which is the handle, is short enough to be hidden when held with both hands. The trigger, which is pulled to fire the gun, is where the index finger is placed. Draw the barrel in a cylindical shape.

Draw the hair flowing from the whorl down toward the face for volume and to add dimension.

Add shadows to the back of the upper arm and forearm.

4

Final touches

When viewed from a slight high angle, draw shadows over the neck and back side. For tight fit clothing, draw horizontal line over the naval area to express the wrinkle and folds.

Use the navel position as a guide and add a few horizontal wrinkles and a shadow.

Using the kneecaps as a guide, add shadow below the knees.

Draw in combat boots that cover the ankles, then add in shadow.

Pose

80

High angle
Straight view

Drawing a Sword

A man runs straight at us with a drawn sword. Think about how the arm extends the blade, how the legs look and how the pose is viewed from a high angle.

Light

Since the arms are raised up, the shoulders frame the face. If you draw the upper arm short and the forearm a little longer, you will get a strong sense of the perspective.

1 Sketching

The lengths from the shoulders to elbow, then from elbow to wrist are different due to the perspective. His left leg is pulled back so you can only see the thighs.

Since he's slashing while pulling the left arm back, the upper body twists to the left a little.

The left foot pulled back can hardly visible from below the knee when viewed from the front and high angle.

The sword is curved at the tip. Draw the curve tightly because it's being seen from a high angle.

There's a gap between the leg in front and the one in back.

Because of the high angle, you can see the top of the head. Decide the position of the whorl.

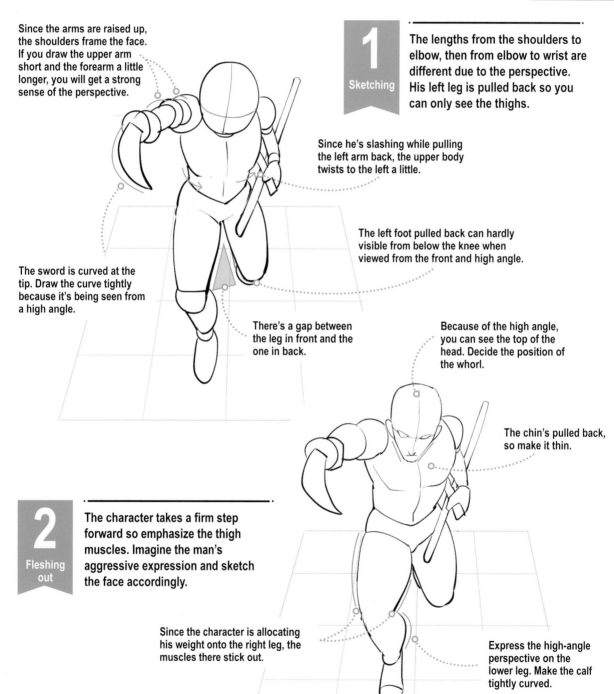

The chin's pulled back, so make it thin.

2 Fleshing out

The character takes a firm step forward so emphasize the thigh muscles. Imagine the man's aggressive expression and sketch the face accordingly.

Since the character is allocating his weight onto the right leg, the muscles there stick out.

Express the high-angle perspective on the lower leg. Make the calf tightly curved.

3

Rough draft

It's a good idea to use images of kimonos and katanas as reference. Allow room around the arms and legs for easier movement.

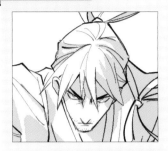

Add a lot of movement to the tip of the hair to add dynamic.

If you draw the tip of the nose downward, you can convey a better sense of the high-angle perspective.

The right foot can be seen through the hem of the hakama, but the left foot can only be seen up to the knee.

Capturing an intense expression

Place the eyes and eyebrows close together to intensify the glare. Draw the nose and tip as a downward-pointing triangle.

4

Final touches

While thinking about the parts that are extended and those in the background, draw in shadows to add dimension. Include details on the sword and sheath for a realistic finish.

On the surface of the sword, draw a wavy line to indicate the blade.

Draw wrinkles pulled toward the knot.

Add wrinkles according to the movement of your right foot.

Due to the forward-leaning posture, there's a slight gap in the front of the hakama. Draw the collars curving toward the tied knot.

Fighting with Swords

Two men are engaged in an intense sword battle. Think about where the blades intersect, and draw details to bring out the illustration's narrative.

Direction of light

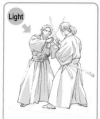
Light

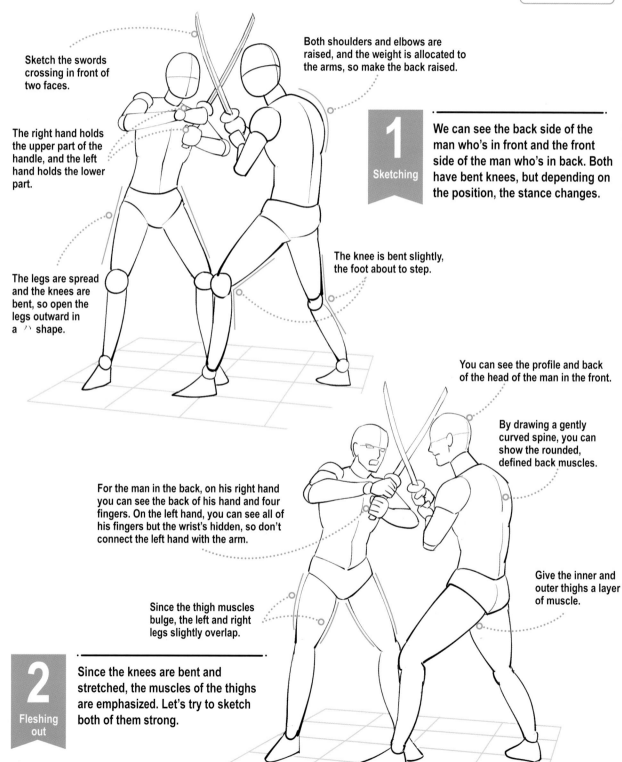

Sketch the swords crossing in front of two faces.

Both shoulders and elbows are raised, and the weight is allocated to the arms, so make the back raised.

The right hand holds the upper part of the handle, and the left hand holds the lower part.

1
Sketching

We can see the back side of the man who's in front and the front side of the man who's in back. Both have bent knees, but depending on the position, the stance changes.

The knee is bent slightly, the foot about to step.

The legs are spread and the knees are bent, so open the legs outward in a ⌃ shape.

You can see the profile and back of the head of the man in the front.

By drawing a gently curved spine, you can show the rounded, defined back muscles.

For the man in the back, on his right hand you can see the back of his hand and four fingers. On the left hand, you can see all of his fingers but the wrist's hidden, so don't connect the left hand with the arm.

Give the inner and outer thighs a layer of muscle.

Since the thigh muscles bulge, the left and right legs slightly overlap.

2
Fleshing out

Since the knees are bent and stretched, the muscles of the thighs are emphasized. Let's try to sketch both of them strong.

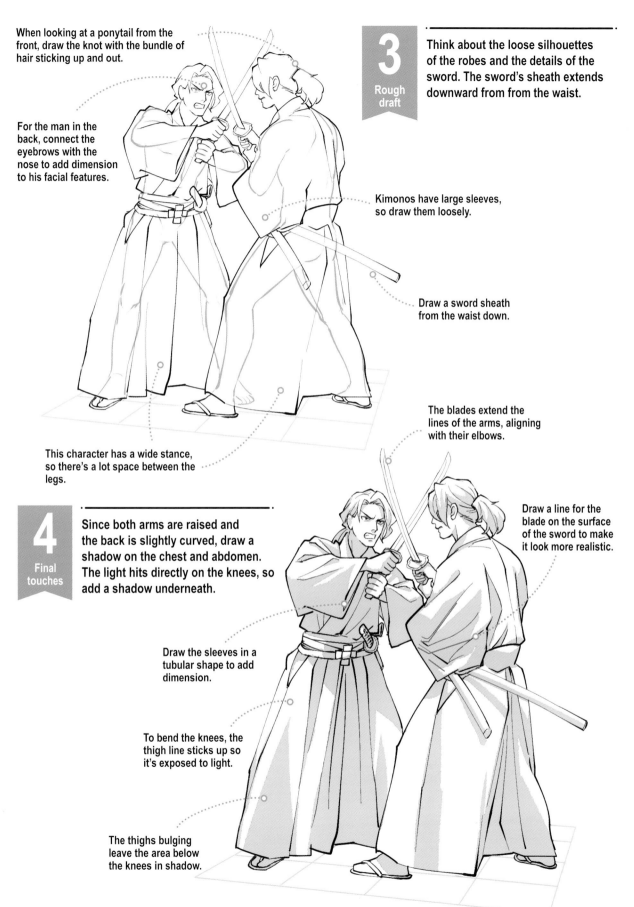

When looking at a ponytail from the front, draw the knot with the bundle of hair sticking up and out.

For the man in the back, connect the eyebrows with the nose to add dimension to his facial features.

3

Rough draft

Think about the loose silhouettes of the robes and the details of the sword. The sword's sheath extends downward from from the waist.

Kimonos have large sleeves, so draw them loosely.

Draw a sword sheath from the waist down.

The blades extend the lines of the arms, aligning with their elbows.

This character has a wide stance, so there's a lot space between the legs.

4

Final touches

Since both arms are raised and the back is slightly curved, draw a shadow on the chest and abdomen. The light hits directly on the knees, so add a shadow underneath.

Draw a line for the blade on the surface of the sword to make it look more realistic.

Draw the sleeves in a tubular shape to add dimension.

To bend the knees, the thigh line sticks up so it's exposed to light.

The thighs bulging leave the area below the knees in shadow.

Onoda To-ya

Pixiv ▶ https://www.pixiv.net/member.php?id=815210
twitter ▶ @SERAUQS

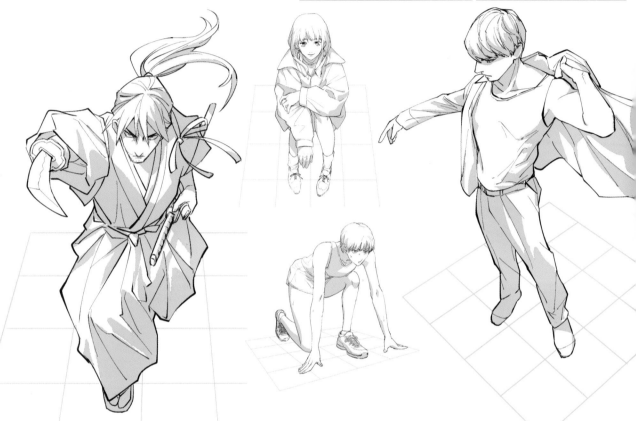

Interview

What made you decide to become an illustrator?

I wanted to see people touched, happy and inspired by my illustrations. So after graduating from high school, I decided to attend vocational school for illustration.

Did you have any weaknesses when you started drawing illustrations?

When I started drawing, I never really thought I had any weaknesses. I overcame that attitude and realized that I couldn't draw many things.

What kind of practice did you follow to improve your illustrations?

I would refer to real photos or pose dolls, or even refer to other good illustrators. I'd analyze illustrations done by people I feel that are better than I am and compare it in my head to see how their illustrations differ from mine.

What are some things you keep in mind when you're drawing?

What do you want to show the most? Also, I always think about what I want to show the audience in a particular illustration.

If a beginner asks you "Teach me how to draw!" what would be your first bit of advice?

Rather than drawing what you see, even if it's a little different from the real thing, it's more important to draw what you think is best.

Karasuba Ame

HP ▶ http://conronca.flop.jp/
twitter ▶ https://twitter.com/conronca

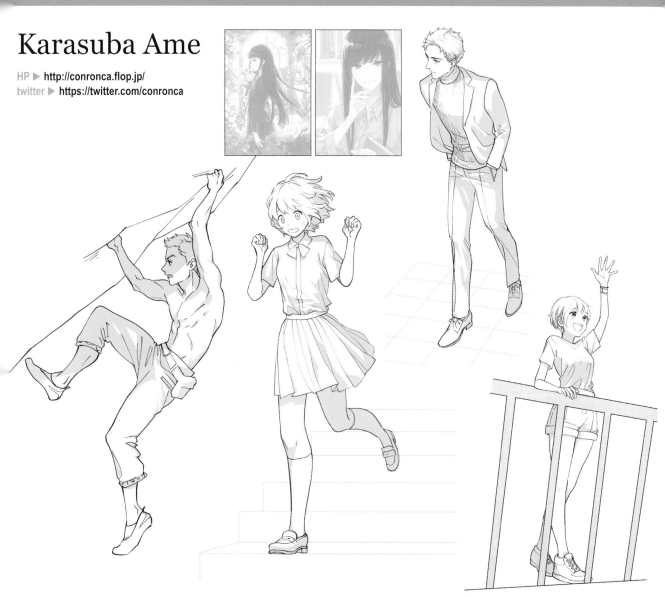

Interview

What kind of practice did you pursue to be able to draw various poses?

When I was a student, I used to do croquis drawings of people on the train. Of course, people change their poses quickly, so it was good training to quickly remember and capture poses. Recently, there are a lot of croquis videos on YouTube, so I draw them while watching.

I think there are many people out there who'd say, "I can draw faces, but I can't draw bodies." What did you do to practice?

"I can't draw bodies" to me means "I don't have a composition to draw." So I saw a lot of talented people's drawings and copied them with similar poses and compositions. Rather than "overcoming my weaknesses," I just wanted to make cooler illustrations. As a result, I was

able to draw more and more widely.

If a beginner asks you, "Teach me how to draw," what would be your first advice?

I recommend following your role model. Tracing or copying is O.K. as a beginner. It's fun to copy your role model. If you get tired of copying, draw while thinking about how your role model would draw the most awesome illustration ever. When it comes to "I have to practice drawing to improve," I get tired of it in a day, so I think the fastest way to improve is to have fun with what you do.

"Books to Span the East and West"

Tuttle Publishing was founded in 1832 in the small New England town of Rutland, Vermont [USA]. Our core values remain as strong today as they were then—to publish best-in-class books which bring people together one page at a time. In 1948, we established a publishing office in Japan—and Tuttle is now a leader in publishing English-language books about the arts, languages and cultures of Asia. The world has become a much smaller place today and Asia's economic and cultural influence has grown. Yet the need for meaningful dialogue and information about this diverse region has never been greater. Over the past seven decades, Tuttle has published thousands of books on subjects ranging from martial arts and paper crafts to language learning and literature—and our talented authors, illustrators, designers and photographers have won many prestigious awards. We welcome you to explore the wealth of information available on Asia at **www.tuttlepublishing.com**.

Published by Tuttle Publishing, an imprint of Periplus Editions (HK) Ltd.

www.tuttlepublishing.com

DONNA POSE MO KAKERUYOUNI NARU! MANGA CHARA ATARI RENSHUCHOU
Copyright © Niko Works 2019
English translation rights arranged with SEITO-SHA CO., LTD. through Japan UNI Agency, Inc., Tokyo

English Translation © 2022 by Periplus Editions (HK) Ltd

ISBN 978-4-8053-1677-1
Library of Congress Cataloging-in-Publication Data in process

Staff (Original Japanese edition)
Illustrations Akariko, Izumi, Ojyou, Onoda To-ya, Karasuba Ame
Design Muraguchi Keita (Linon)
Editorial Contributors Ohta Natsumi (Niko Works), Domyo Satoko

Distributed by

North America, Latin America & Europe
Tuttle Publishing
364 Innovation Drive
North Clarendon, VT 05759-9436 U.S.A.
Tel: 1 (802) 773-8930
Fax: 1 (802) 773-6993
info@tuttlepublishing.com
www.tuttlepublishing.com

Japan
Tuttle Publishing
Yaekari Building, 3rd Floor
5-4-12 Osaki
Shinagawa-ku
Tokyo 141 0032
Tel: (81) 3 5437-0171
Fax: (81) 3 5437-0755
sales@tuttle.co.jp; www.tuttle.co.jp

Asia Pacific
Berkeley Books Pte. Ltd.
3 Kallang Sector, #04-01
Singapore 349278
Tel: (65) 67412178
Fax: (65) 67412179
inquiries@periplus.com.sg
www.tuttlepublishing.com

25 24 23 22 10 9 8 7 6 5 4 3 2 1

Printed in China 2201EP